Portraits

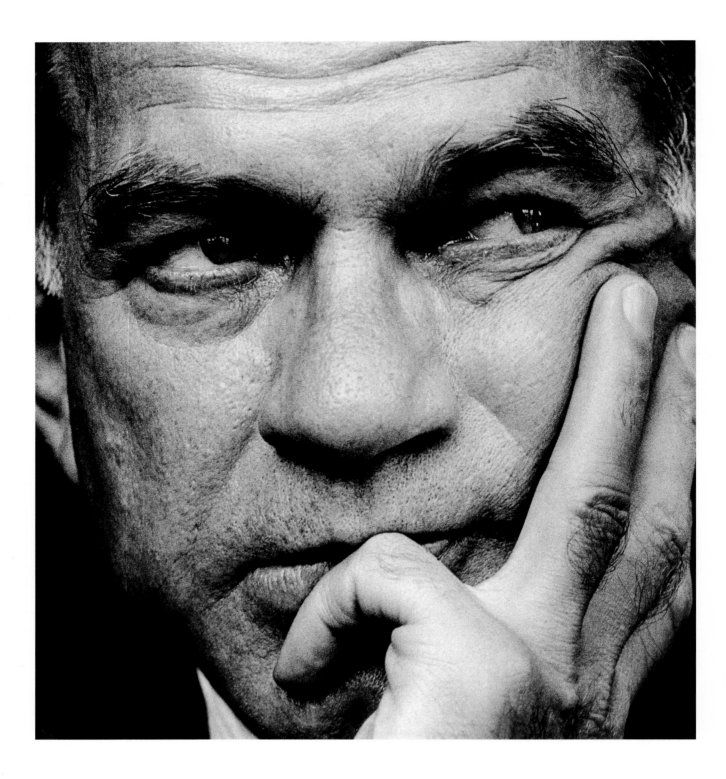

Senator J. William Fulbright, 1968

Published in Great Britain in 2000 by
Collins and Brown Limited
London House
Great Eastern Wharf
Parkgate Road
London SW11 4NQ

Distributed in the United States and Canada
by Sterling Publishing Co, 387 Park Avenue South,
New York, NY 10016, USA

Copyright © Collins and Brown Limited 2000
Text copyright © Collins and Brown Limited
and John Hedgecoe 2000
Photographs © John Hedgecoe 2000

Front cover: Francis Bacon
Back cover: David Hockney

1 3 5 7 9 8 6 4 2

British Library Cataloguing-in-Publication Data:
A catalogue record for this title is available
from the British Library.

ISBN 1 85585 726 X (hardback)
ISBN 1 85585 840 1 (paperback)

Editorial Director: Sarah Hoggett
Associate Writer: Adrian Bailey
Editor: Katie Hardwicke
Designer: Grant Scott

Reproduced by Mediaprint Services (UK) Ltd
Printed in China

Portraits

John Hedgecoe

COLLINS & BROWN

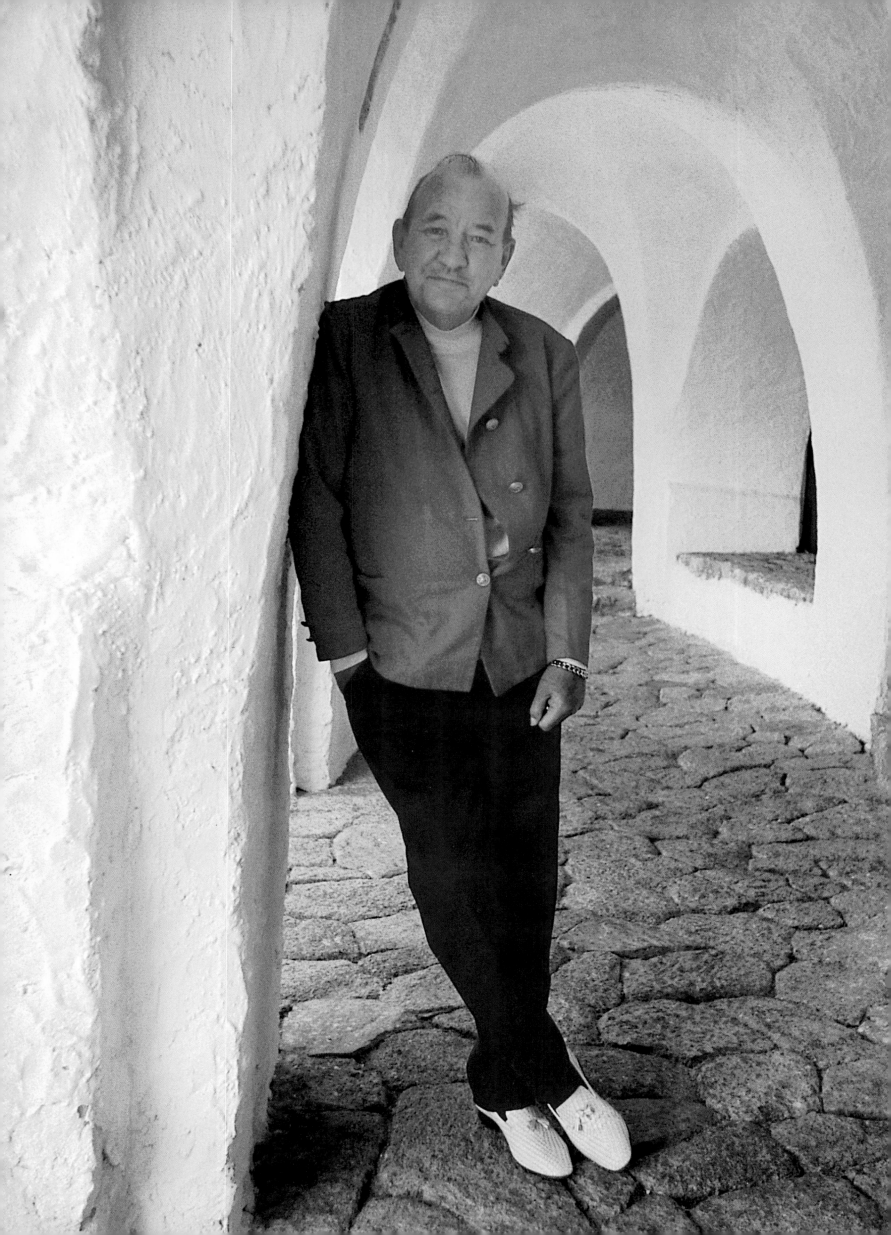

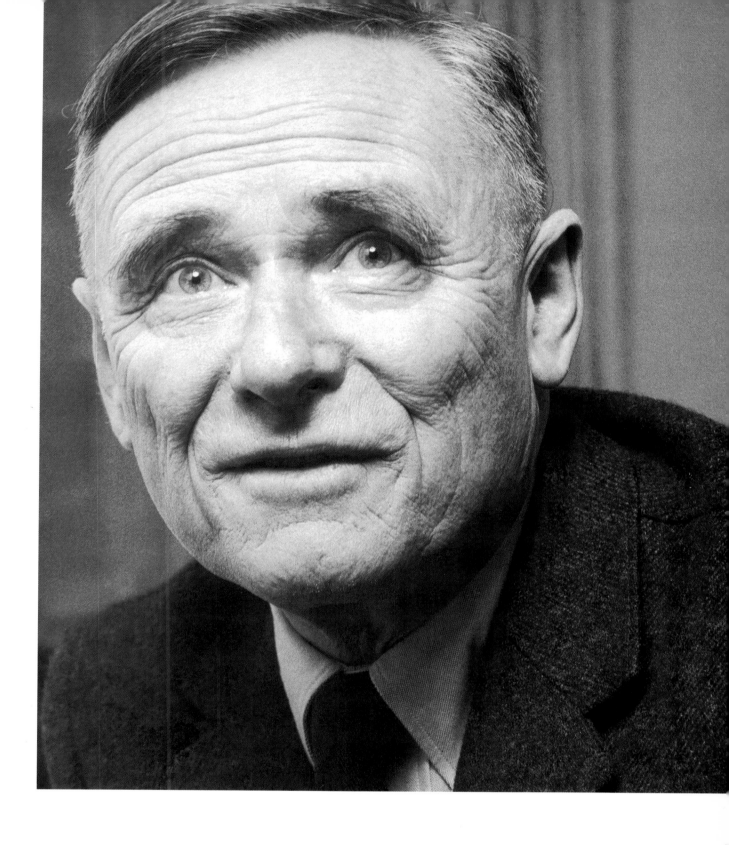

Left: Noël Coward, playwright, actor, entertainer, 1969
In the 1960s the really smart place to go was the Hotel Cala-di-Volpe, on the Costa Smeralda in Sardinia. At the time it was a small hotel – more of a yacht club – and the dining room had a wonderful panoramic view of the bay. I was there on an assignment, having dinner while watching a beautiful 1930s' steam yacht arrive at the landing stage. Everyone in the dining room was intrigued. Eventually two elegant men stepped ashore and headed towards the hotel. One of them was Loel Guinness, dressed in a white suit, and the other was Noël Coward, in a red jacket and black trousers. The dining room was packed with celebrities – many aristocrats were there, along with heads of state and exiled royals – and was humming with noise but as soon as the two new guests entered there was total silence. Coward stepped forward, turned to everyone and bowed. As he was being shown to his table he spotted me and said, 'Hello, John!' He came over, we chatted for a few minutes and he went on to his table. It was a wonderful moment. By chance we had met a week before, at a party for Christopher Isherwood. Why did he pick me out from the crowd? I think it was deliberate. He realized that he couldn't speak to just one group without speaking to them all, and it was easier to talk to me as I was probably the least socially important person there. The conversation in the dining room only resumed once he had taken his seat. When he finally stood up to leave the restaurant fell into silence again – a real mark of respect from the assembled glitterati. He reached the doorway and turned, bowed again and left. The room, in silence, watched him walk away. A few minutes passed until the conversation started to hum once more. The following day we met again and I photographed him in the arches of the hotel grounds.

Above: Christopher Isherwood, writer, 1969
I photographed Isherwood in his London apartment. At the party where I met Noël Coward, Isherwood did his party piece: putting on lace-up shoes without using his hands.

Following pages: John Mortimer, barrister, playwright, actor; N.F. Simpson, playwright; and Harold Pinter, actor and playwright; performing in *Three*, a triple bill at the Arts Theatre, London, 1960.

The entire cast of the Edinburgh Festival revue: Jonathan Miller, Alan Bennett, Peter Cook and Dudley Moore, 1960
This was taken before their success in the 1962 revue *Beyond the Fringe*. We agreed to meet for a location shot in Piccadilly. It was the first session they'd ever done for a magazine, and I walked along taking pictures while they created havoc, climbing up lamp-posts, putting waste bins on their heads, posing in shop doorways – Jonathan Miller in his usual duffel coat. It was hilarious, but difficult to concentrate on taking photographs – people in the street thought we were mad.

Following pages: Two faces of Peter Cook, 1960

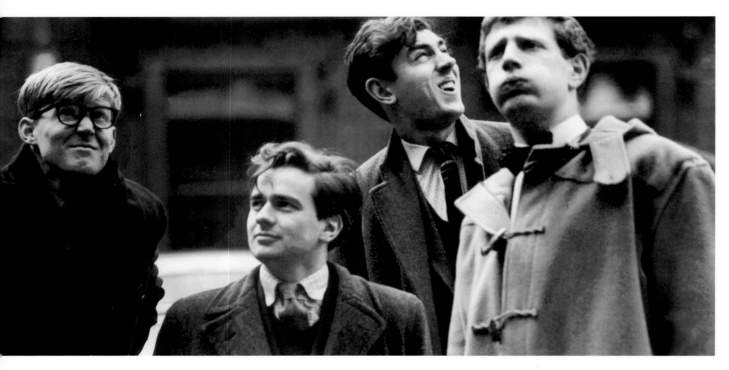

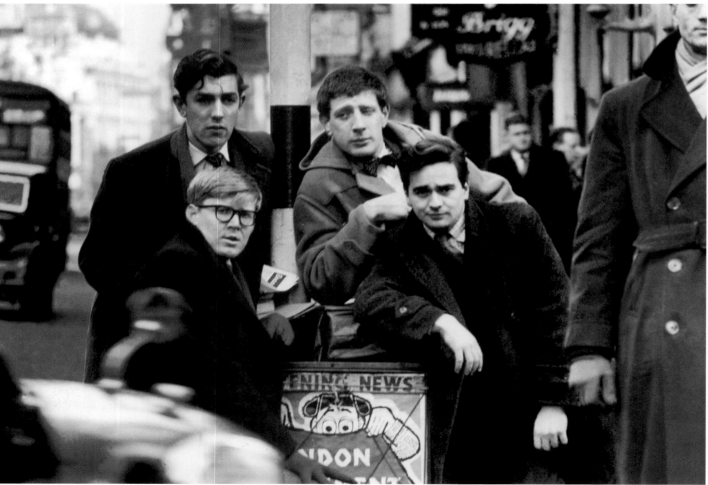

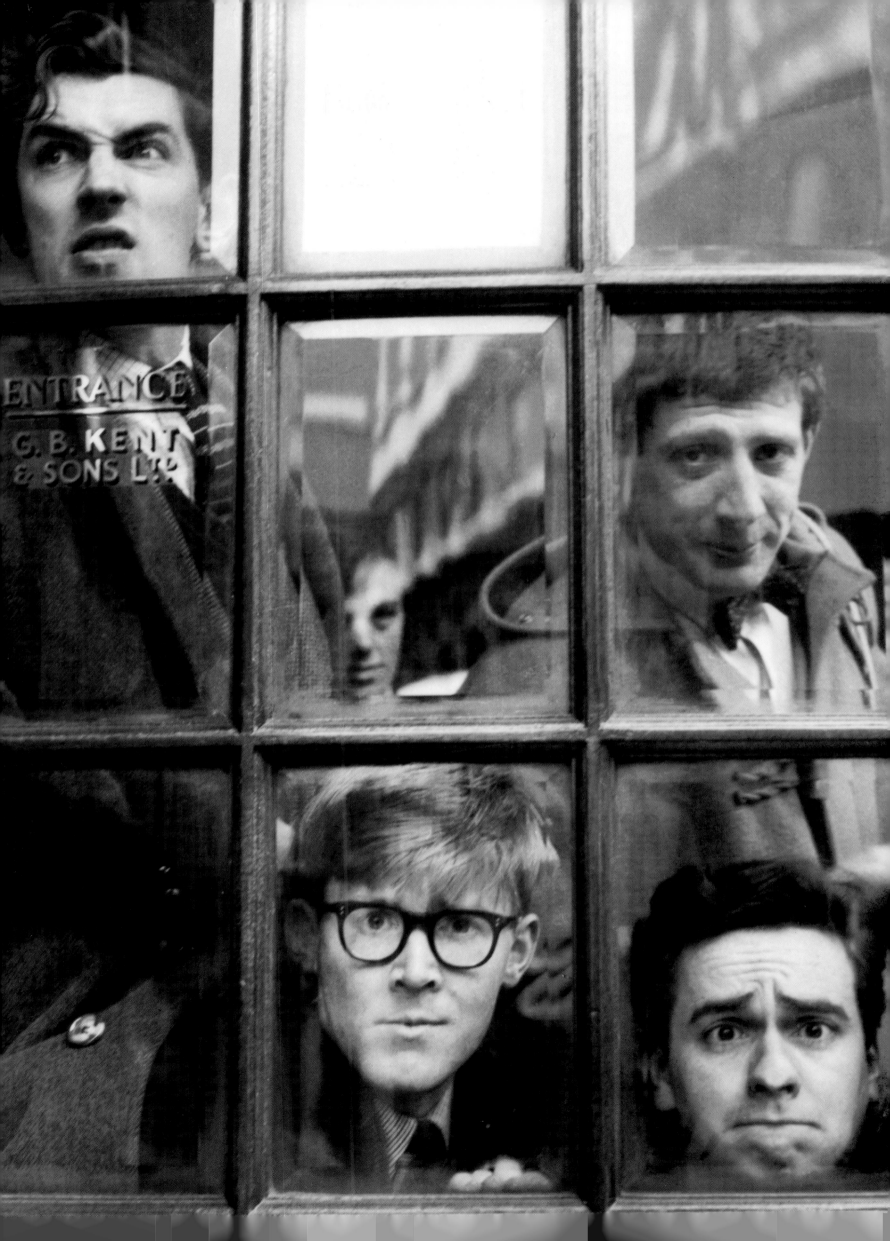

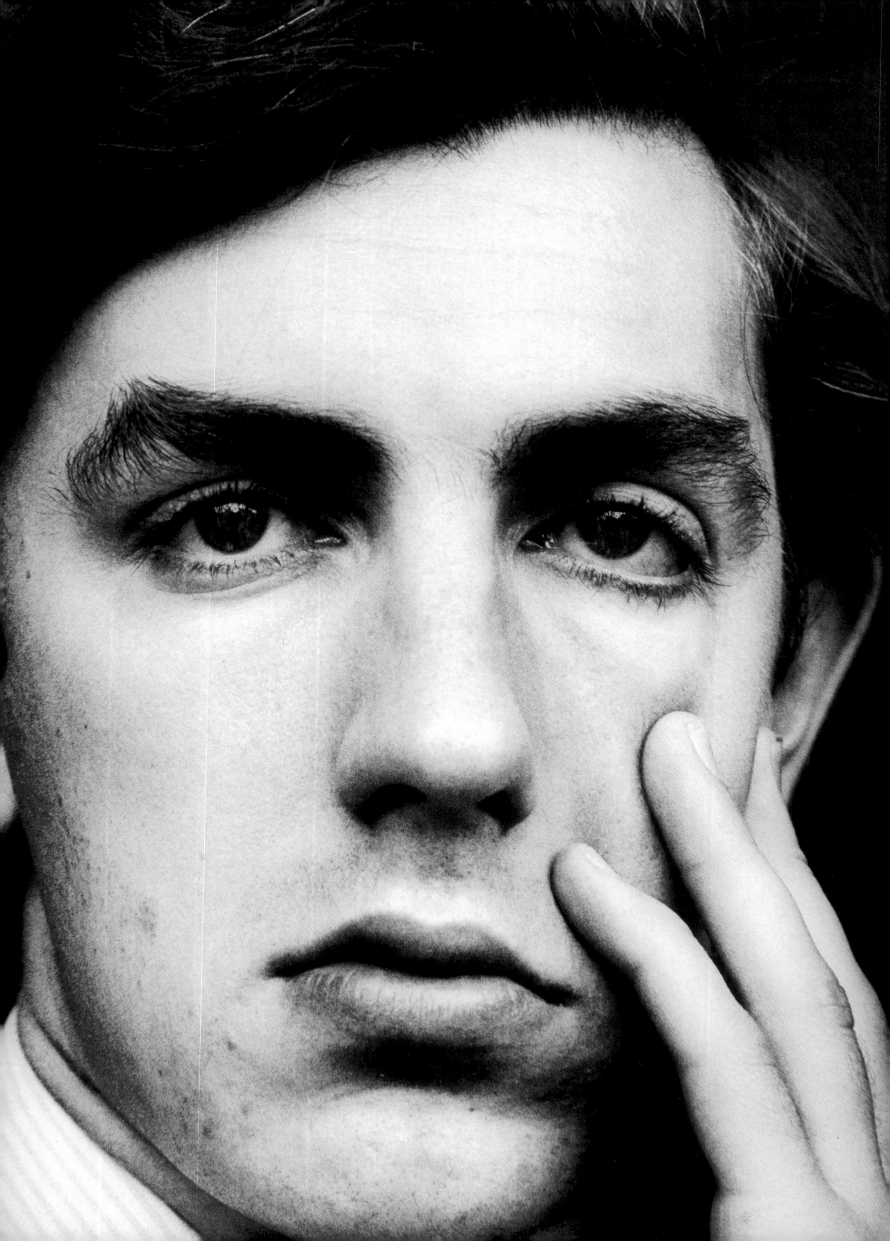

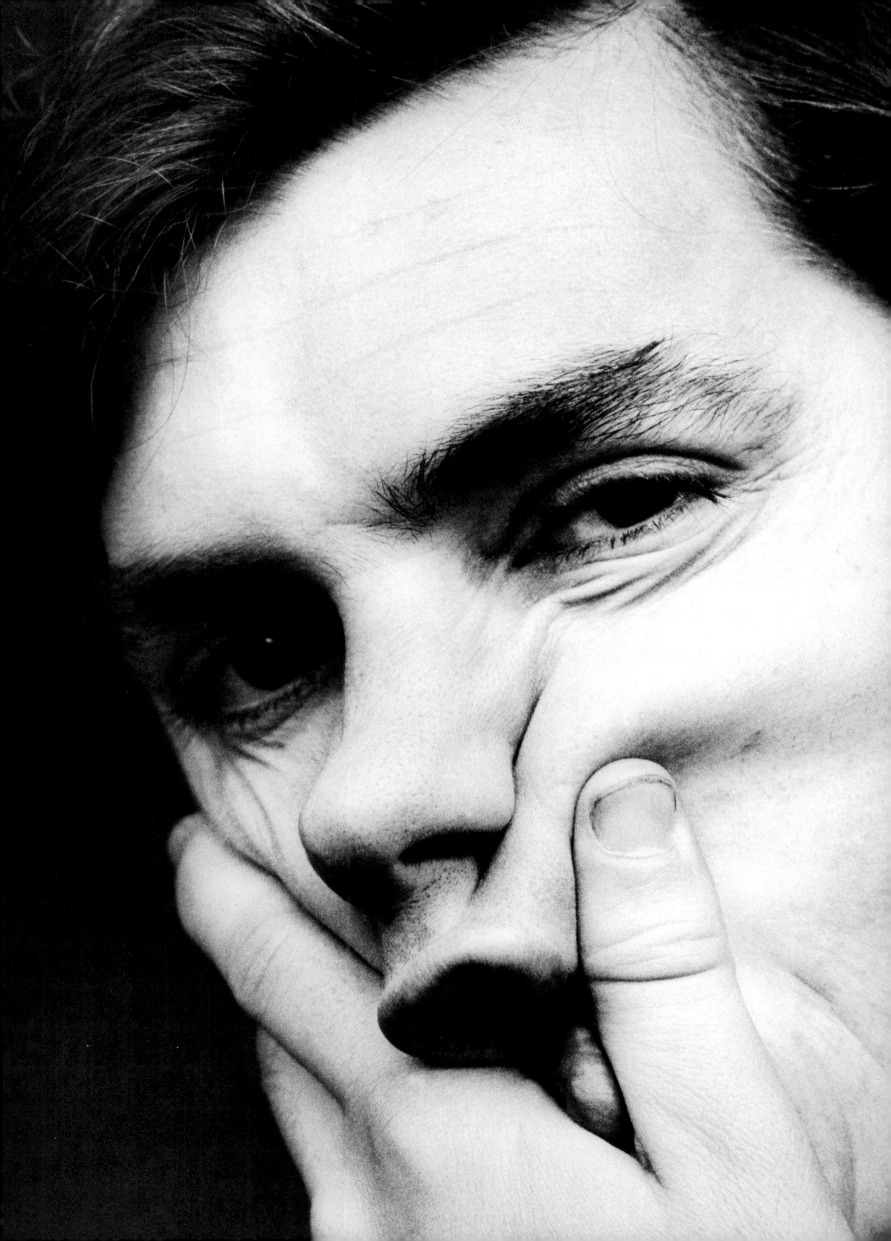

Watch for the Little Birdie

IN the stable, respectful, good old days before the camera became candid and the public didn't know it wanted to see at least the back teeth—failing the basic psyche—of the sitter, photographs suitable for inclusion in the elegant magazines were a matter of one rigid, non-breathing studio pose and thank you so much, charming, charming, that will be quite all.

Actresses were glorified with a halo of heavenly light behind the hair, whatever might be the nature of their private lives. Officers and gentlemen squared up to the tripod like men, staring coldly at the centre of the lens in the position of attention, even while sitting down. Actors appeared in sculptured profile, with a finger laid along the line of the jaw, indicating intelligence while concealing structural deficiencies. Authors had pipes, often provided by the studio, clenched in a firm hand at a safe distance from the face, demonstrating profundity of mind. Duchesses looked ducal, politicians sternly benevolent and all children like models for Bubbles.

* * *

In those stable, respectful, good old days photographers approached their clients like reassuring, kindly dentists, intent upon producing by purring words and soothing gestures a condition of general anaesthesia in which their work might be swiftly and painlessly completed.

Nowadays, having one's picture taken for inclusion in an elegant magazine bears a fair resemblance to being involved in a fast, cross-talk variety act, jazzed up with acrobatics, where both performers are on the verge of a nervous breakdown. I was done only the other day and am still sufficiently strung up to be chattering volubly, smiling wolfishly, laughing merrily, pointing imperiously, scratching industriously and crouching in corners in the semblance of fear.

The invitation came from an elegant magazine who wanted my views on Christmas—enough to turn the heart to stone—with a photograph to illuminate and lend substance to whatever these views might be. Views of a conservative nature—Scrooge poisoned Christmas for the truthful—were put together and inserted into the telephone and an hour later the photographer arrived, in something of a hurry to get on and take Lady Lewisham, whose reflections on the Feast were also being canvassed.

Carefully arranged for him in a good light. I had typewriter, pipe, flattering books of reference and the rudiments of Writer's Face, but we scrapped these archaic props instantly and went out with a kitchen chair into the cold, shadowy, Ingmar Bergman, October backyard. We arranged the chair beside a drainpipe. "Sit on the edge of it, throw out your legs, lounge about and keep talking." A far cry from haloed hair, the sculptured profile, even the model for Bubbles.

Some babble about the weather was coming from me while he fixed the sights on a short, blunt, huge-barrelled death-ray gun, probably an electronic camera, but then all the best photographers these days are Leonardos, all-round men, artist, scientist, engineer, even prospector, digging for the basic pysche through the living rock.

I got up as much basic psyche as I could, nearly divided in half by the edge of the kitchen chair, while the photographer ducked and weaved around me, firing his death-ray from all angles at the range of three feet. Conversation, staccato but very full, had shifted up a notch from the weather to the discovery and character analysis of mutual friends. And all the time the death-ray clicking on. He came back on target, "Lounge a bit more—relax—laugh . . ." Hard down on the accelerator once more.

* * *

Wild cachinnation, eyes rolling, blinking, occluding, head writhing, teeth protruding and receding, all becoming more and more extravagant in the desire to propitiate the huge and hungry muzzle of the gun. The photographer stopped to reload once more. "I suppose," he said, "you couldn't use your hands a bit?"

We took another reel, with hands. One hand clutching the forehead, both hands pulling like bell-ropes on the ears, one hand round the back of the neck, the other covering an eye. Then we disengaged from the face and the hands pointed to the wall, to the sky, to the drainpipe. They flapped like bats, the digits stuck up like palisades, and all the time gabble - gabble, laugh - laugh, being naturally relaxed and animated for the gun.

* * *

At the end of that reel the photographer said he hadn't quite got the one he wanted yet. "Try it this way." Subject and photographer were suddenly crouched on all-fours, face to face. the subject waving its front paws and by now nearly barking like a dog.

After he'd gone, I couldn't help wondering if he was applying the same technique to Lady Lewisham, but decided against it. With some fortunate, naturally mobile subjects the basic probably comes out sweetly and smoothly, with no greater stimulus than a faint halo of light behind the hair.

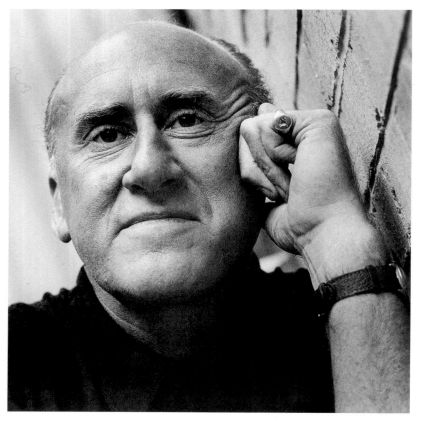

Above: Patrick Campbell, columnist, humorist, 1957
One weekend, reading Campbell's column in *The Sunday Times*, I realized that I had provided the material for it, having photographed him a few days before. Journalists with a weekly deadline are often short of something to write about, so I was the photographer in a hurry described in the column.

Right: Alan Bates, actor, 1966
The photograph of Bates in his garden was taken in 1966 when he had just finished work on the French film *King of Hearts*, about the First World War. In a way the picture reflects Patrick Campbell's remarks on the 'backyard' style of modern photography, as opposed to the carefully lit studio shot, where the actor is 'in sculptured profile, a finger laid along the line of the jaw, indicating intelligence'.

Following pages: Tom Courtenay, actor, 1961
These photographs were taken at about the time Courtenay did the film *Billy Liar*.

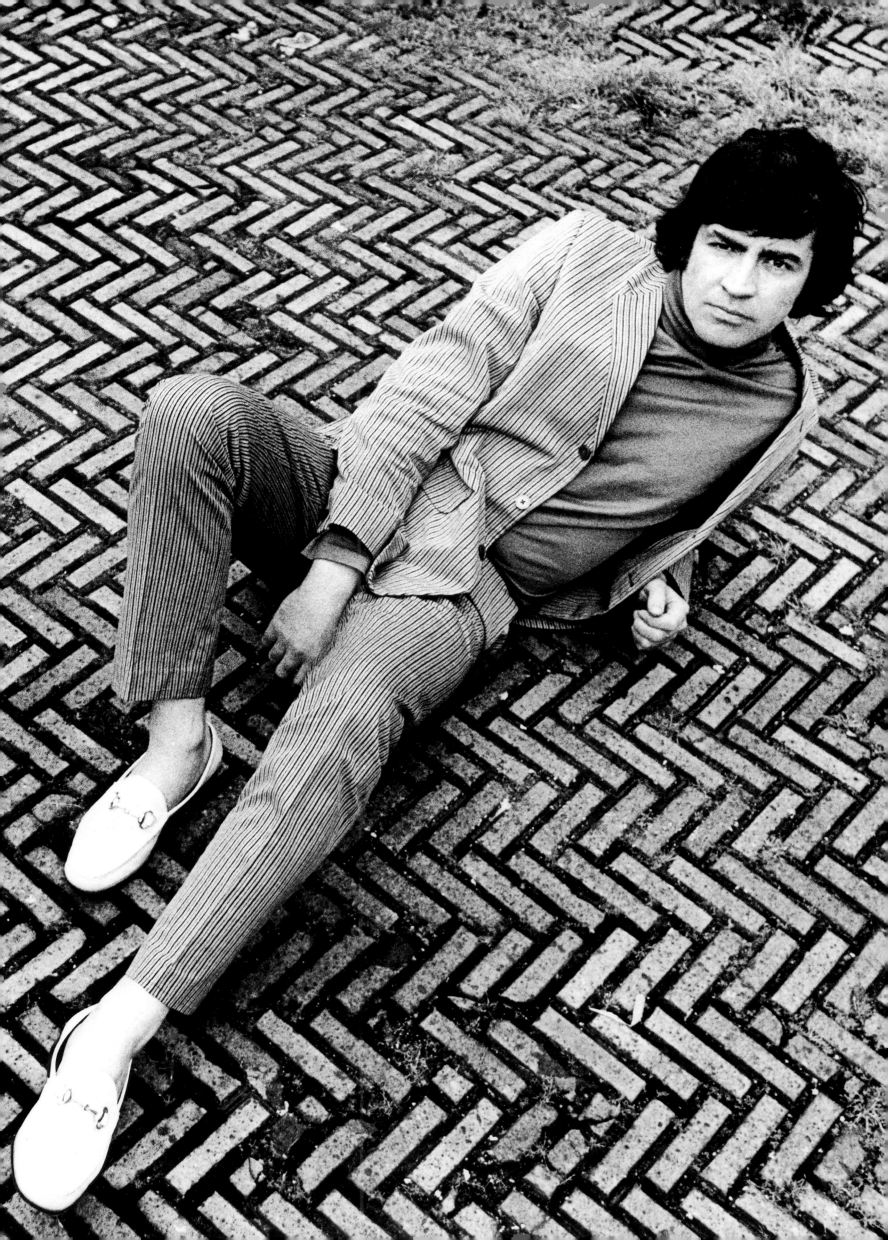

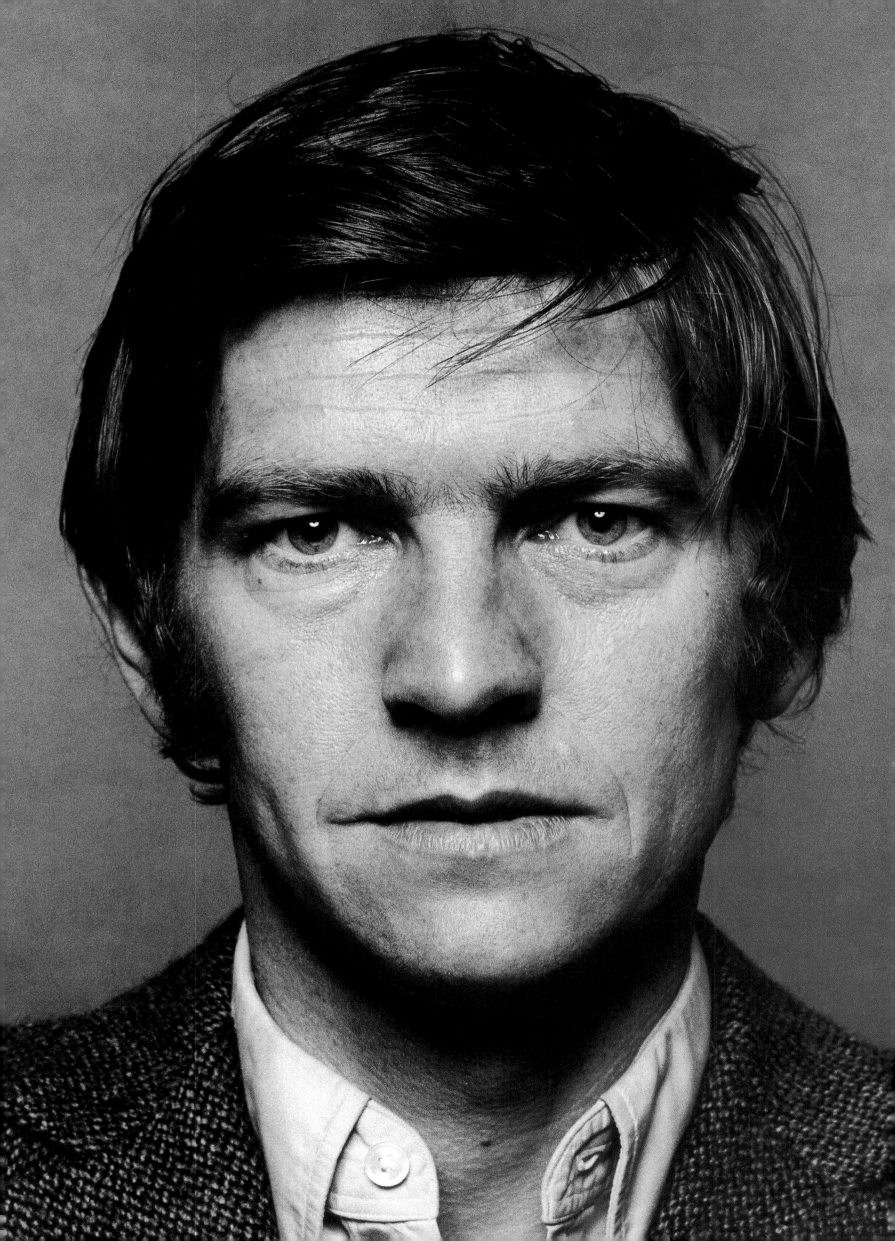

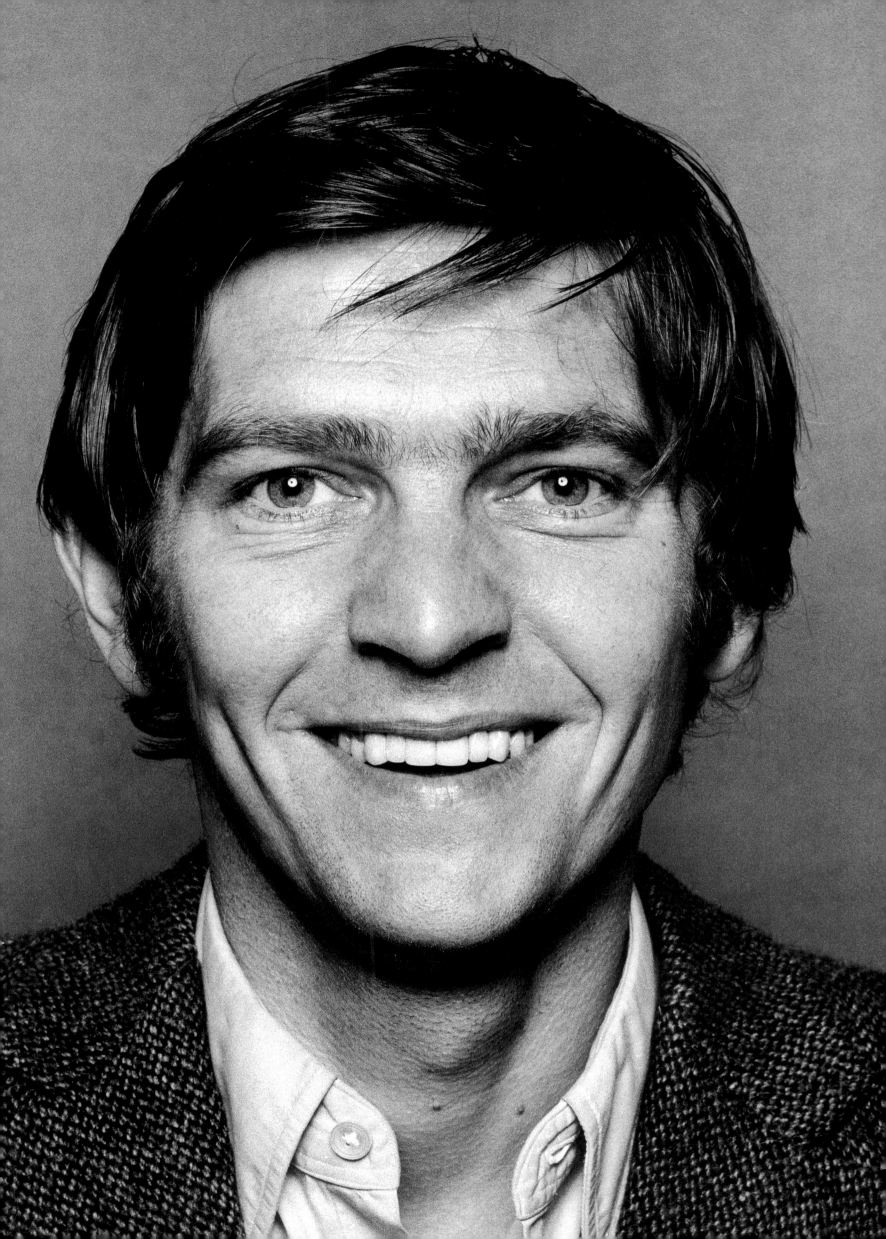

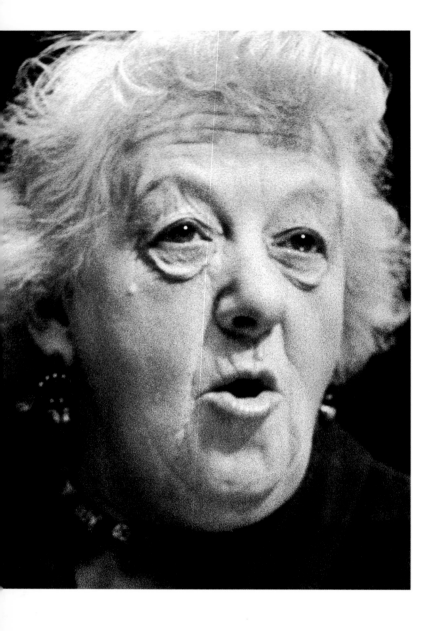

Above: Dame Margaret Rutherford, actress, 1962
Dame Margaret lived in a house with the most beautiful view over London. She made tea and sandwiches for us, and it was rather like going to tea with your aunt, although I had the feeling that I was taking part in one of her films – like being on the set of *Blithe Spirit*.

Right: Wee Georgie Wood, comedian, 1958
I met Wood on a train going to Edinburgh. He really was diminutive – you can see in the photograph that his head didn't even reach up to the headcloth of the chair. After a while I found the courage to ask him if he was Wee Georgie Wood, and of course he said: Yes, he was. I took a series of pictures of him on the train, and I think he was quite pleased that I had recognized him. He was one of those legendary northern comics, along with George Formby and Frank Randall. He told me how he used to tour the music halls with Gracie Fields and Arthur Askey.

Following pages: Sir Peter Ustinov, raconteur, actor and playwright, 1958
Ustinov was giving a teatime talk at Harrods – but I think he found it hard work. The audience wasn't particularly receptive, consisting as it did mainly of ladies who had gone for tea and a gossip. Sir Peter – or plain Peter Ustinov, as he was then – seemed unable to grab their attention.

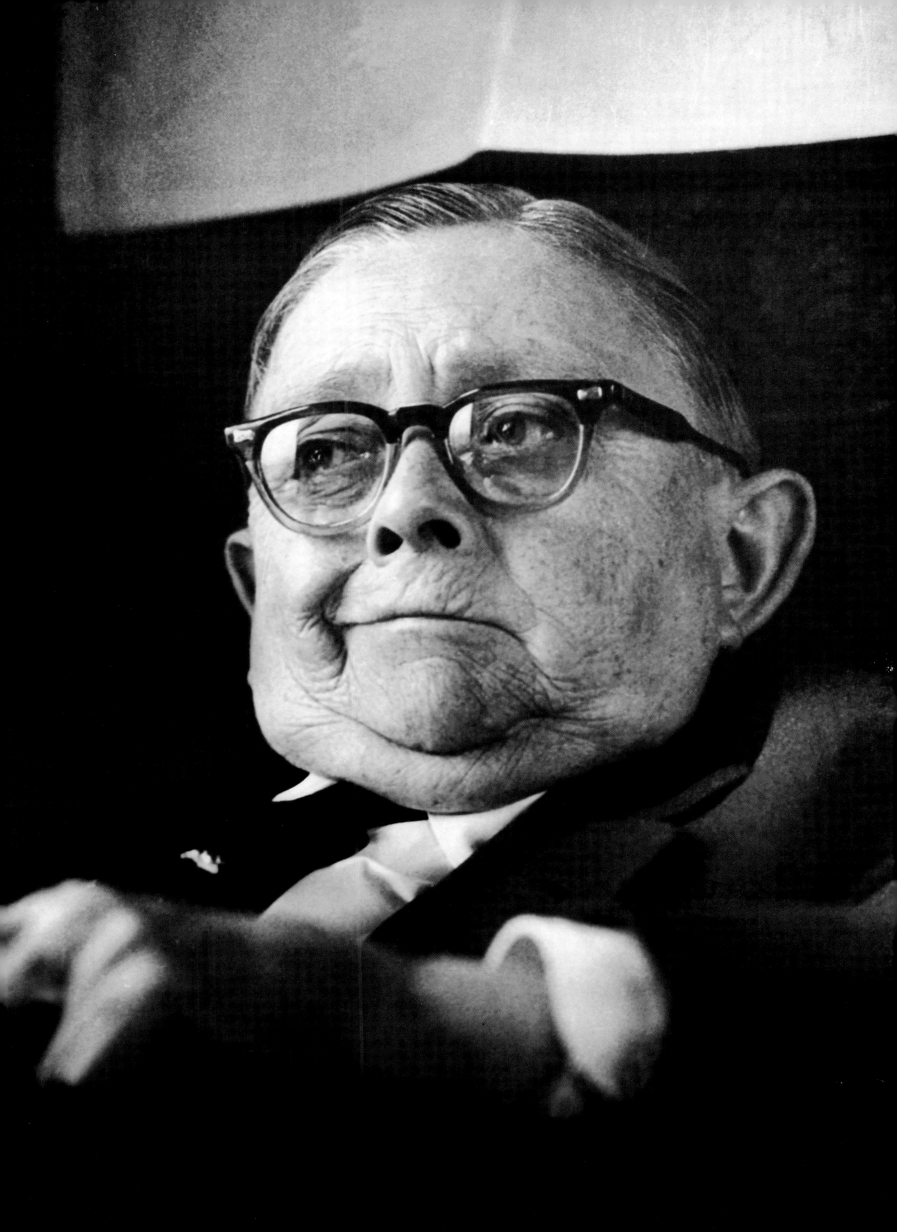

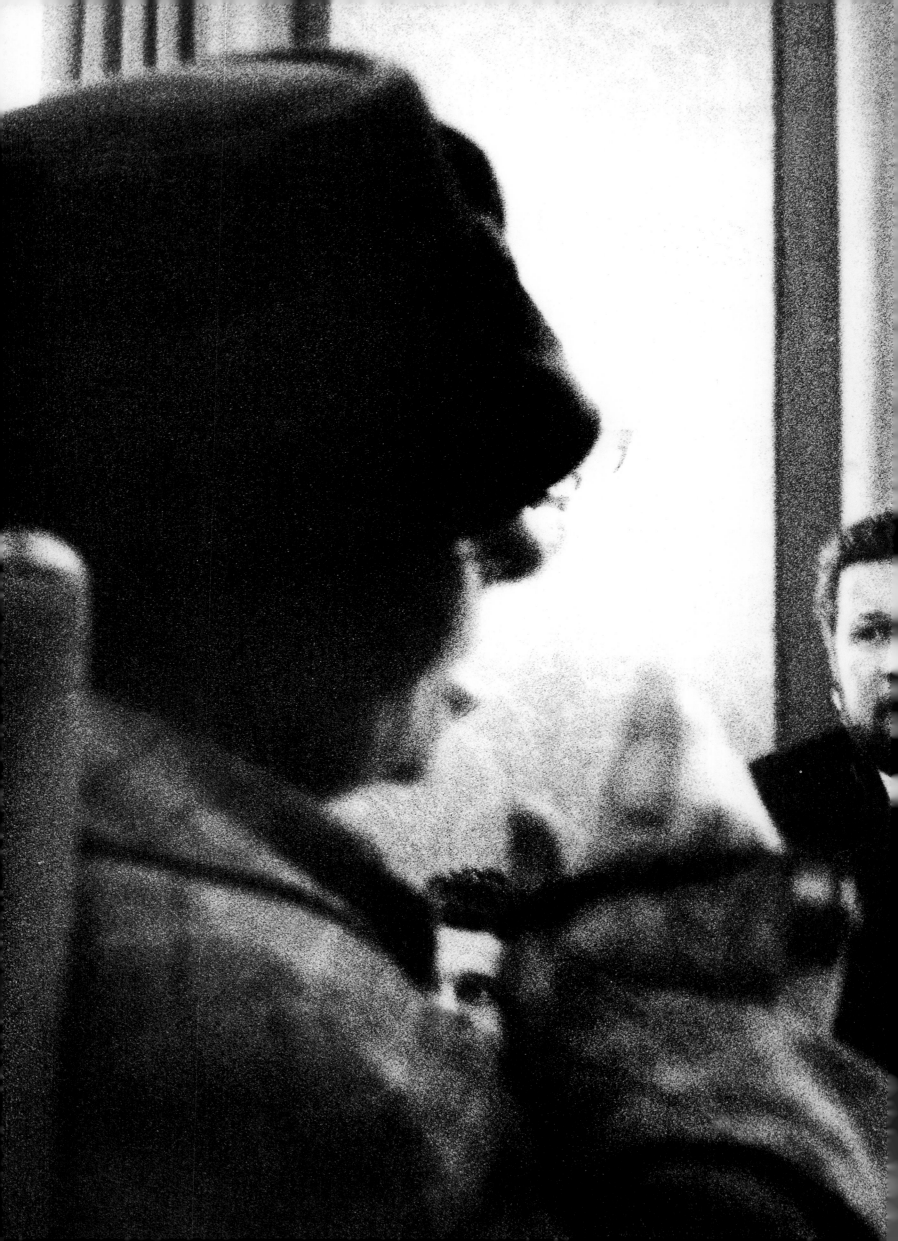

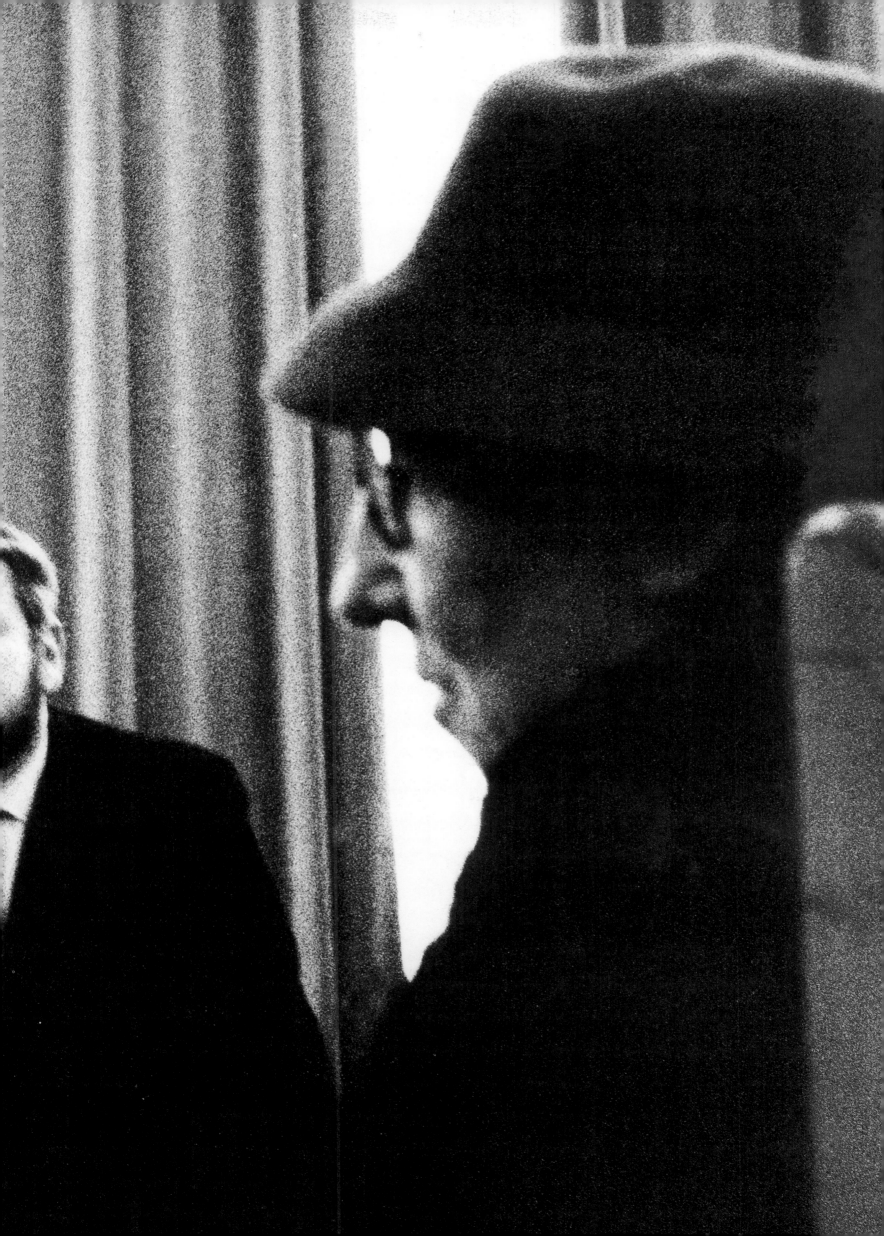

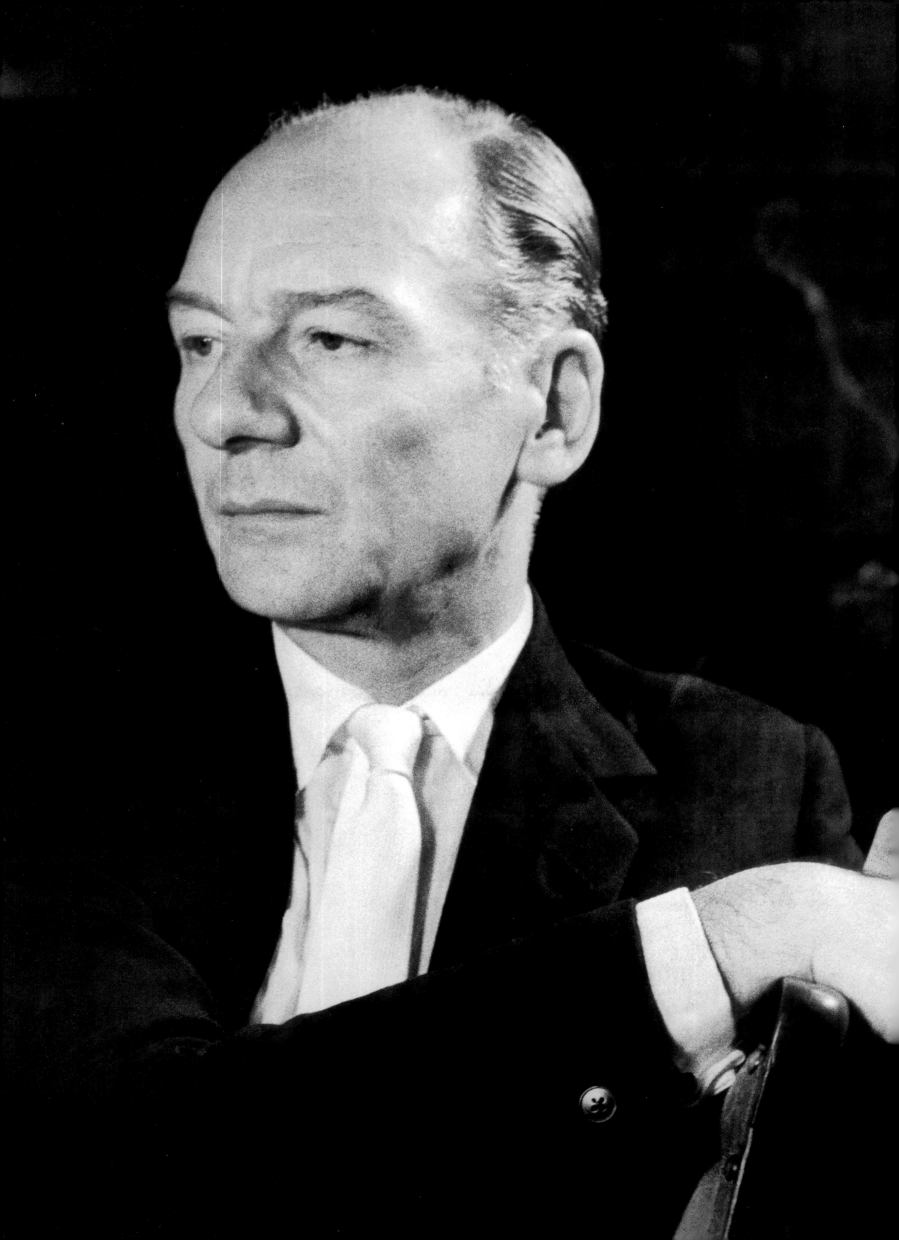

Sir John Gielgud, actor, 1959
This picture was taken during Gielgud's first
one-man show in London, a Shakespeare reading
called *The Ages of Man*. As a new photographer,
I was slightly in awe of famous actors and
actresses. This photograph was shot in the Queen's
Theatre, which was being renovated at the time. The
building was full of workmen and I had to move him
to a spot where there was sufficient light. A lot of
the great stars wait to be directed, and then they
will do almost anything you ask of them.

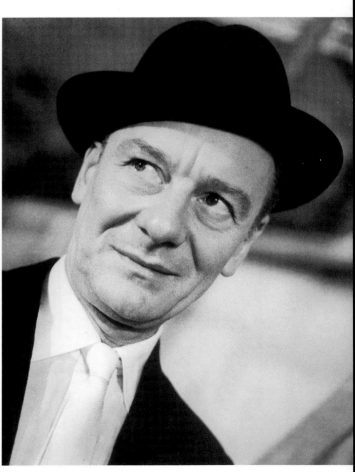

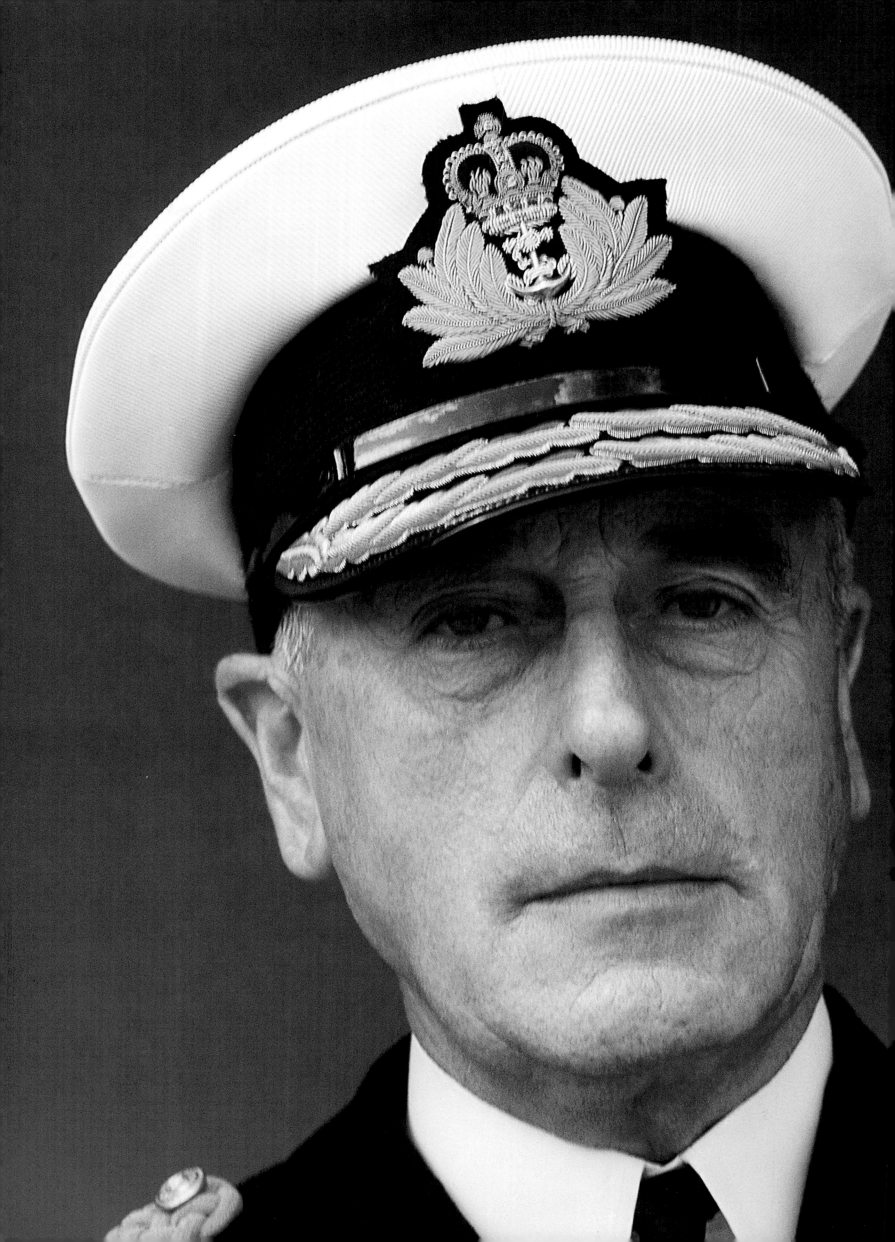

Lord Louis Mountbatten, Earl Mountbatten of Burma, First Sea Lord and statesman, 1964

Mountbatten was the subject of the very first cover of the *Observer* magazine. Obviously it was an important job and getting permission to photograph him was not easy, because of his schedule, but in the end they said I could have half an hour. I had to be at the Ministry of Defence building by twelve o'clock sharp. I had been kept waiting for about ten minutes of my precious half-hour when they told me that he was just leaving Downing Street and was on his way over. In the meantime I'd arranged the lights in the only spare space, in a room crammed with desks, chairs, cupboards, and so on. When you are shooting for a magazine cover you have to allow space in your picture for the title and cover words, and you need to avoid having too much clutter in the background. Lord Mountbatten arrived dressed in civilian clothes, with a number of aides who fussed and busied around him, while my valuable time was slipping away – I now had only ten minutes left to do the job. Eventually he glanced at me and snapped, 'Get on with it then.' I asked him to sit in the chair, but he wouldn't stop talking and wouldn't sit still, while the aides blocked my view from the camera and stood in front of the lights; it was a nightmare. I was a young photographer, on an important assignment, and now had to face up to a difficult sitter – and the First Sea Lord to boot. Mountbatten suddenly turned and shouted, 'What's the matter now?' He began to read some documents and refused to cooperate, so I said, 'At least you could look at me, sir, and open your eyes a bit wider.' The room fell silent. Lord Mountbatten glared. Then he said, 'Damnit, man, they're open as wide as they'll go!' And with that everyone faded away and gradually he began to pay attention to me. I'd only had about eight minutes, but I got some good shots. When I'd finished, dead on time, he said pleasantly, 'Finished already?' and then added, 'Would you like to photograph me tomorrow in my uniform?'

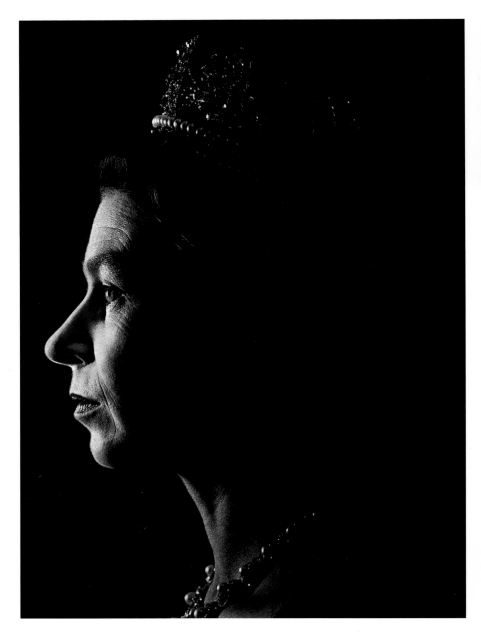

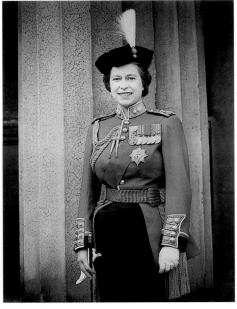

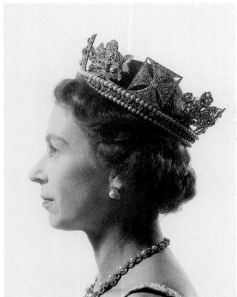

HM Queen Elizabeth II, 1966

In 1966 Professor Dick Guyatt at the Royal College of Art recommended me to do a portrait of the Queen for a new set of postage stamps. She had already been photographed, but the pictures had been turned down, so the Post Office was in rather a panic and running out of time. I was commissioned by the Postmaster General two days later and asked to go to Buckingham Palace to select a location. What would I like Her Majesty to wear, and could I choose a suitable crown or two? It's not the kind of thing you're asked to do every day, and it was interesting that I had to make my choice of crowns and costumes from a Palace scrapbook of pictures of the Queen at various functions, cut from magazines and newspapers. I selected a couple of crowns and decided to shoot the pictures in the Palace art gallery. I was told that they needed a profile, so I worked out various lighting schemes, and because I wanted it to look very professional I hired extra lights, so that I could select from a variety of light positions and avoid having to lug them around.

The Queen had set aside two hours for the session, and after about twenty minutes I must have taken well over a dozen rolls of film, although not without some difficulty. There were cables everywhere. I was tripping over them, while losing track of which cable supplied which light. Another problem was that the Queen was incredibly polite and, since I had to take her in profile, I wanted her to look straight ahead, but every time I spoke to her she turned to look at me, so that I had to stop talking. I had just about finished, so I thanked her and said I'd completed the job. The Queen said, 'So soon, Mr Hedgecoe? Don't you want to do some more?' The music room next to the gallery looked inviting, so I said I'd take them in there. And that's where I shot the silhouettes, against the window, in the same way that I'd taught my students to do them: you simply place the subject against the light and expose for the highlights.

After the pictures were processed they were shown to the Queen, who marked out fourteen of which she approved. These were then sent to the sculptor Arnold Machin, who made an exact relief plaster image of the profile, which I then photographed. This photographic image became the definitive issue of postage stamp; it was also the final matrix for the design on Commonwealth stamps in New Zealand and Australia, on commemorative plaques, coins, mugs, and so on. The picture has been in constant use for thirty-four years – millions of stamps are printed and coins minted every day. It has to be something of a record!

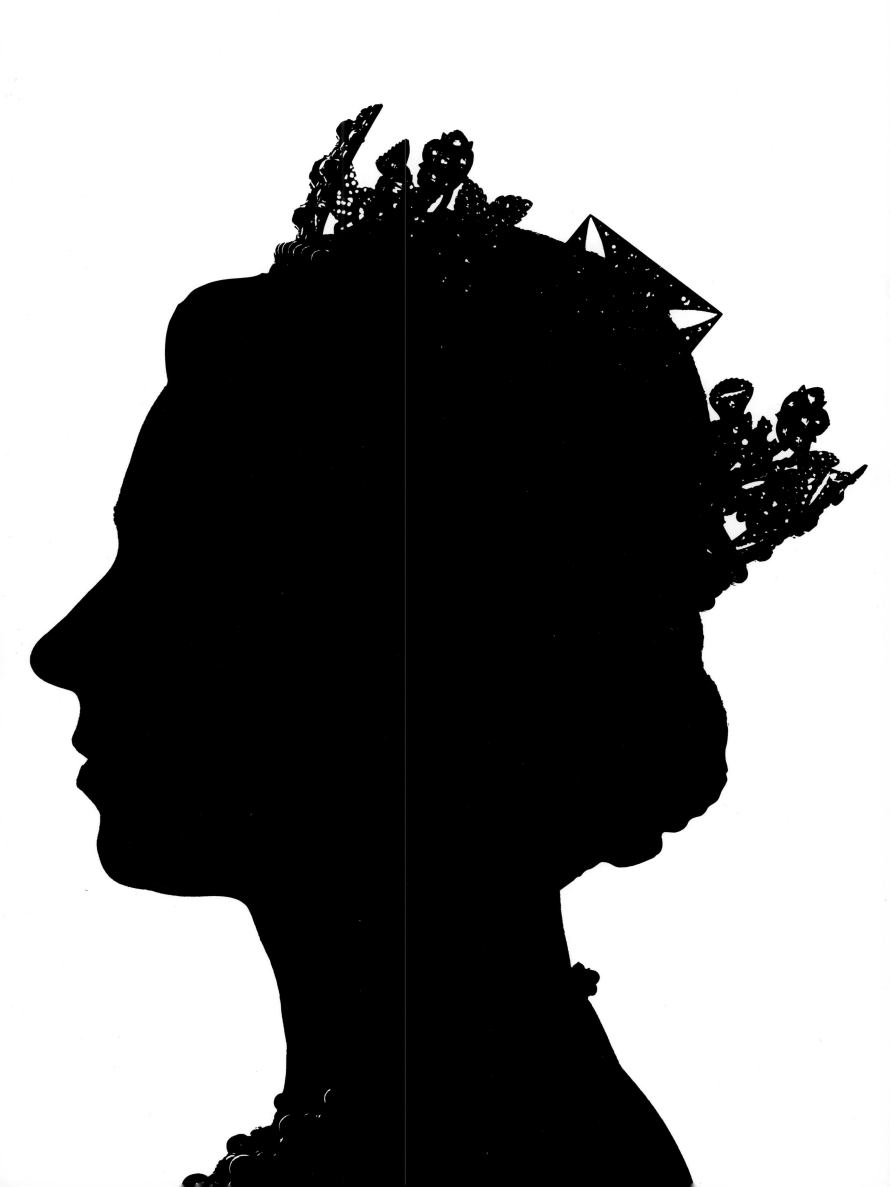

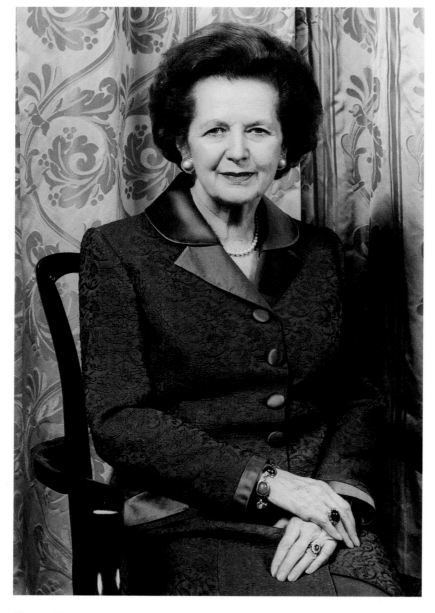

Above: Margaret Thatcher, politician and former Prime Minister, 1999
This is a very recent picture, taken in Margaret Thatcher's office. I asked for twenty minutes, and that's exactly what I got. She looked marvellous: her skin is incredibly smooth and free of lines. She was charming to me – she's incredibly sharp and quick-witted. Before you've finished asking a question she's answered it. I asked her if she missed the buzz of the House of Commons, the cut-and-thrust of political skirmishing, and she said, 'Yes, but I do find it very difficult to ask questions when I've spent most of my life answering them.'

Right: Sir Winston Churchill, politician and former Prime Minister, 1957
Churchill was in his eighties when I took this picture. I was sent by a magazine to photograph the then Prime Minister, Harold Macmillan, and while I was waiting for him I noticed Churchill sitting in the lobby. I couldn't pass up such a unique opportunity, so I asked if I could photograph him. He just nodded, so I did it in about two minutes – just a few shots with a hand-held flash bounced off the ceiling. I was slightly worried that I was doing something illicit, because my job was to photograph Macmillan. I was young at the time and felt that I was stealing something.

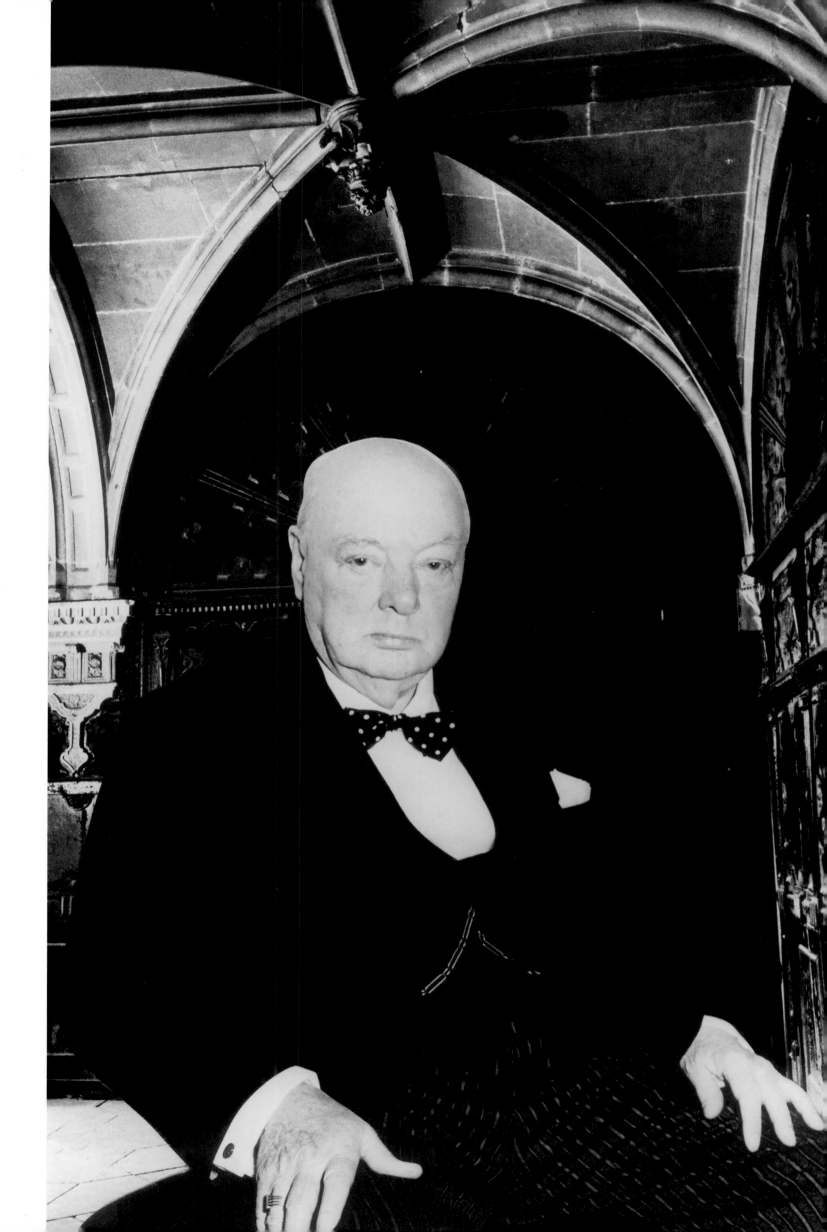

**Dame Agatha Christie, novelist, on her seventy-ninth birthday, with her husband
Sir Max Mallowan, 1969**
By 1969 the *Observer* magazine, in common with others, had been seeking to photograph
Dame Agatha for many years, but she had always refused. When they tried again, she finally
agreed, on condition that I would be the photographer. I found this very flattering, since I'd
never met her. I took the pictures in her Chelsea apartment. By then she'd written eighty books
with worldwide sales topping 300 million. Yet she was rather motherly and gentle, although very
up-to-date on current affairs. After my pictures were released, her publishers rang me and
urgently requested some prints. She hadn't let them have any pictures for over forty years – I
suppose since she'd mysteriously disappeared for a few days, in Harrogate in 1926.

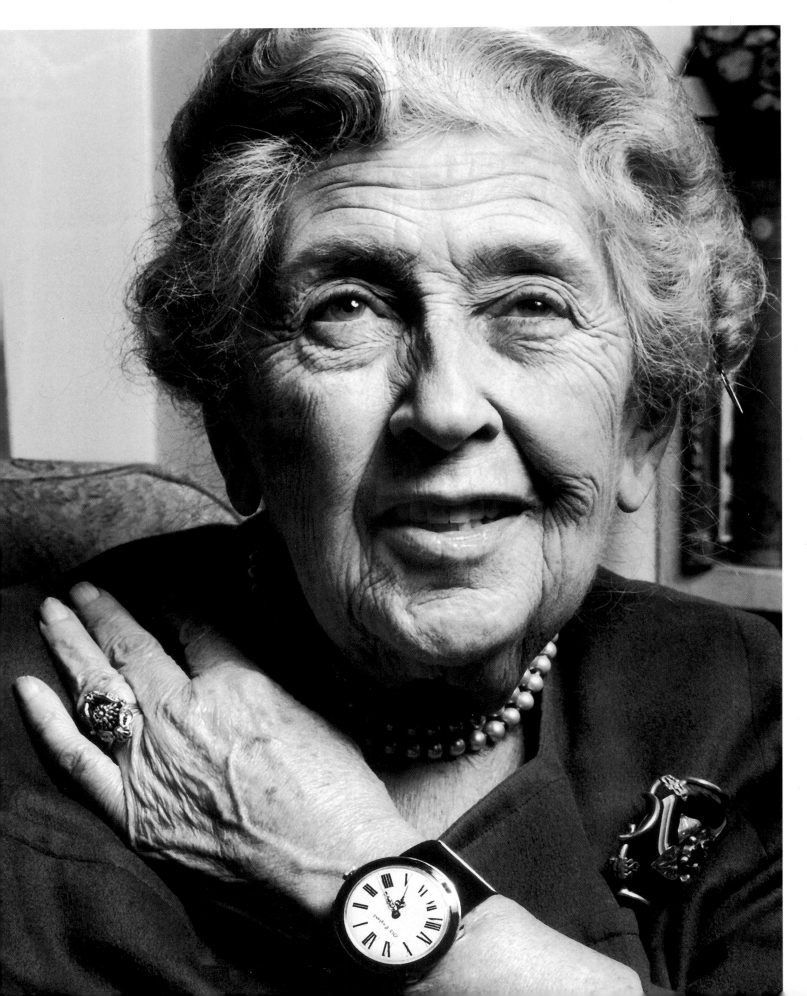

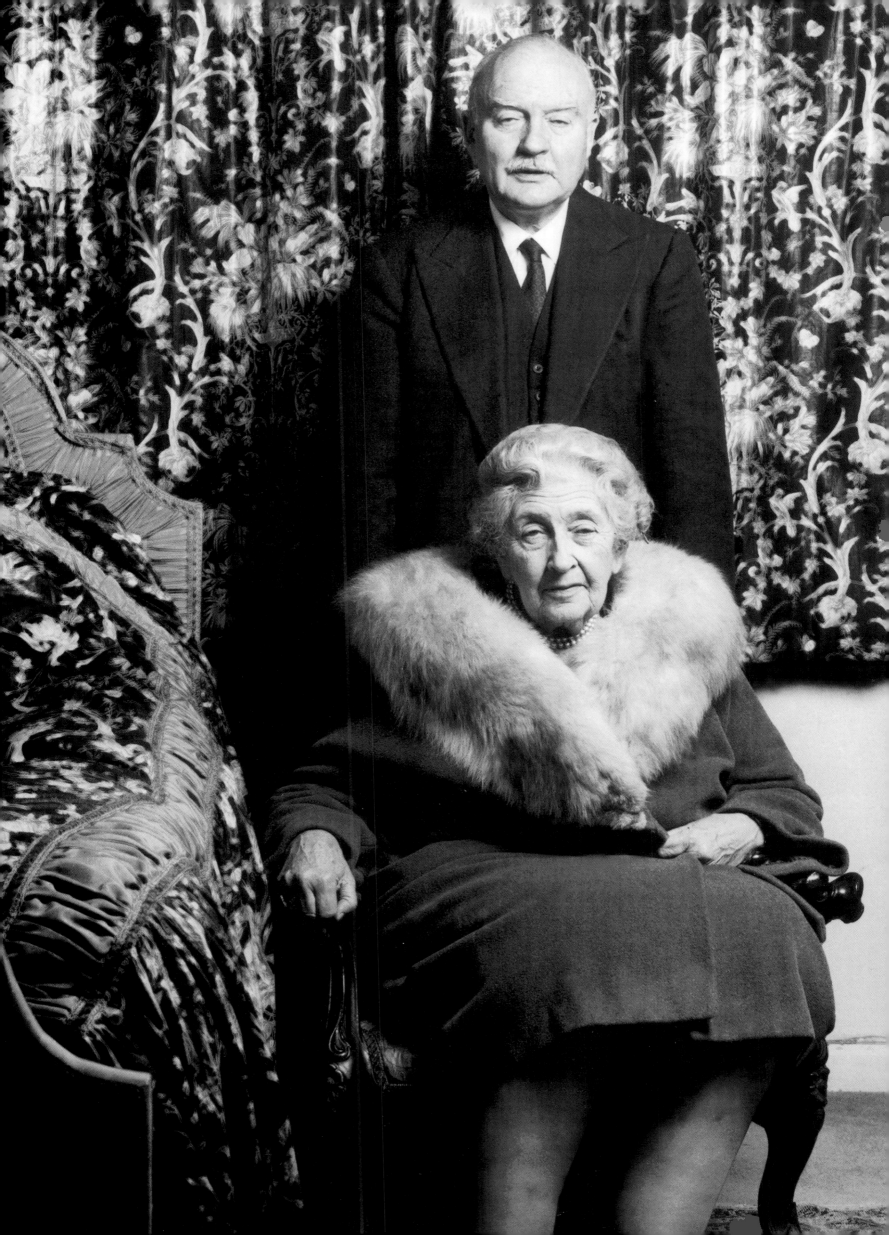

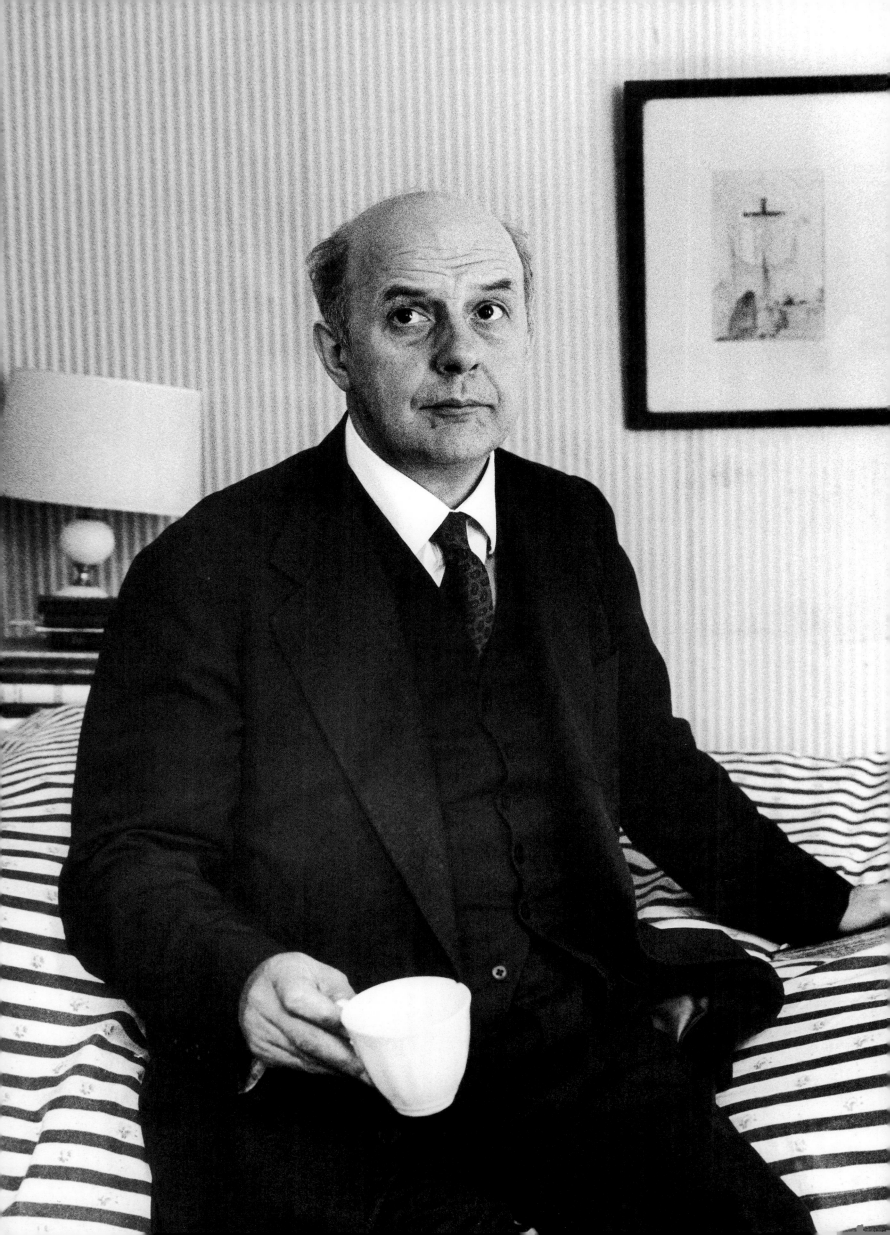

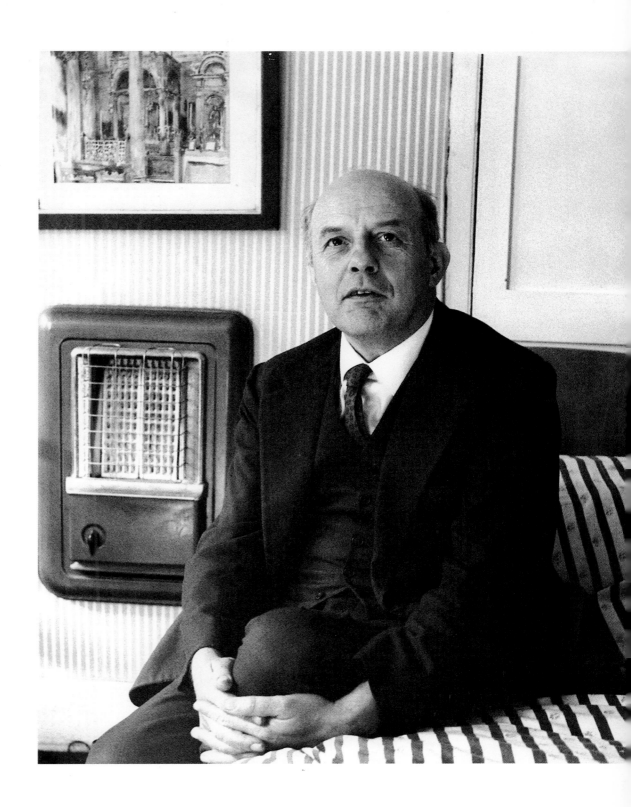

Sir John Betjeman, Poet Laureate, 1972
Betjeman had the most remarkable memory of anyone I'd ever met, yet
paradoxically he was absent-minded. You could mention some remote church and
he'd say, 'Ah, yes. If you go to the back of the church and look behind the rood-
screen, there are some curtains on the left-hand side. Open them and you'll find a
wonderful stone carving, quite perfect for the period.' His driving was hair-raising
and quite equalled by his indifference to authority. Once we drove into the
forecourt of a railway station – the wrong way, I think it may have been in
Huddersfield – and a policeman tried to stop us. Betjeman rolled down the car
window and, nodding in the direction of the station, said, 'Just look at that
magnificent façade, officer! Don't you realize what a wonderful place you work in?
You're so lucky!'

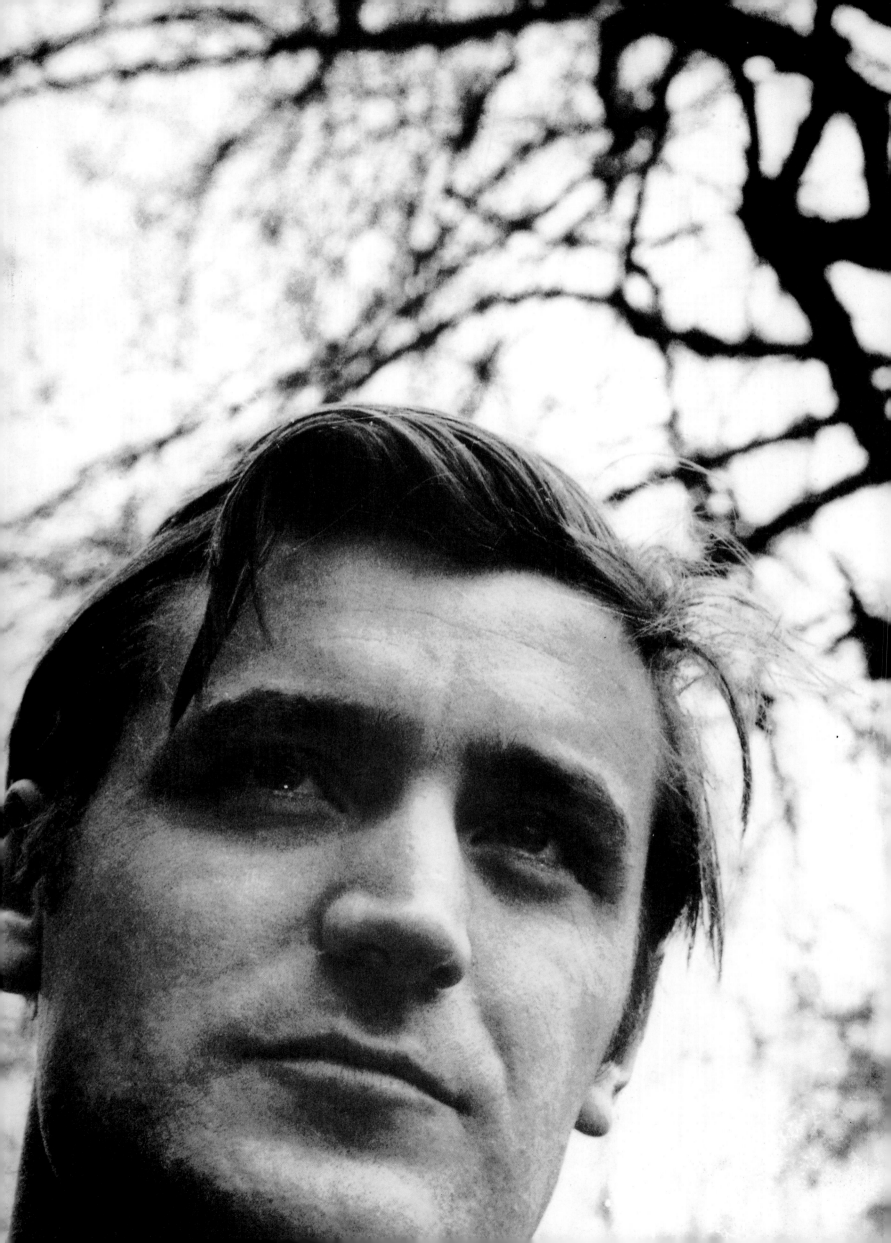

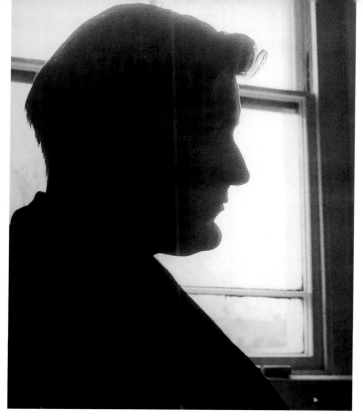

Ted Hughes, poet and future Poet Laureate, 1959
These pictures come from a series of photographs
of new poets that I took in 1959 for *Queen*
magazine. Sylvia Plath was there, but I didn't
photograph her, which was rather foolish of me.

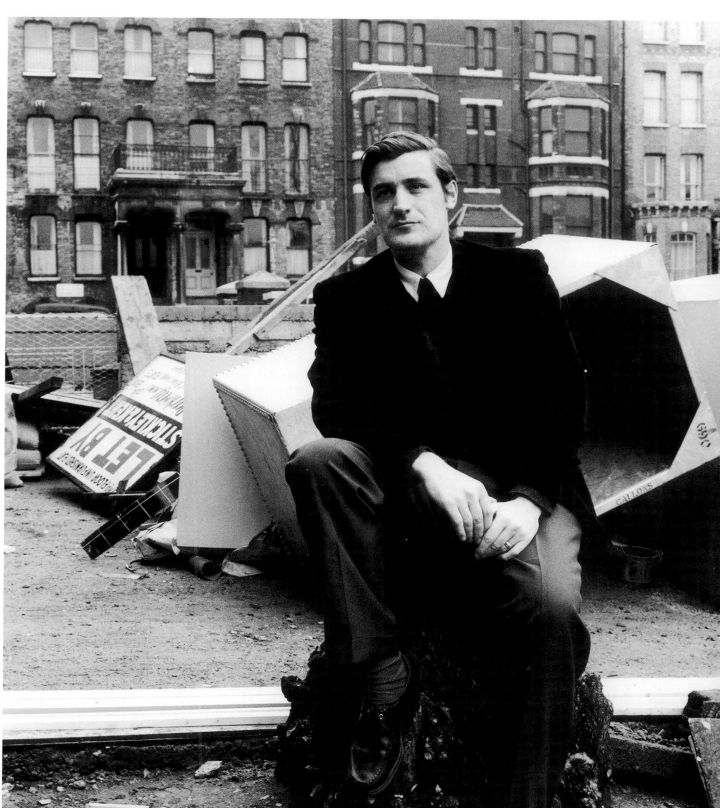

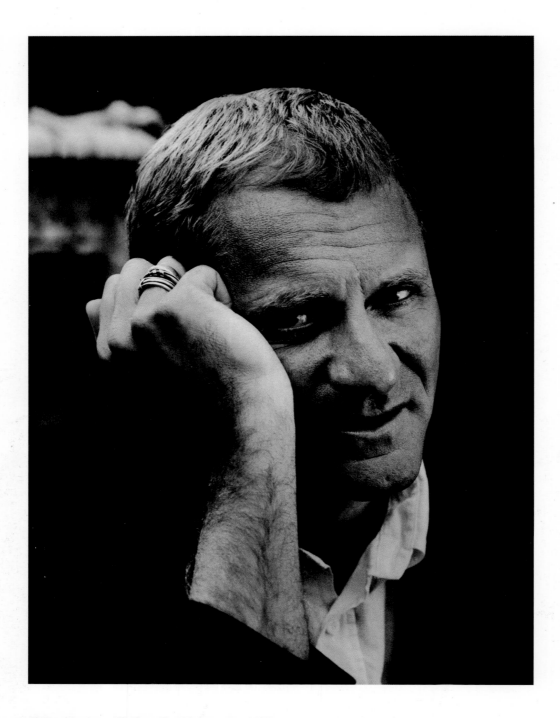

Above: Andrew Motion, Poet Laureate, 1999
This photograph was taken at Motion's London home. He now runs the
department of Creative Writing at the University of East Anglia.

**Right: Malcolm Bradbury, writer and Professor Emeritus of English
and American Studies at the University of East Anglia, 1996**

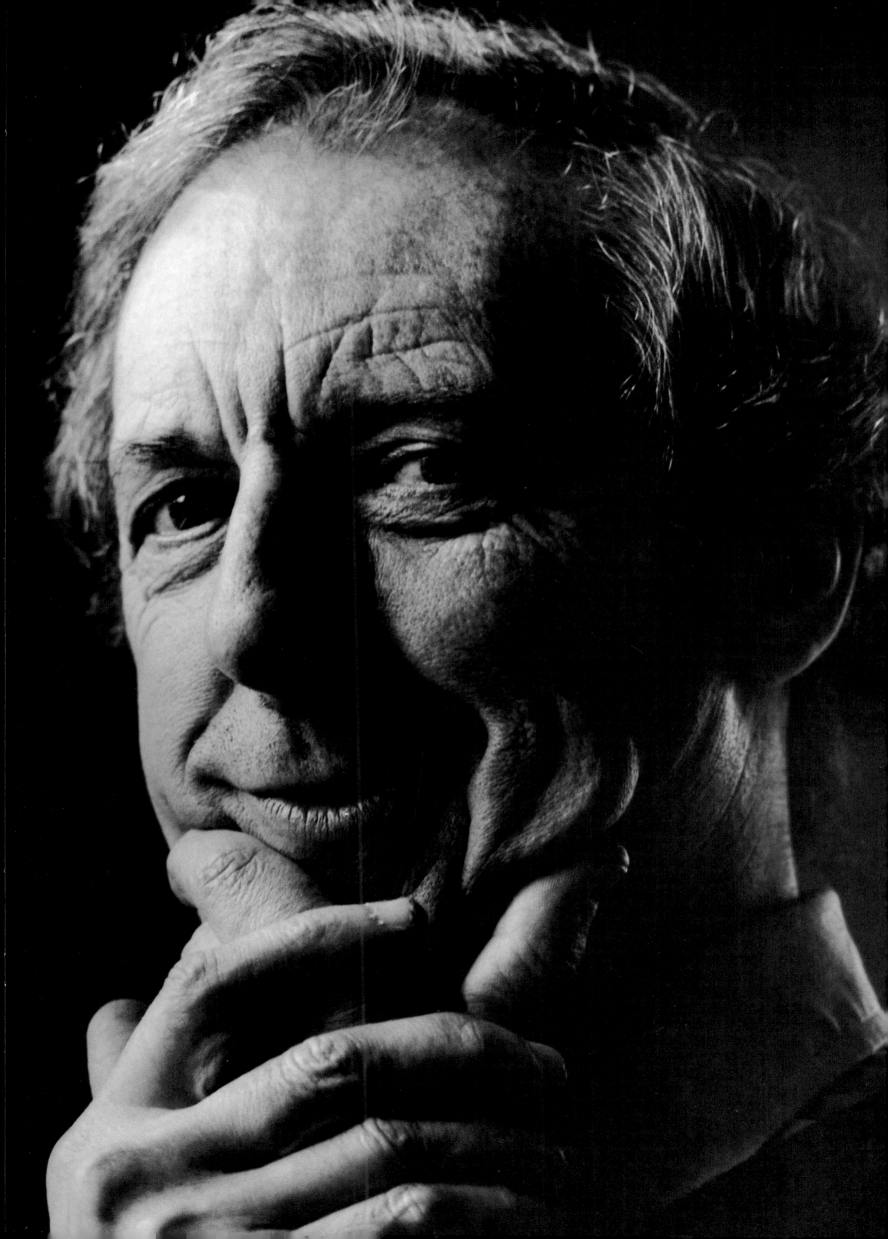

Below: Angus Wilson, writer, 1970
Wilson, author of the 1956 novels *Anglo-Saxon Attitudes*, founded the Creative Writing course at the University of East Anglia. He was charming, witty and a great raconteur.

Right: E.M. Forster, writer, 1969
I photographed Forster in his huge, spartan room at King's College, Cambridge, just before he died. Of vast build, he had a small bed tucked in a corner among his books. He seemed very pleased to have his studies interrupted and invited me to join him in a glass of sherry.

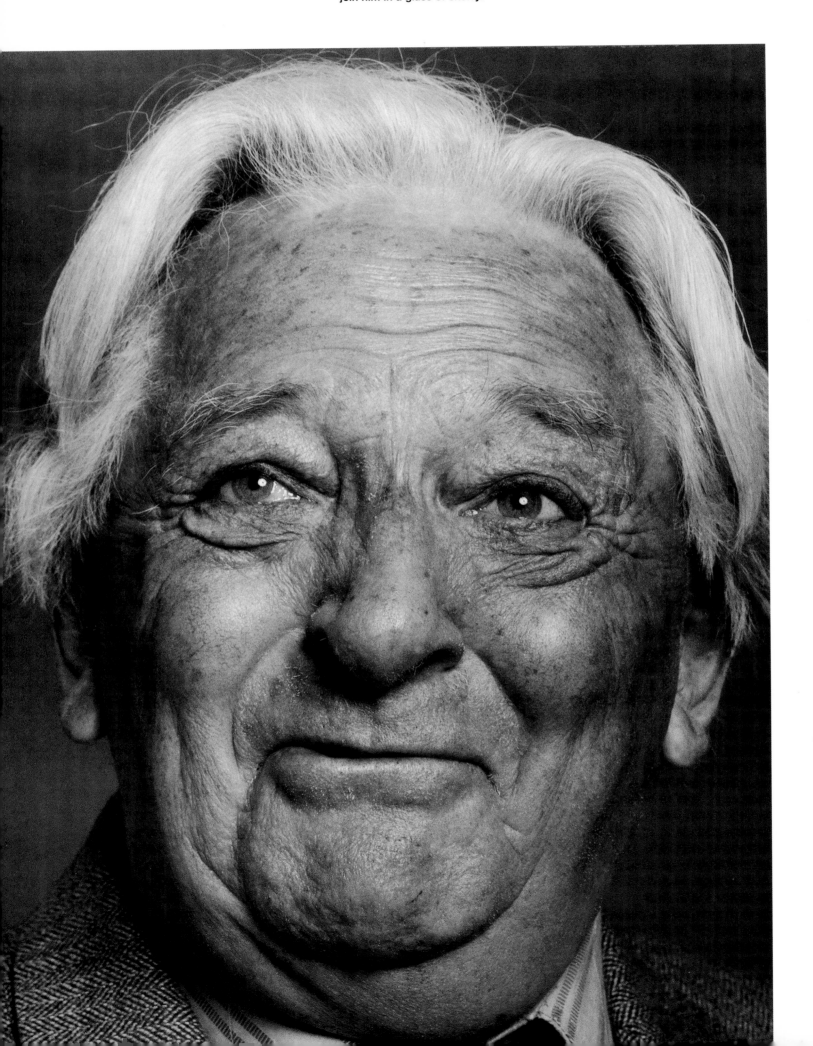

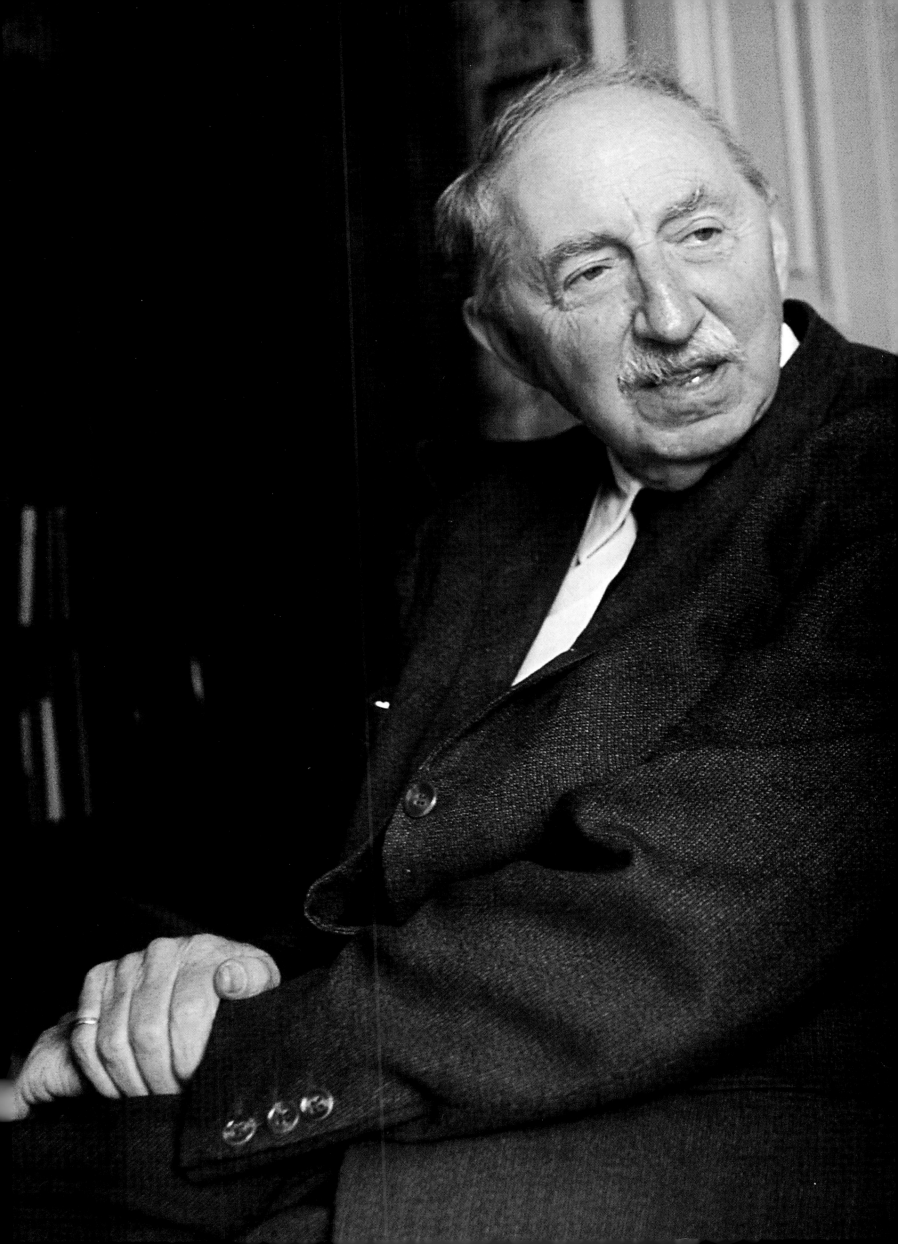

Below: Daphne du Maurier, writer, 1987
In 1987 I was taking photographs with A.L. Rowse. As Daphne du Maurier, the reclusive author of *Rebecca,* was a friend of Rowse's, we went to visit her. In fact she had just moved out of Menabilly, the Manderley of the novel, to Kilmarth House – the last house she lived in. She came out for a brief moment to greet Rowse, so I was able to photograph her. She appeared to me a rather strange, remote woman, whose thoughts were elsewhere.

Right: Kevin Crossley-Holland, writer and poet, 1961
I photographed Crossley-Holland walking on the Norfolk sand dunes.

Robert Graves, writer, poet and mythologist, 1960
The first words Graves said to me were, 'Are all photographers homosexual?' I replied, 'Not that I know of, but I know several writers who are!' The pictures were shot in Deya, on Majorca, where Graves lived. I was staying in the next village with the Weedon family. Veronica Weedon, a stern Scotswoman (and the wife of my tutor at Guildford Art School), was now teaching Graves's children and we were frequent visitors. The rear-view shot of him was taken in his garden. A keen gardener, he'd worked out an elaborate system of irrigation, complete with sluice-gates – vital in an arid climate such as Majorca's.

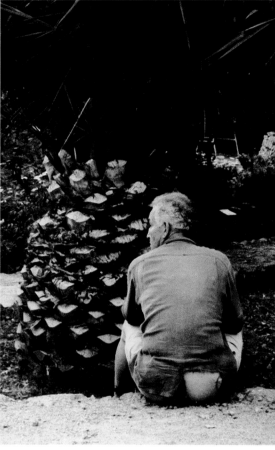

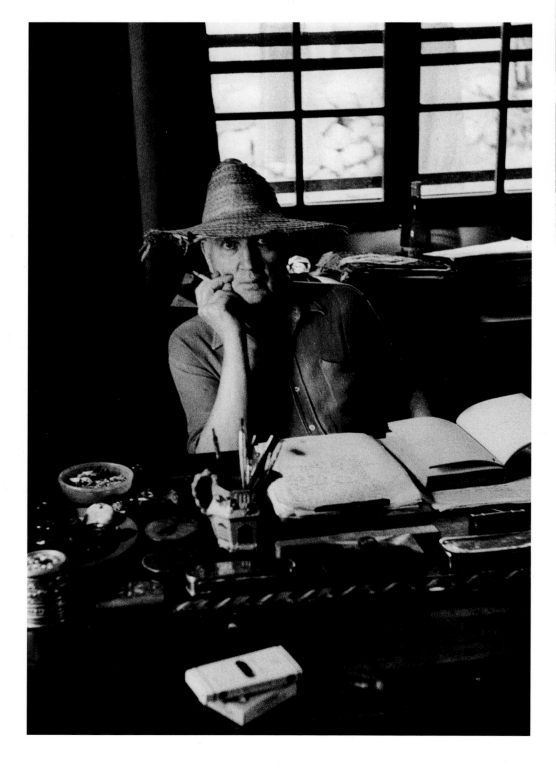

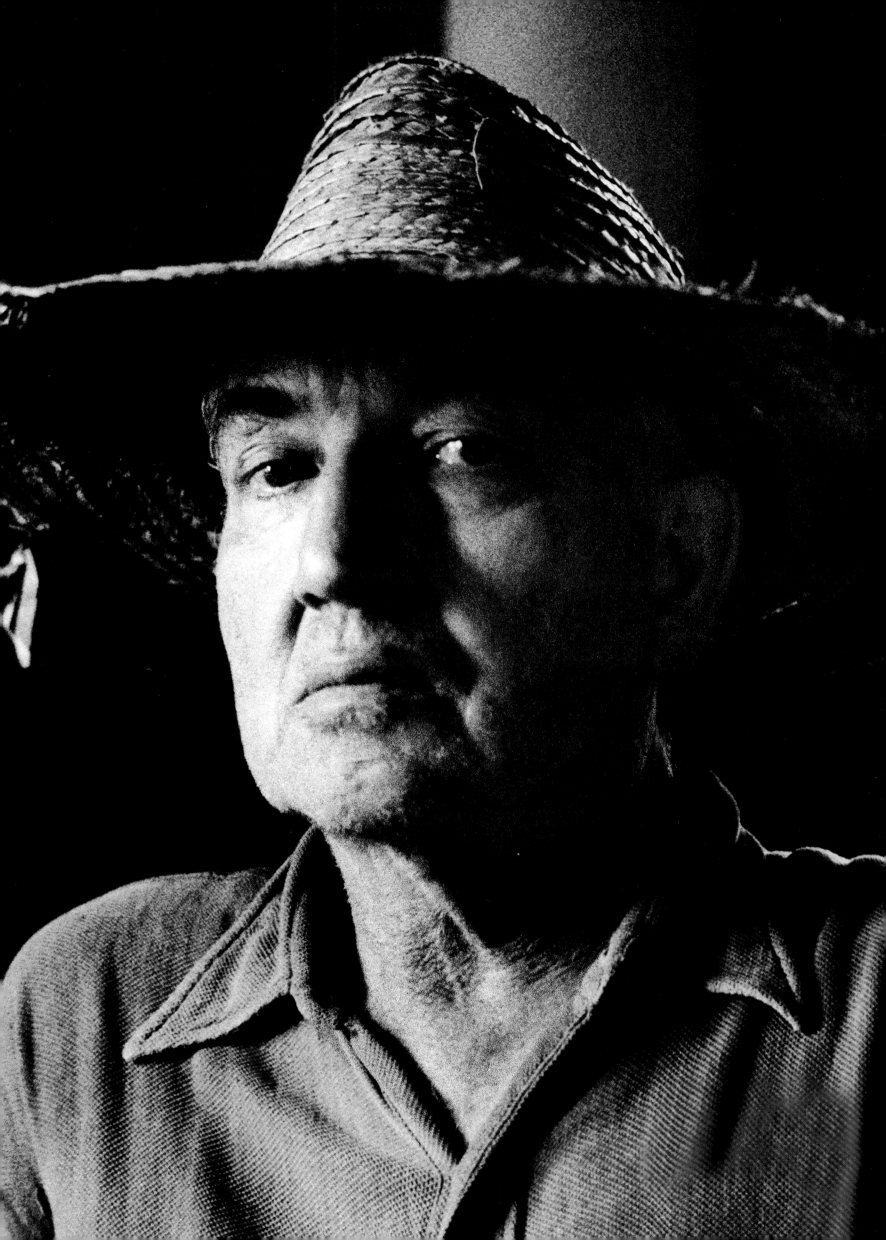

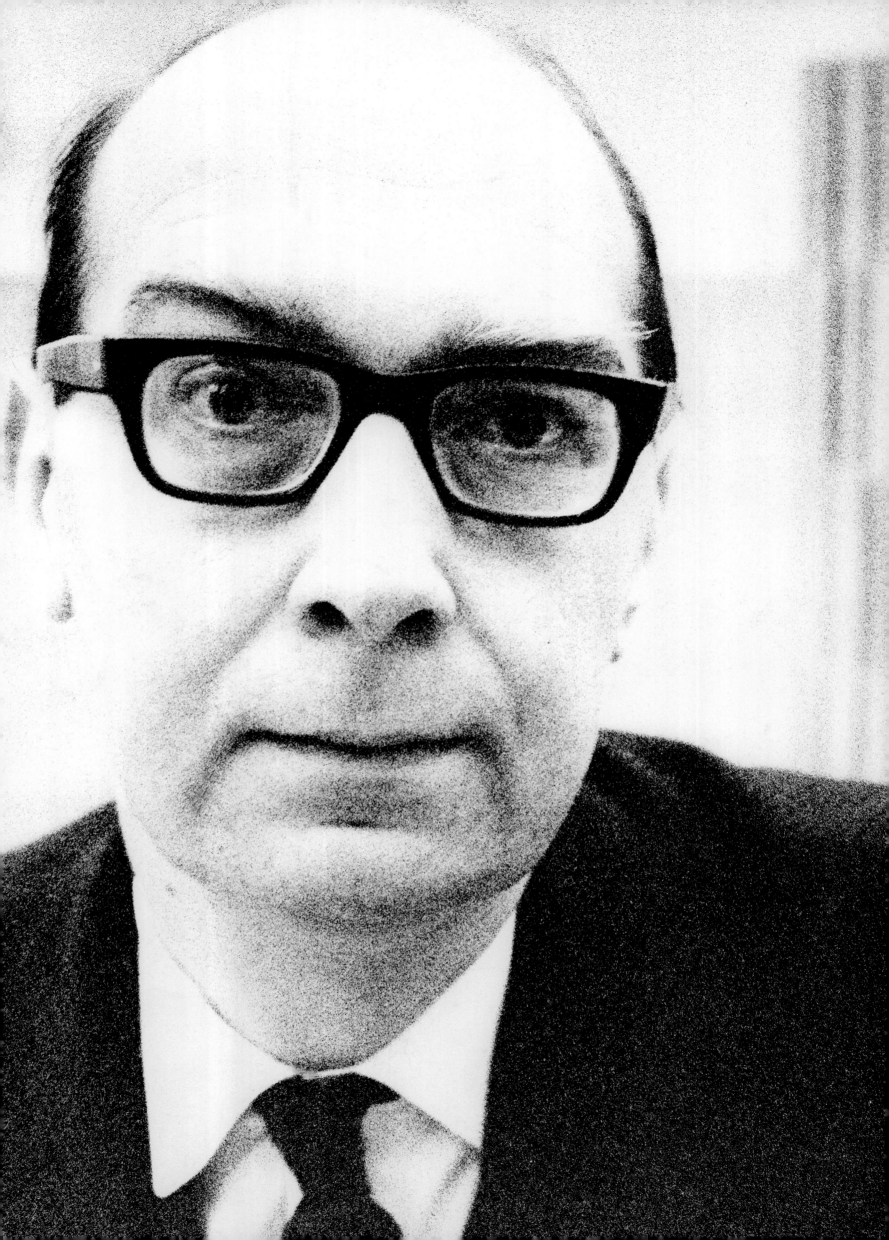

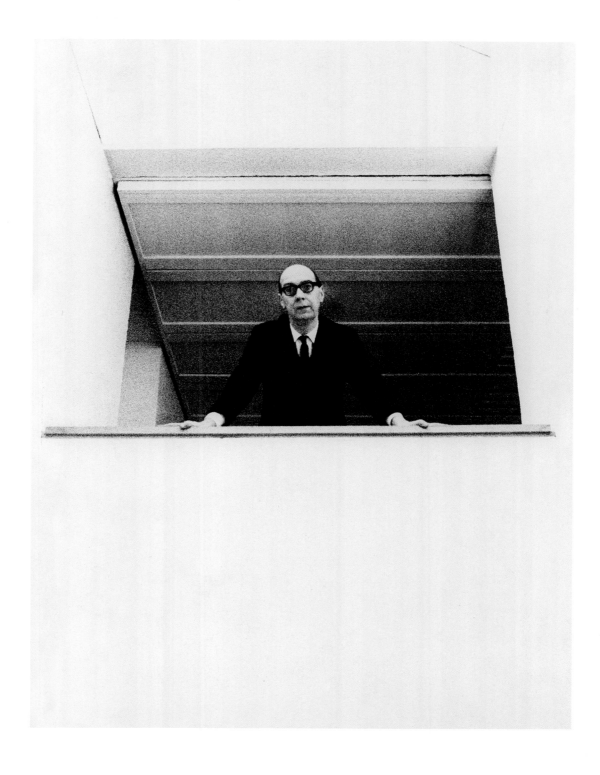

Philip Larkin, poet, 1966
We met in Hull, in the university library where he worked, on a dark and miserably rainy day. I didn't have any lights with me, so I had to shoot the picture in existing daylight – what little there was. Larkin was a rather shy and silent man, but very willing to cooperate to enable me to get a picture.

Following pages: R.S. Thomas, poet and clergyman, 1966
The Welsh poet photographed in the village of Eglwysfach in Wales: 240 souls – eighty for the Church, eighty for the Chapel and eighty for the Devil, said the vicar, R.S. Thomas. After a long drive in appalling weather, I was desperate for a cup of tea – even something stronger. No such luck! The Reverend Thomas stepped out of his house and firmly closed the door behind him. No tea, no Welsh cakes or slice of tea-bread. Later he mellowed – slightly – and I was able to get a few shots, although he didn't seem to have much time for the English, or even for the Welsh. But I've come to the conclusion that most poets prefer their solitude, and here I was, disturbing his!

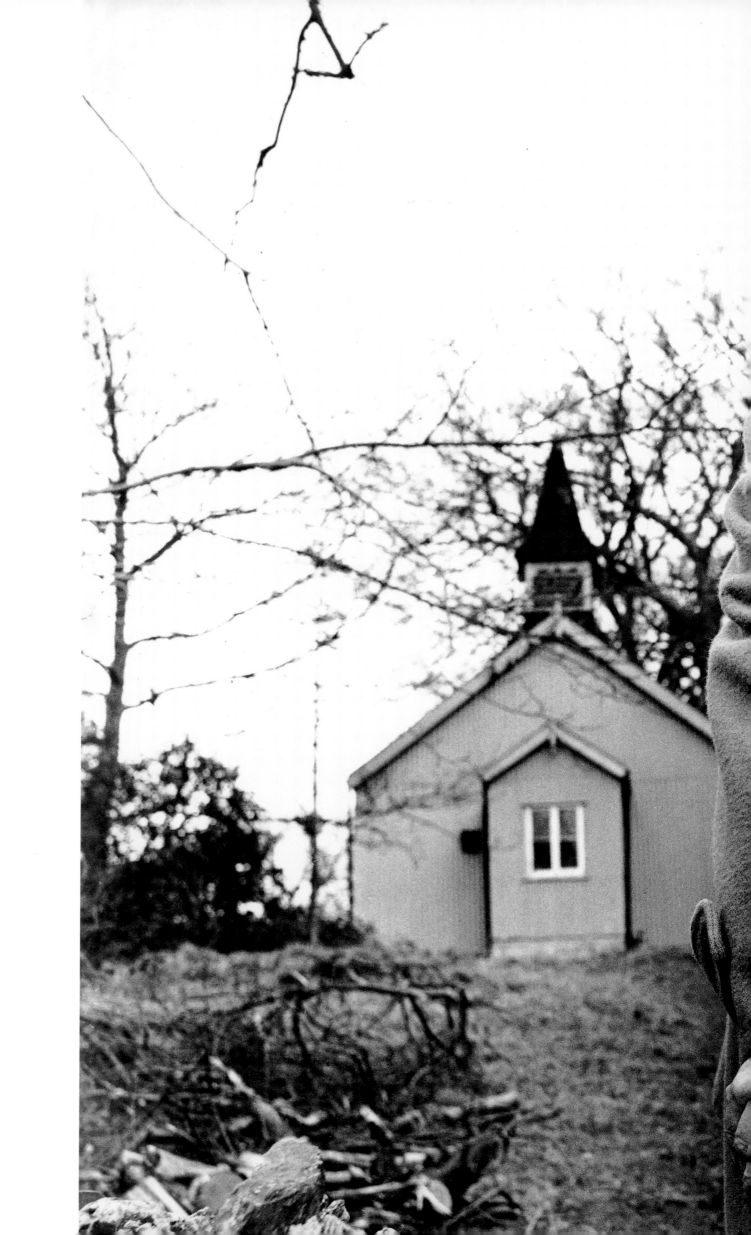

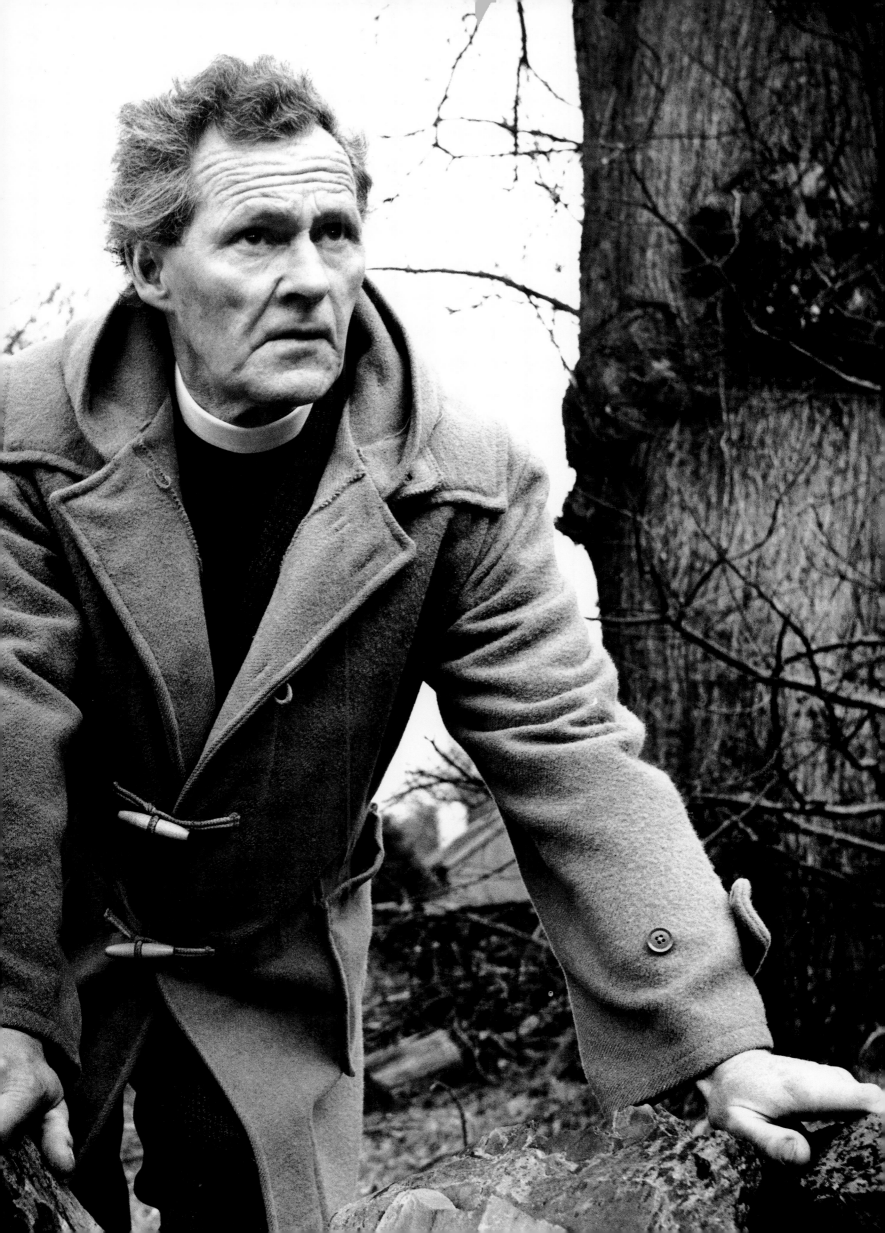

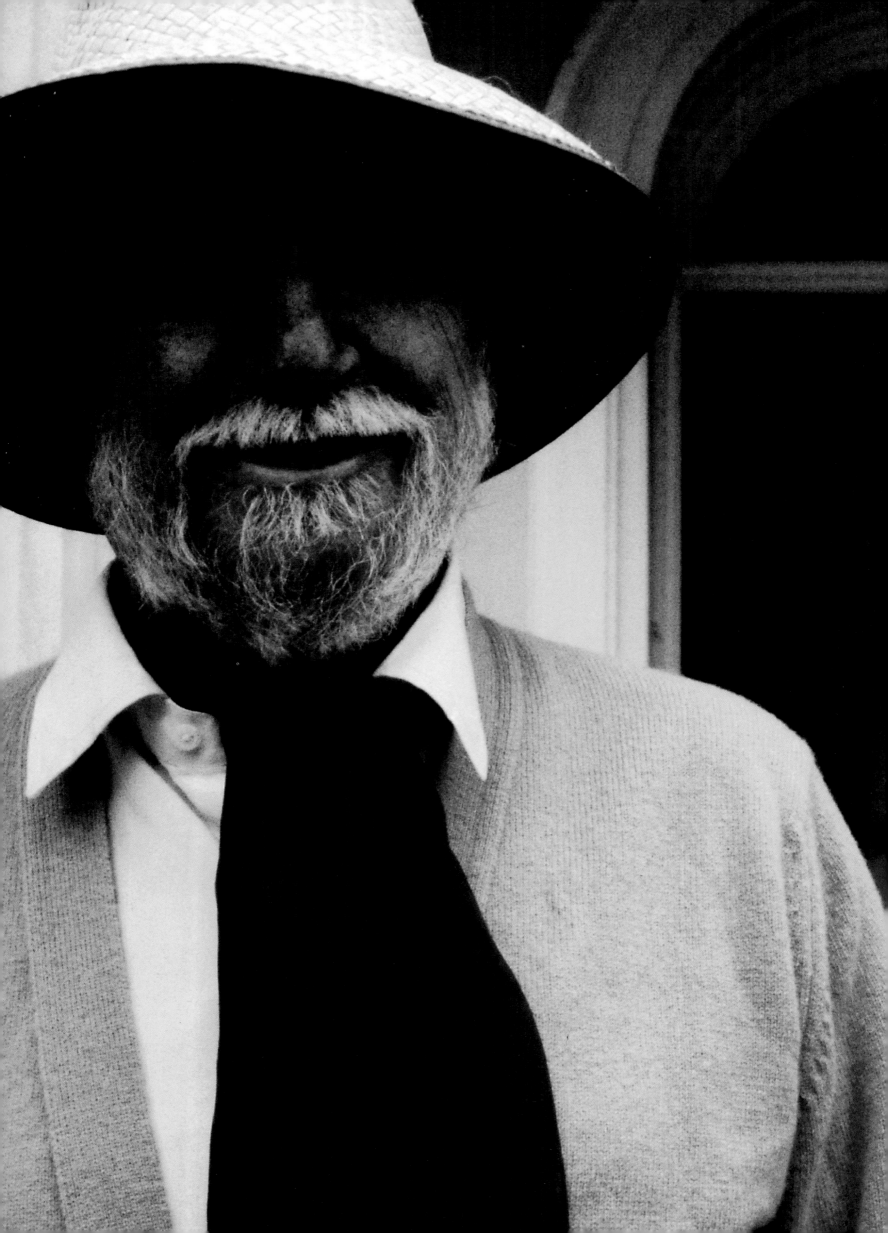

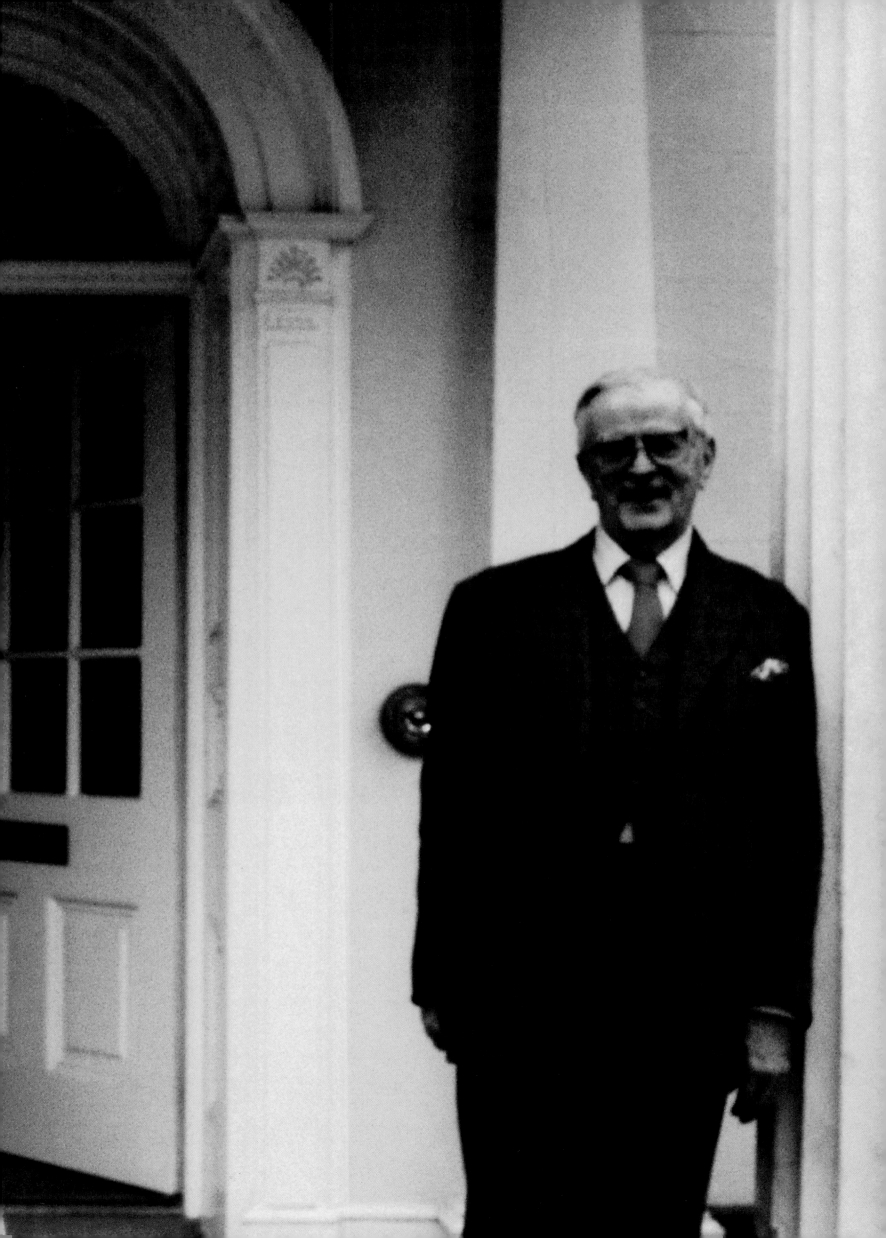

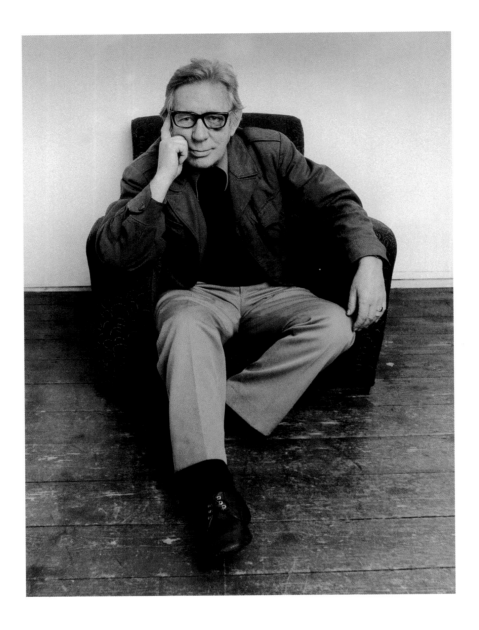

Previous pages: Sir William Golding, writer and Nobel Prize-winner, 1987
Here is the author of the celebrated novel *Lord of the Flies*, photographed outside
his Regency house at St Perran's, Cornwall, with A.L. Rowse, in 1987. Sir William
invited us for tea. There was a certain amount of good-natured banter about
Golding not being 100 per cent Cornish – his mother was, but his father wasn't.

Above: Laurie Lee, poet and writer, 1983
Lee, seen posing for a shot in my studio at the Royal College of Art, where he was a
frequent visitor. He lived just around the corner from the Chelsea Arts Club and
enjoyed the company of artists, being a drinking buddy of the painter Ruskin Spear,
among others. Perhaps this was what Lee was referring to when he listed one of his
recreations as 'indoor sports'.

Right: Sir Stephen Spender, poet and critic, 1974
Spender was one of the poets of the left-wing literary movement of the 1930s who
served in the Spanish Civil War. He was a quiet, elegant, reflective man. I took this
picture of him at his house in St John's Wood.

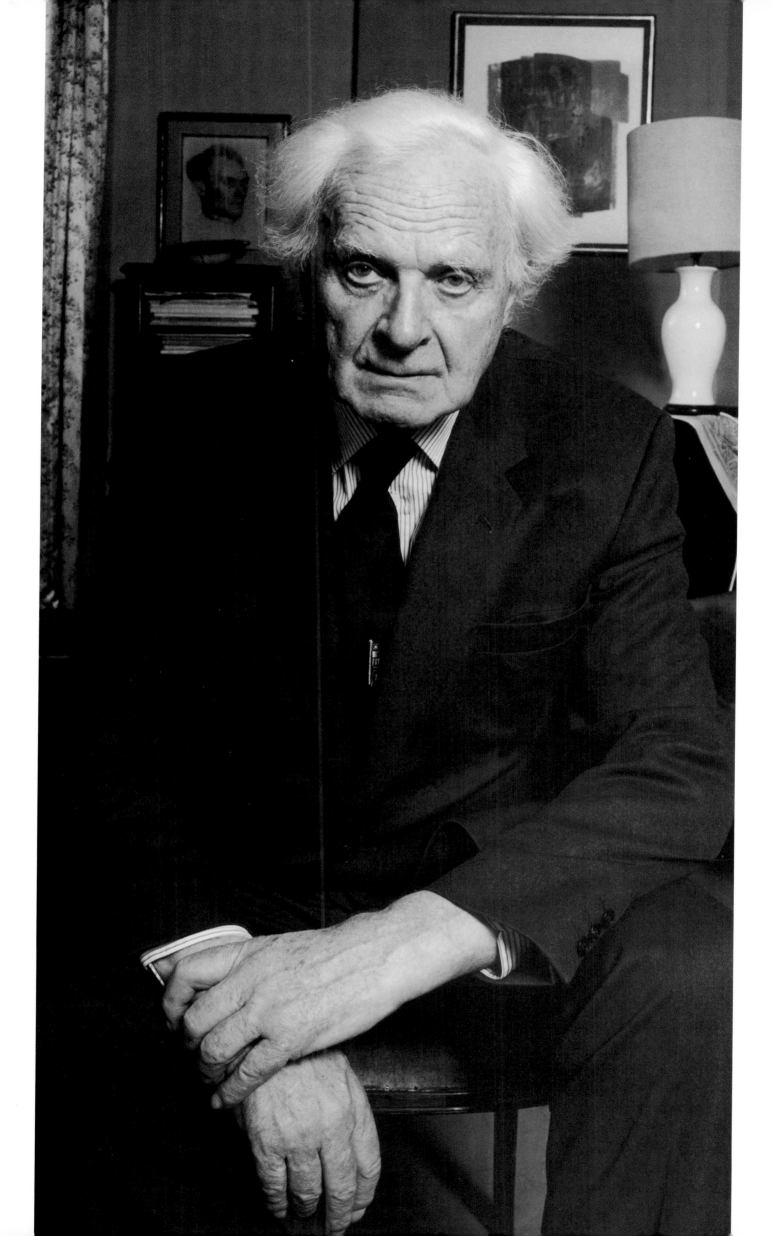

My Skinny Little Cherry Tree by George Barker

My skinny little cherry tree
 alighting without sound
like a feather fallen from
 a bird to the ground,
you shake, as you tremble there
 bare in the bitter day,
birds out of your braided hair
 and like memories they
grow dark in the the evening air
 as they sweep away.

But once above your aery house
 the sun of the summer day
hung among your golden boughs
 and watched the children play
as summer sauntered by
 trailing her hand in the auburn
cornfields of July.
 O skinny little cherry tree
in chains of memory bound
 what is the image that you see
black on the bright ground?
 Where once on a summer time
lovers and children stood,
 an old man without a scythe
gathering up wood.

George Barker, poet and writer, 1966
George was a neighbour of mine in Norfolk, and
when I was asked by a magazine to take a series of
photographs with dawn as the subject, he wrote the
text to accompany them. I was very flattered to have
poems written around my pictures. 'My skinny little
cherry tree' was my favourite.

Adrian Henri, poet, painter and songwriter, 1982
I met Henri in his terrace cottage in Liverpool and had to agree to go on a pub-crawl so that he could show me all the best local pubs. As I had a car, he suddenly decided that he would like to visit the house where he was born, so we drove through the Mersey tunnel to Birkenhead. When we got there the house was empty and the doors and windows had been bricked up. It was rather sad, and Henri rushed up and down, knocking on doors to see if anyone remembered him. But the council had filled the houses with short-term occupants, prior to demolishing the street.

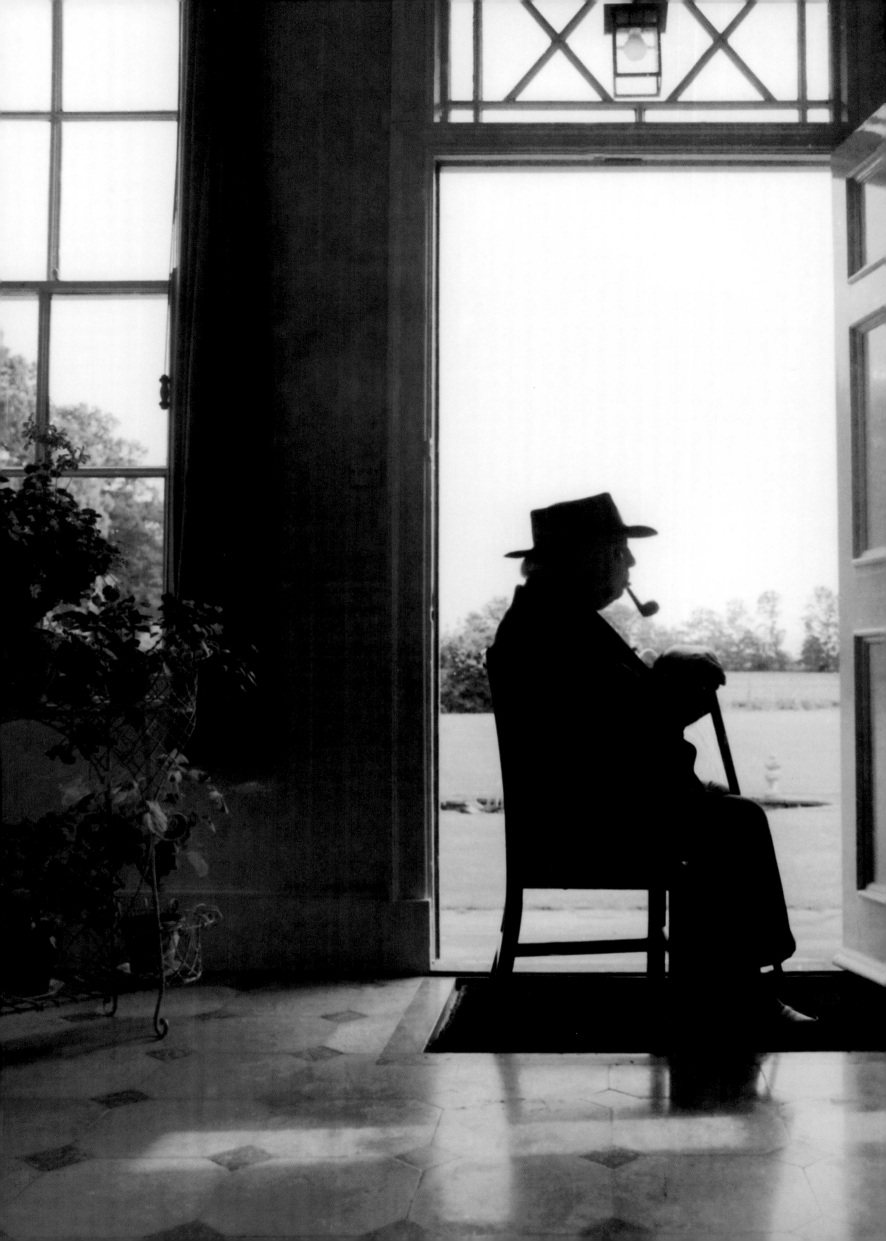

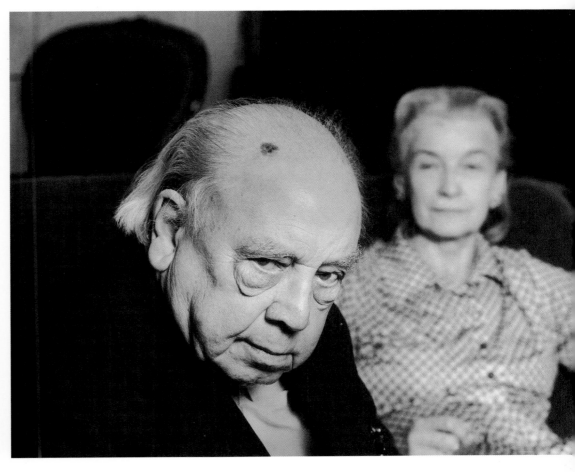

J.B. Priestley, author, with his wife Jacquetta Hawkes, author and archaeologist, 1978
Henry Moore had introduced me to J.B. Priestley – they were both Yorkshiremen.
The second time we met he invited me for a drink. He talked about the rugged,
wild character of the Yorkshire Dales, but in fact preferred Stratford-upon-Avon,
which is where I photographed him. He seemed to enjoy being photographed,
suggesting several locations and poses, and added the Priestley trademarks
of hat and pipe.

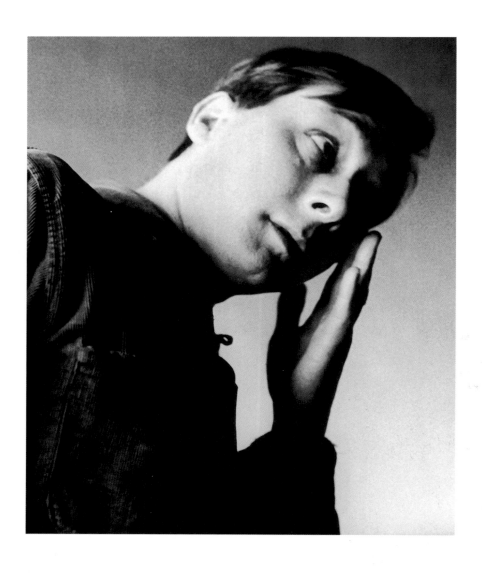

Alan Sillitoe, writer, 1959
Of the numerous novels and stories written by Sillitoe, many were made into films, including *The Loneliness of the Long-Distance Runner*. He lived for a time near Robert Graves's home in Majorca and used regularly to call on Graves, recounting his own working-class Nottingham background. After some weeks of this Graves had had enough. 'Don't tell me any more,' he said crossly, 'just go away and write about it.' Sillitoe did just that – and the result was *Saturday Night and Sunday Morning*. Sillitoe has a different version of this story, but Graves wanted to take the credit of having inspired a modern classic.

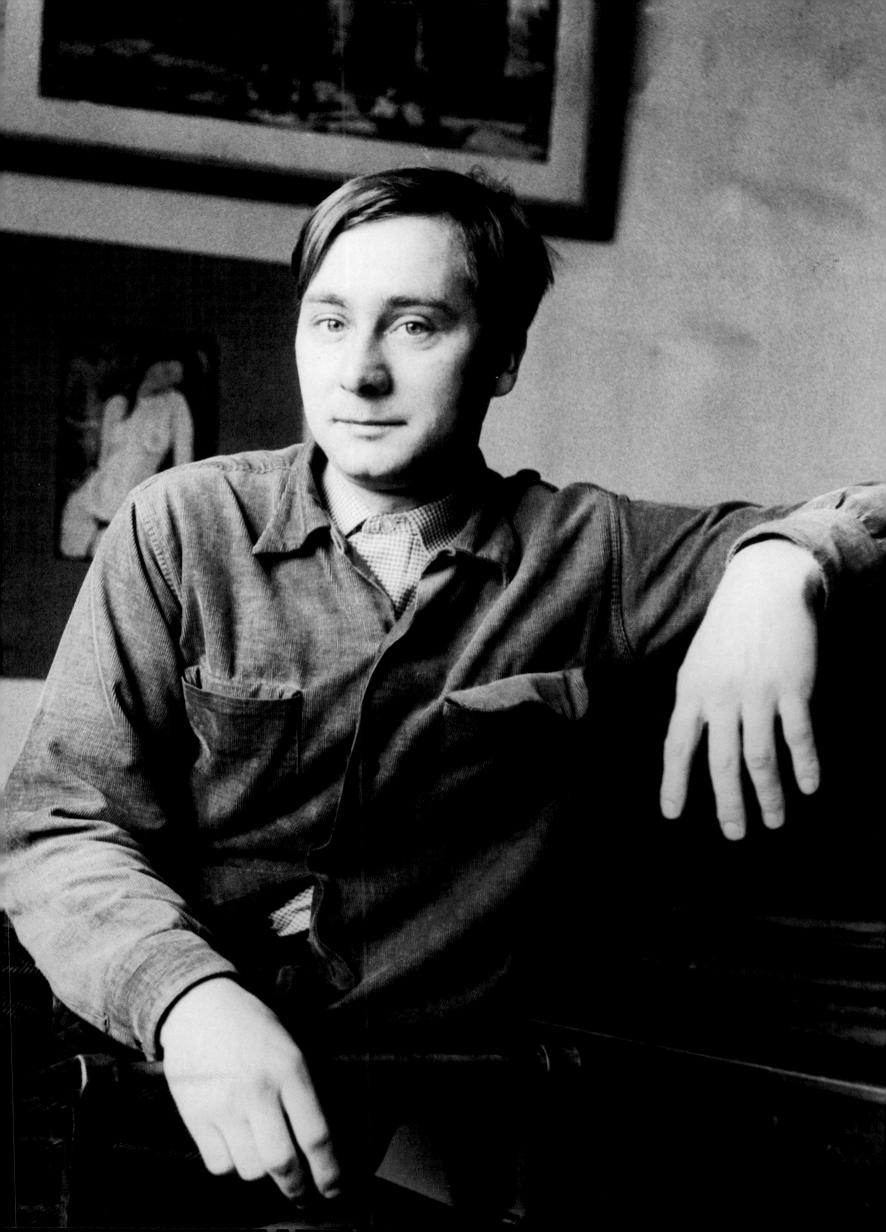

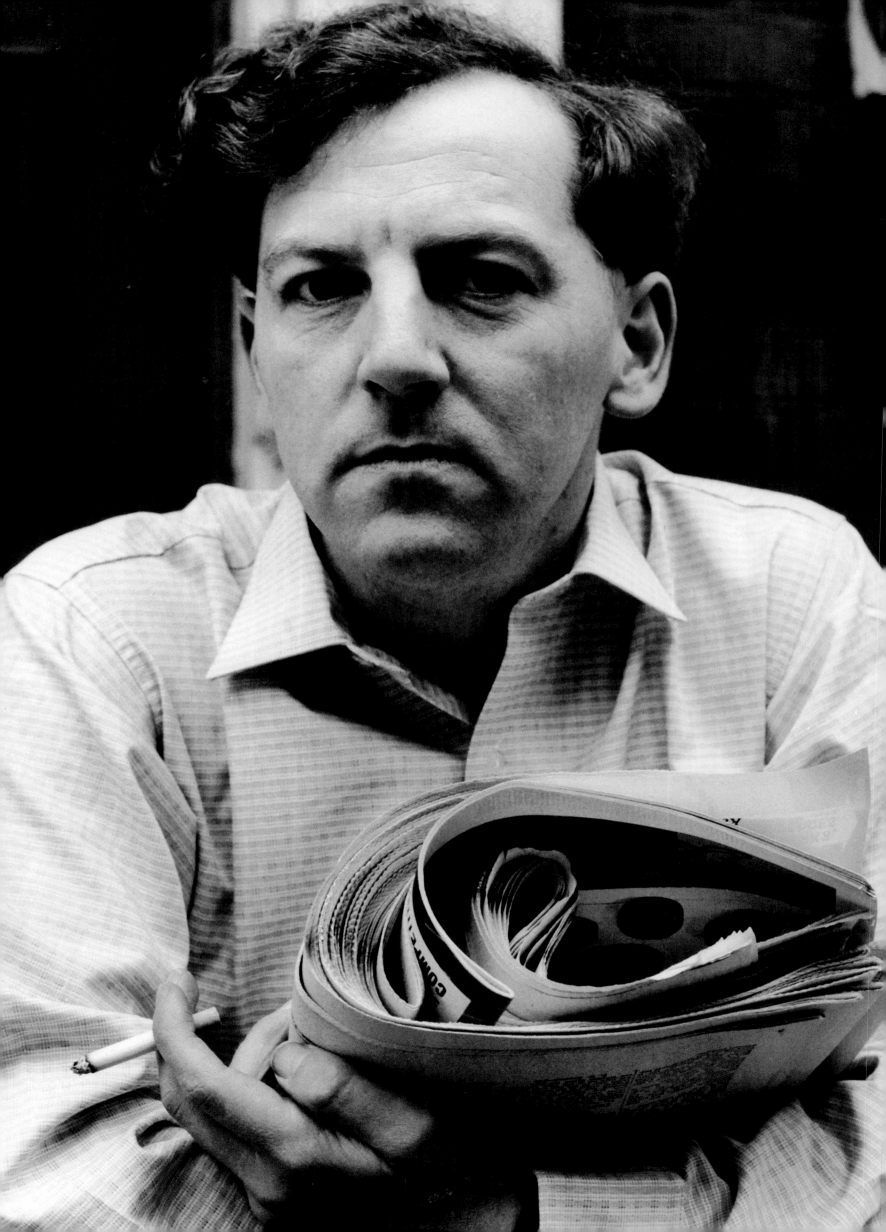

Left: Keith Waterhouse, journalist, writer and playwright, 1959
I took this shot of Waterhouse sitting on his doorstep in about five minutes – he was in a hurry, and so was I. I had to shoot some half-dozen people that day, in a variety of locations. Waterhouse had written the celebrated novel *Billy Liar* the previous year.

Below: Colin Wilson, writer, 1987
A.L. Rowse asked me if I would do the photographs for his book on Cornwall. After photographing a succession of churchyards, I told Rowse that I was fed up doing crumbling old churches and asked why we didn't photograph some of his friends. Rowse thought this a good idea. The friends included William Golding, Daphne du Maurier and Colin Wilson. I knew that Wilson lived in Cornwall and that his writing focused on the dark side of human nature and on the occult. I had visions of him living on the edge of a cliff, overlooking wonderful, ancient scenery, but in fact he lived on a housing estate in a bungalow where, he told me, he had 40,000 books and 25,000 records, plus a collection of parrots. His garden was just an exercise place for the dogs and he didn't seem concerned about material things.

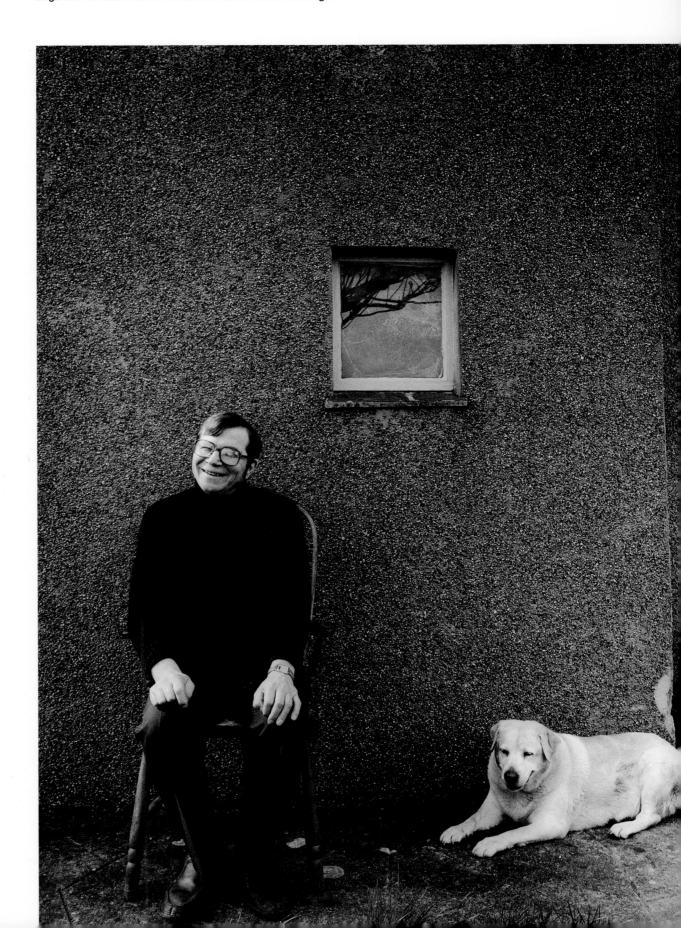

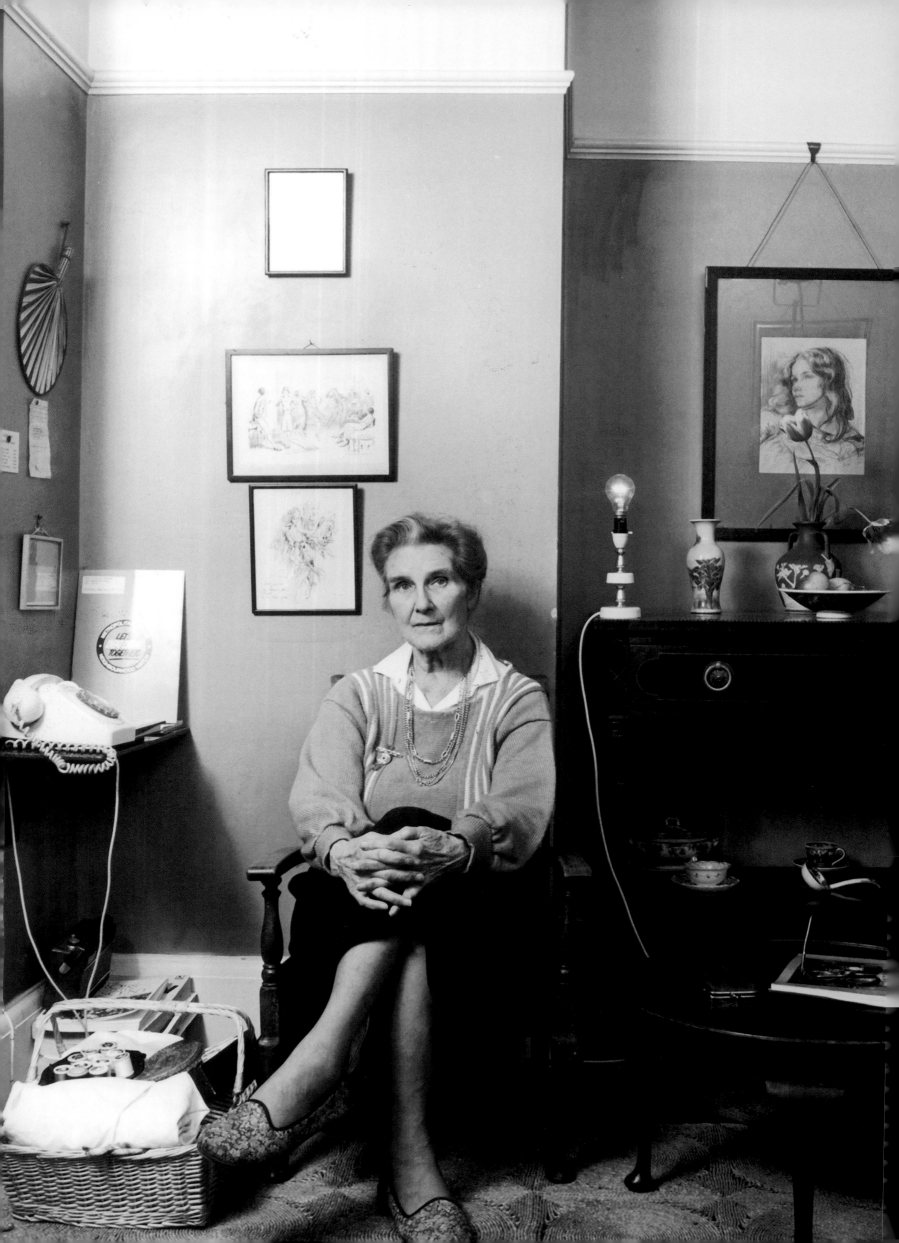

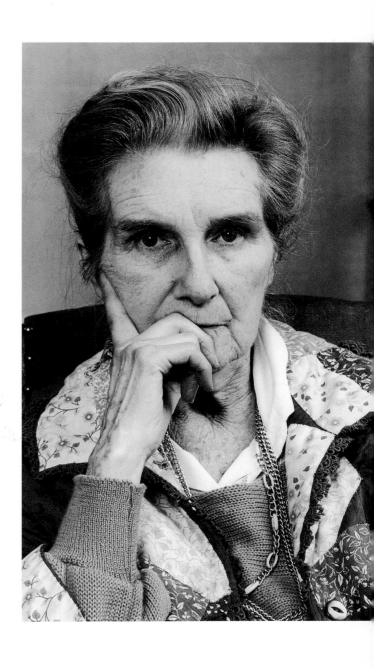

Stella Gibbons, novelist and poet, 1988
Cold Comfort Farm is a book I've always loved; it is one of the most enduring novels in modern English literature of course, and in fifty years it has never been out of print. Stella Gibbons wrote it, apparently, while commuting on the London Underground to her job on the *Evening Standard*. I was very excited at the idea of meeting her and was surprised to find that she lived in a home without much atmosphere or any feeling of warmth – appropriately enough, a house of cold comfort. She struck me as being an intensely lonely person, who seemed to spend much of her time looking out of the window and watching passers-by. I think that when I turned up she was pleased to have someone to talk to and share a cup of tea with.

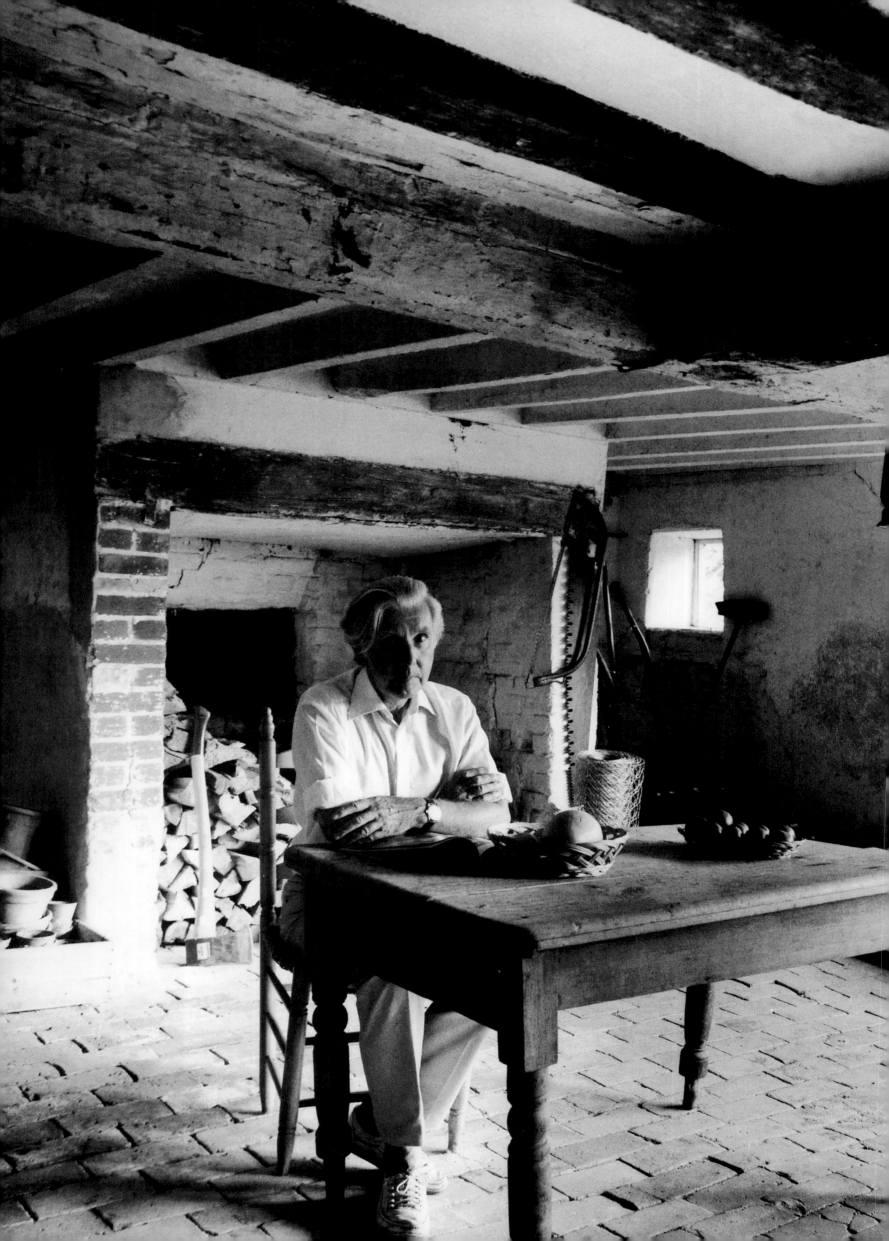

Ronald Blythe, writer, 1986
Blythe's famous portrait of the village of Akenfield in Suffolk – a biography, really –
is rather like John Moore's *Portrait of Elmbury*, with which it has much in common.
This picture was shot in Blythe's Akenfield home, a very remote and primitive
cottage situated across several fields.

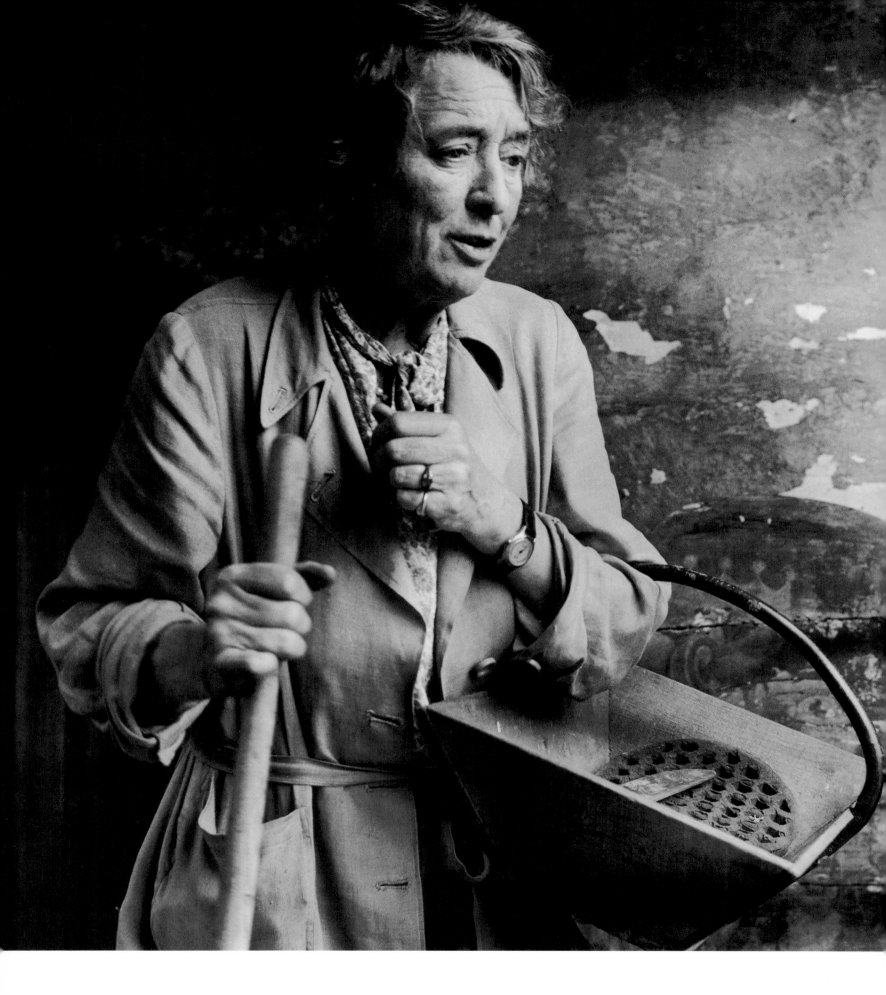

Vita Sackville-West, writer, 1958
Vita Sackville-West was fascinating. She was a wonderful person to talk to and very entertaining. Apparently her office study in the tower at Sissinghurst was strictly out of bounds to everyone – even her husband wasn't admitted. But she had all the time in the world to chat and show me around, and so she allowed me in. The room was like her personal inner sanctum, with piles of dusty books and bowls of flowers gathered from the surrounding gardens. I managed to shoot many pictures of her there.

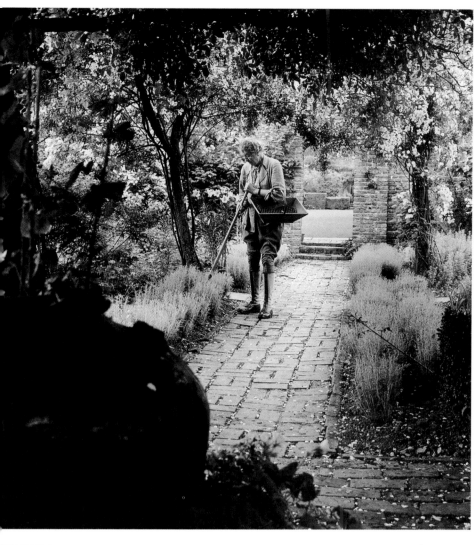

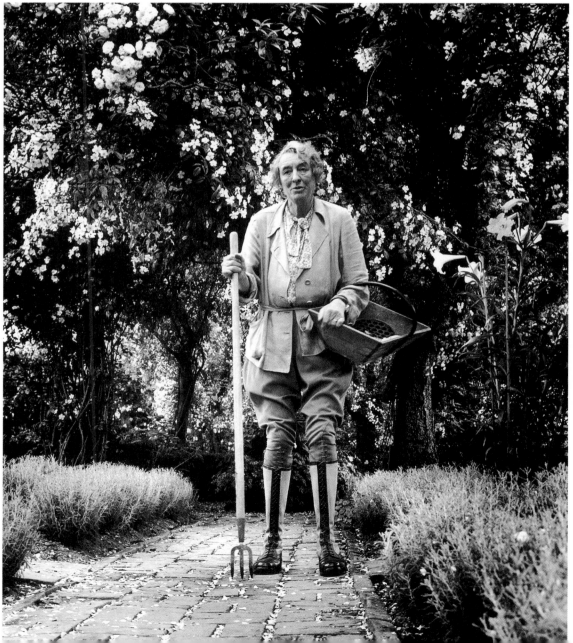

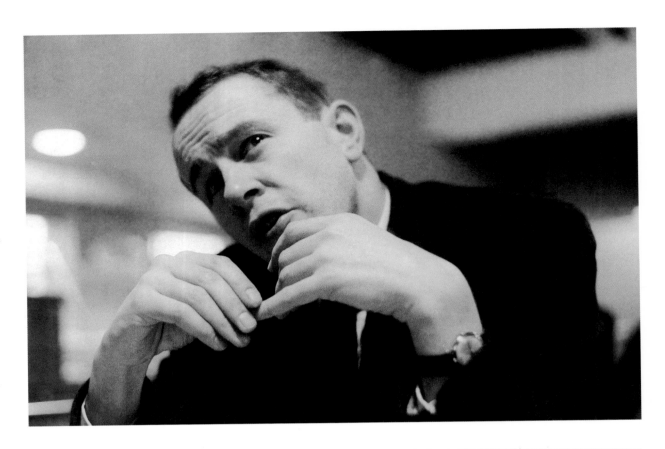

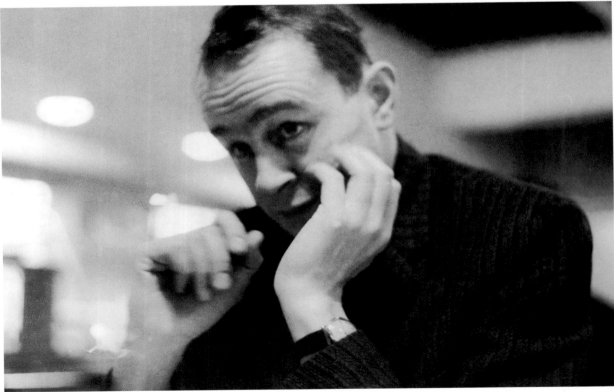

Above: Ned Sherrin, broadcaster and theatre producer, 1960

Right: Auberon Waugh, writer and journalist, 1959
Jocelyn Stevens gave Waugh his first job on *Queen* magazine, where I first photographed
him – he was nice and obliging, but rather distant. He said he couldn't understand why
anyone would want a picture of him.

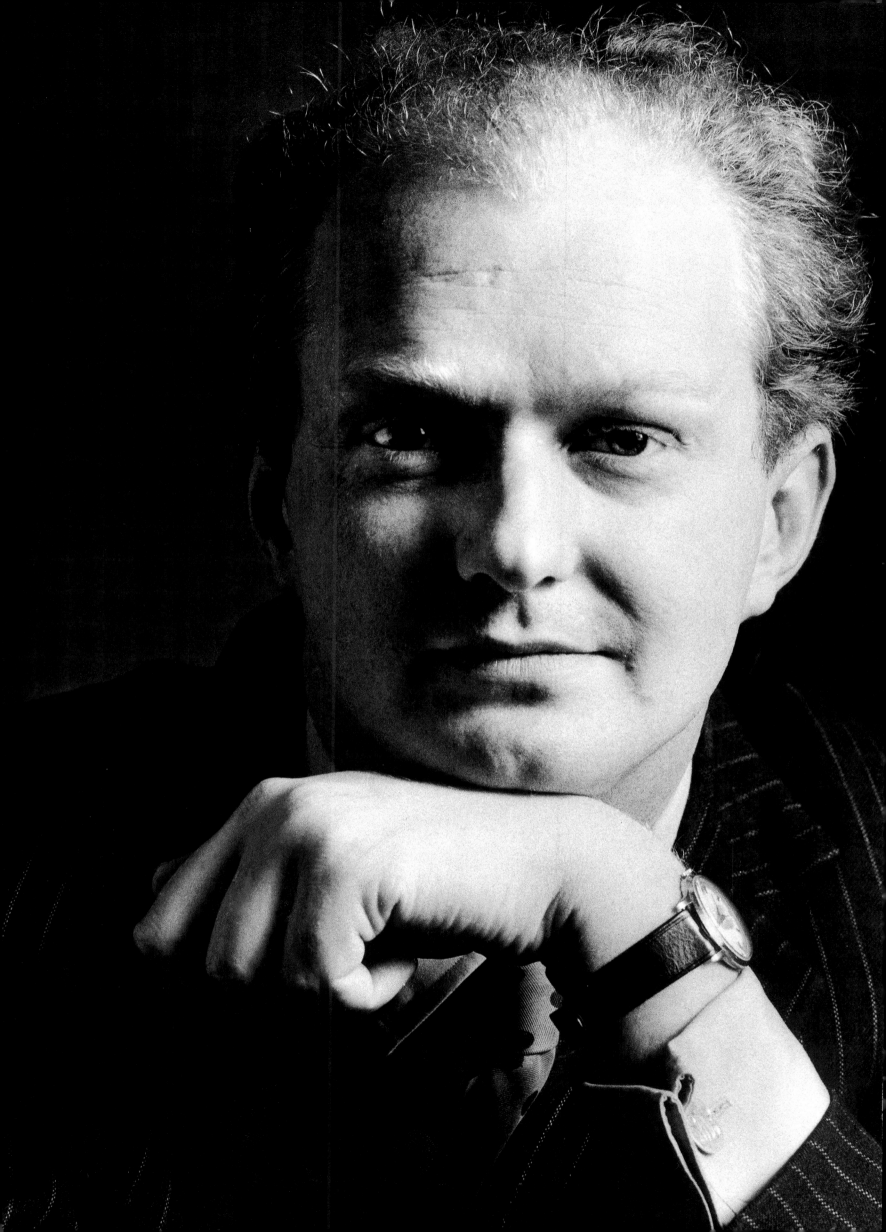

Marina Warner, writer and critic, 1974
Marina is a beautiful, intellectual writer and a long-time friend. We met in 1968, when we worked together on the serialization of my first Henry Moore book in the *Sunday Telegraph* magazine.

Enid Bagnold, writer, 1970
Enid Bagnold's most famous book, *National Velvet*, was made into the film that launched the career of Elizabeth Taylor. Bagnold was a formidable and resilient woman, who in her younger days had been seduced by Frank Harris in the Café Royal in Paris. I photographed her in her house, which once belong to the Pre-Raphaelite painter Edward Burne-Jones, at Rottingdean on the Sussex coast.

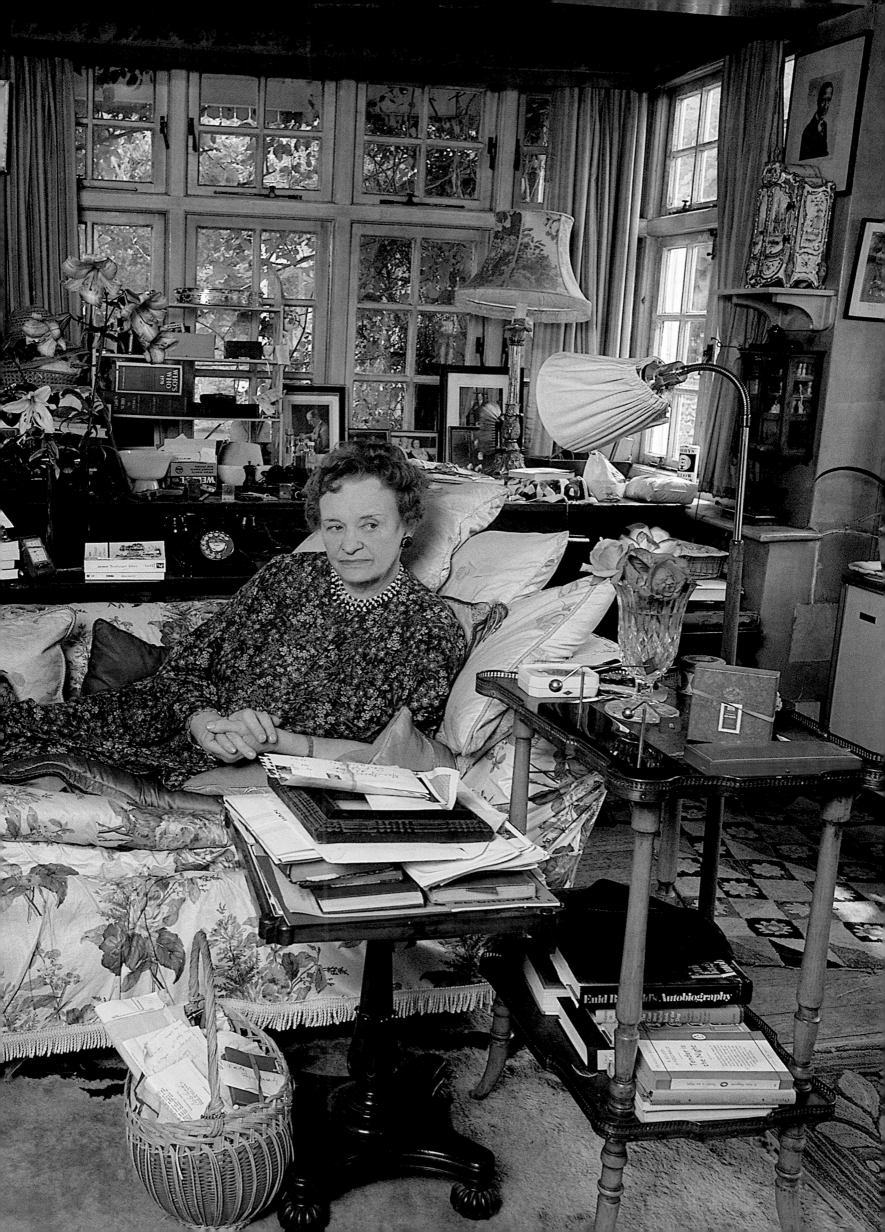

Below: Gladys Bertha Stern, novelist and biographer, 1960

Another formidable woman! I rang from my London studio to say that I'd arrive in about half an hour. 'No, you won't,' she said gruffly. 'It'll take you at least an hour and a half.' She was right, of course. She displayed in her Wallingford house a collection of walking sticks and told me that during the Second World War she had given a series of lectures about them, since all the sticks had been owned by famous men and women. She was proud to be able to say that she'd raised enough money from these lectures to 'put a tank in the field'. Looking at her, I secretly wondered why she bothered to sponsor a tank, but didn't just go herself!

Right: Germaine Greer, writer, essayist and lecturer, 1970

A wonderful person to photograph, she never stopped talking about anything and everything.

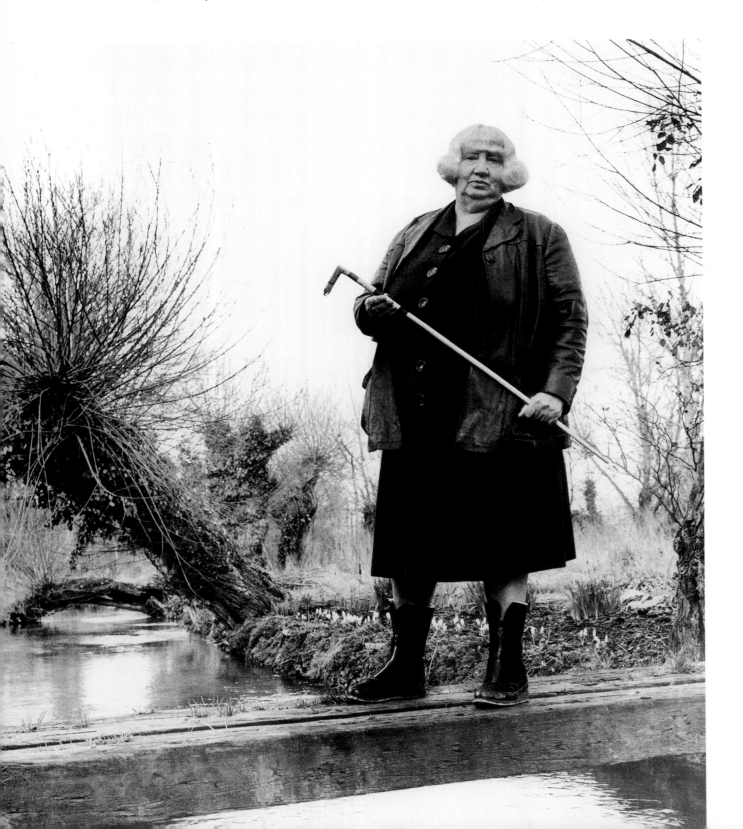

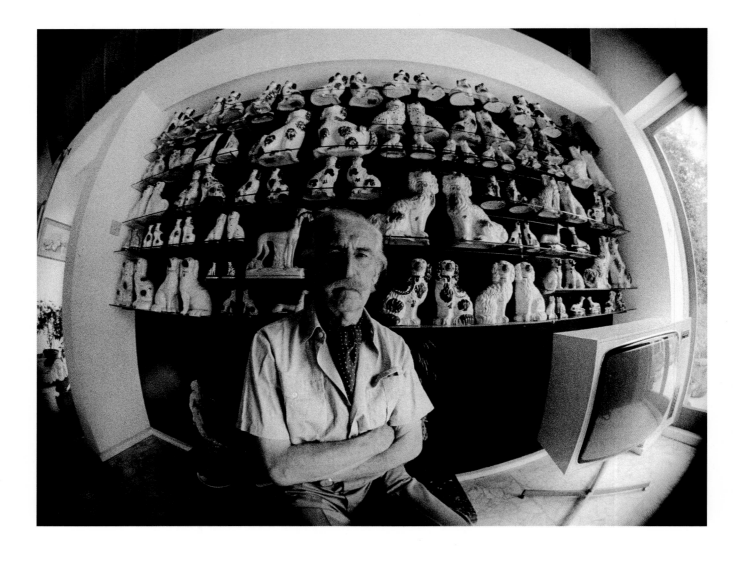

Above: Freddie Gibberd, architect, 1975
Gibberd designed Harlow New Town and the Catholic cathedral in Liverpool, which
Liverpudlians call 'the wigwam'. He was a great friend, neighbour and gardener, and we
competed against each other to build follies in our gardens. Whatever I did, he'd go one
better. Once he found out that I'd got some black swans on my lake. 'Bugger!' he said.
'Now I'll have to get some crocodiles!'

Clough Williams Ellis, architect, 1969
The designer of Portmeirion, the finest folly of the century.

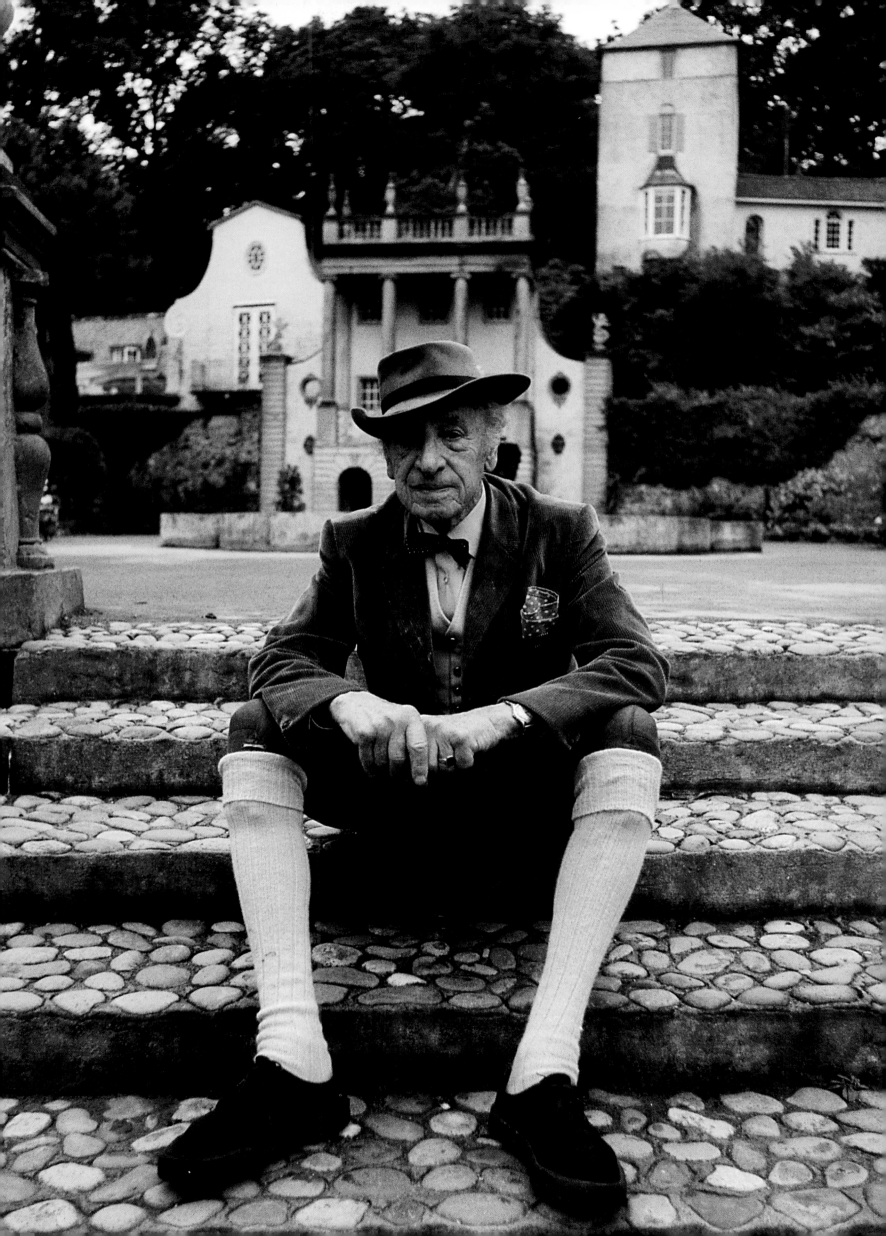

Lord Richard Rogers, architect, 1993
This photograph was taken in Lord Rogers's house, which features girders and glass, space and stainless steel, and a clinical style that has made him one of the great architects of his time.

Dame Lucie Rie, studio potter, 1980
The diminutive Austrian potter was an septuagenarian
when I photographed her in her home – she'd been making
collectors' pieces since 1927. She invited me to stay for
tea, which she'd set out like a Mondrian painting: all the
sandwiches were cut into neat squares and triangles, with
the plates arranged with precision, while a single tulip
stood in one of her pots. It all looked fantastic and I
could hardly bring myself to eat it and spoil the effect.

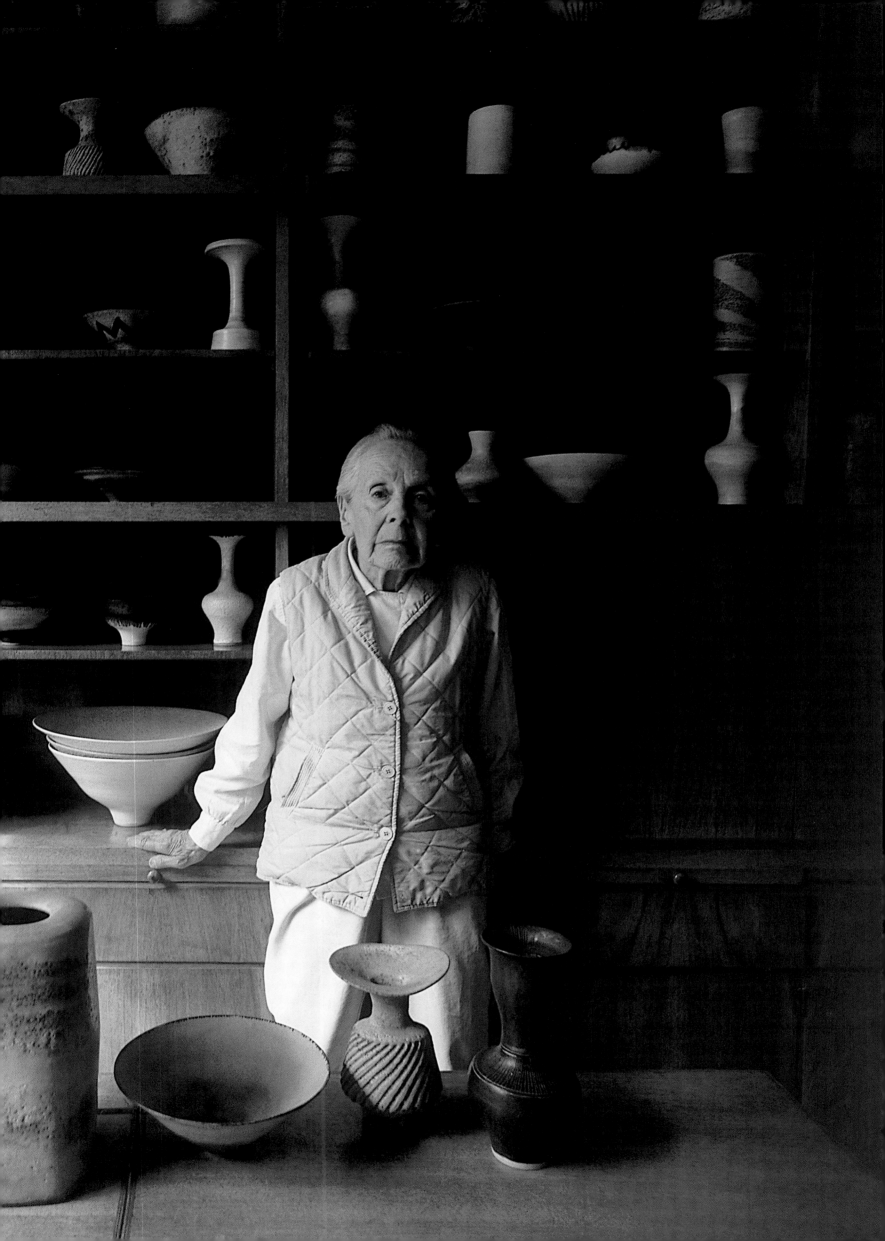

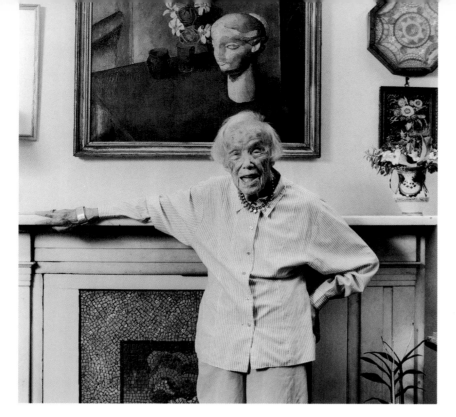

The Bloomsbury Set
Frances Partridge, 1999; Duncan Grant, 1957; and Wilhelmina Stirling, 1959
Frances Partridge (top, seen in Mayfair), the last of the Bloomsbury set, is 100 years old on the Ides of March 2000. The painting seen in the picture above her is by Duncan Grant (above), whom I photographed in Charleston. I took the picture of Wilhelmina Stirling (right) in Battersea House. She told me that her great ambition – were she able to afford it – would be to knock down the old flour mill on the embankments and restore her view to the River Thames.

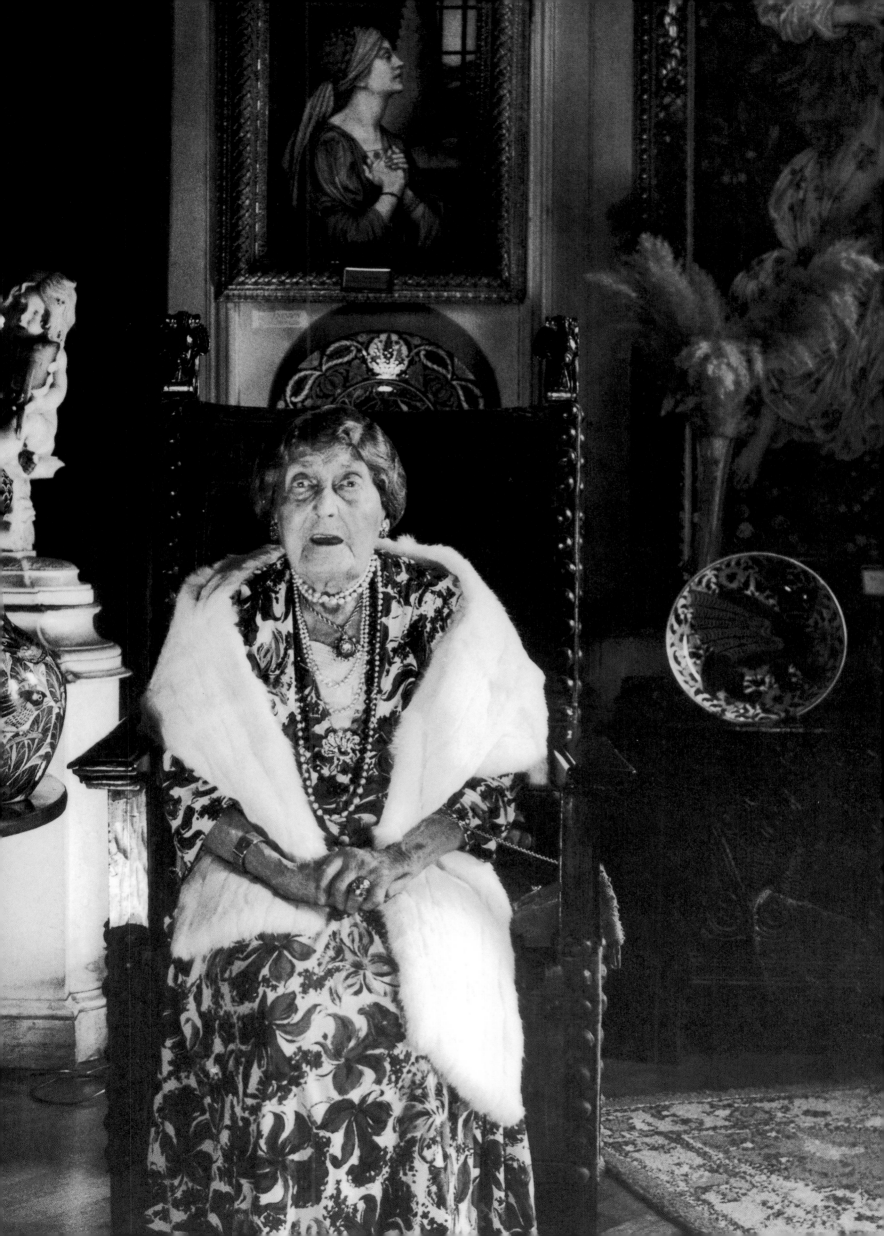

Augustus John, painter, 1957

I'd been invited to lunch at John's house in Hampshire. We sat at a vast table that would have accommodated twenty people, although there were just the two of us, except for a girl who appeared and served food. We were not introduced. The trouble was that by then John was stone-deaf and his hearing aid wasn't working – or perhaps he'd switched it off. Since I was unable to communicate with him and he hardly spoke a word, I had to lead him round and steer him into the positions I wanted. It felt as if we were taking part in a silent film. John was a remarkably tall, big man and I was using a camera with a viewfinder at waist level (a Rolleiflex), so many of the shots were of his head, taken from underneath.

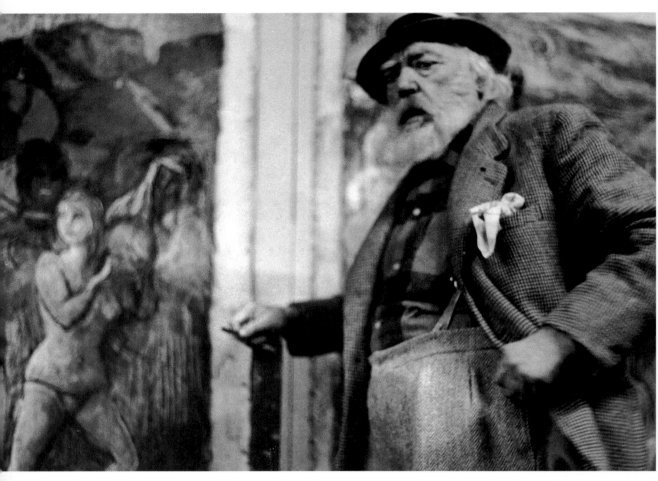

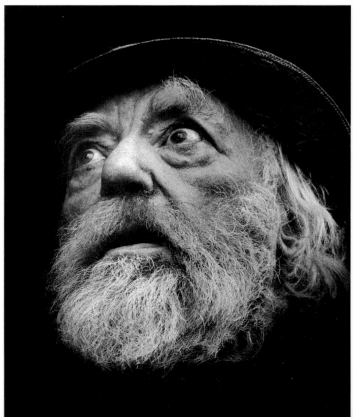

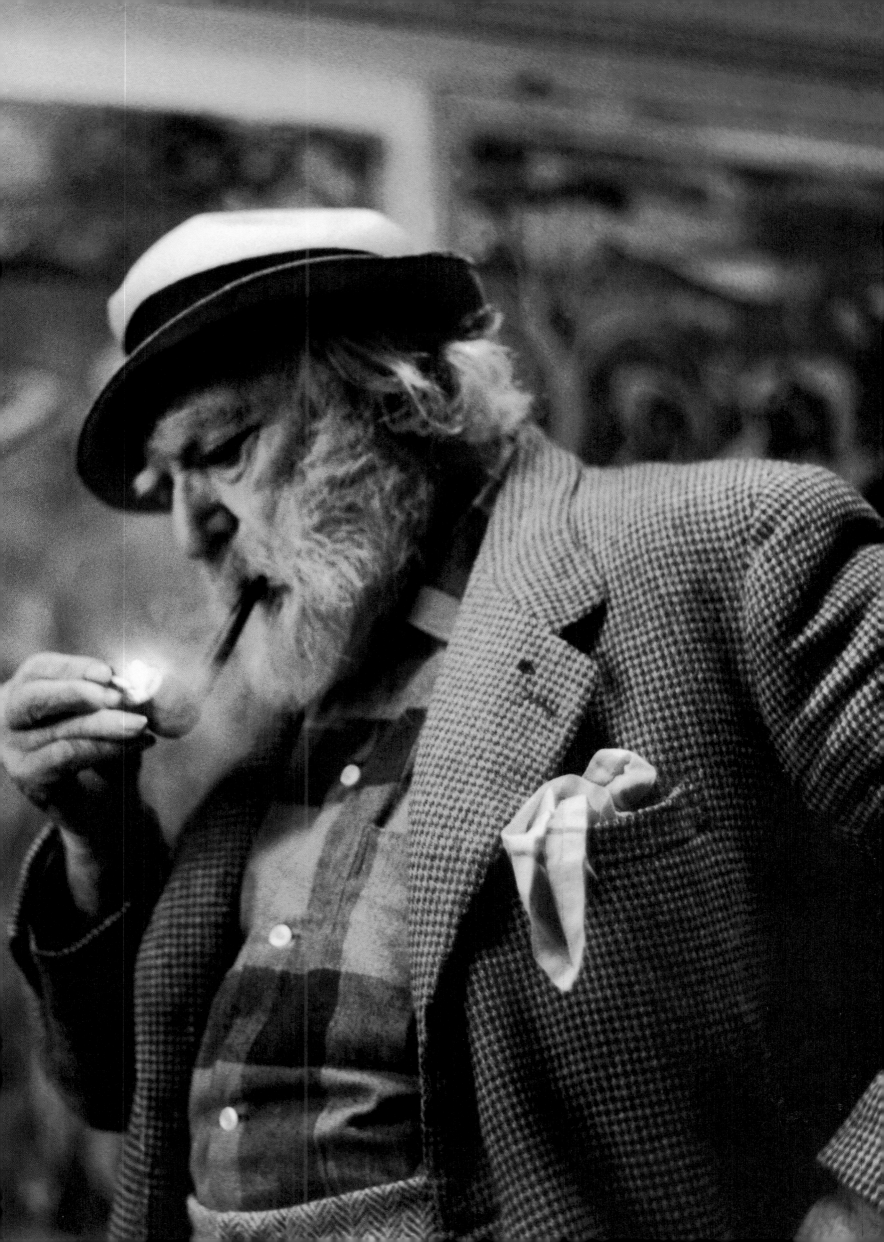

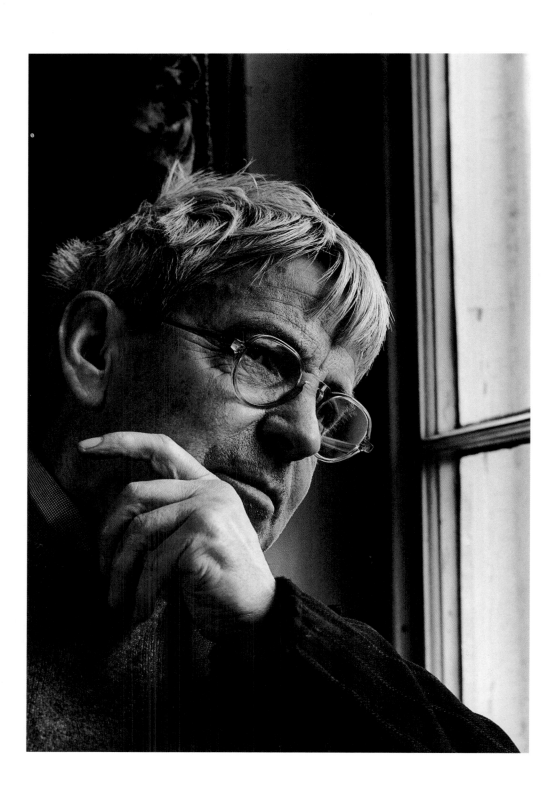

Sir Stanley Spencer, painter, 1957
Spencer was a truly eccentric genius. He invited me for tea to his house in
Cookham on the Thames on numerous occasions. He could be quite
temperamental, greeting you warmly one day, while on another saying, 'You've
come to waste more of my time.' He worked in his small bedroom (note the
dressing gown hanging on the door) and most of his paintings were on a very large
scale, so the canvas had to be unrolled bit by bit while he painted a section,
working from pencil sketches on tracing paper. The huge picture of Cookham
Regatta (right) was his last. Being a small man and needing to work close-up, he
would sit perched on a stool on a rickety trestle-table. His only source of light
when it got dark came from an angle-poise lamp. He was very methodical and
systematic, painting in all the blues, then the reds, and so on. He worked like an
illustrator, using a tiny palette and sable brushes.

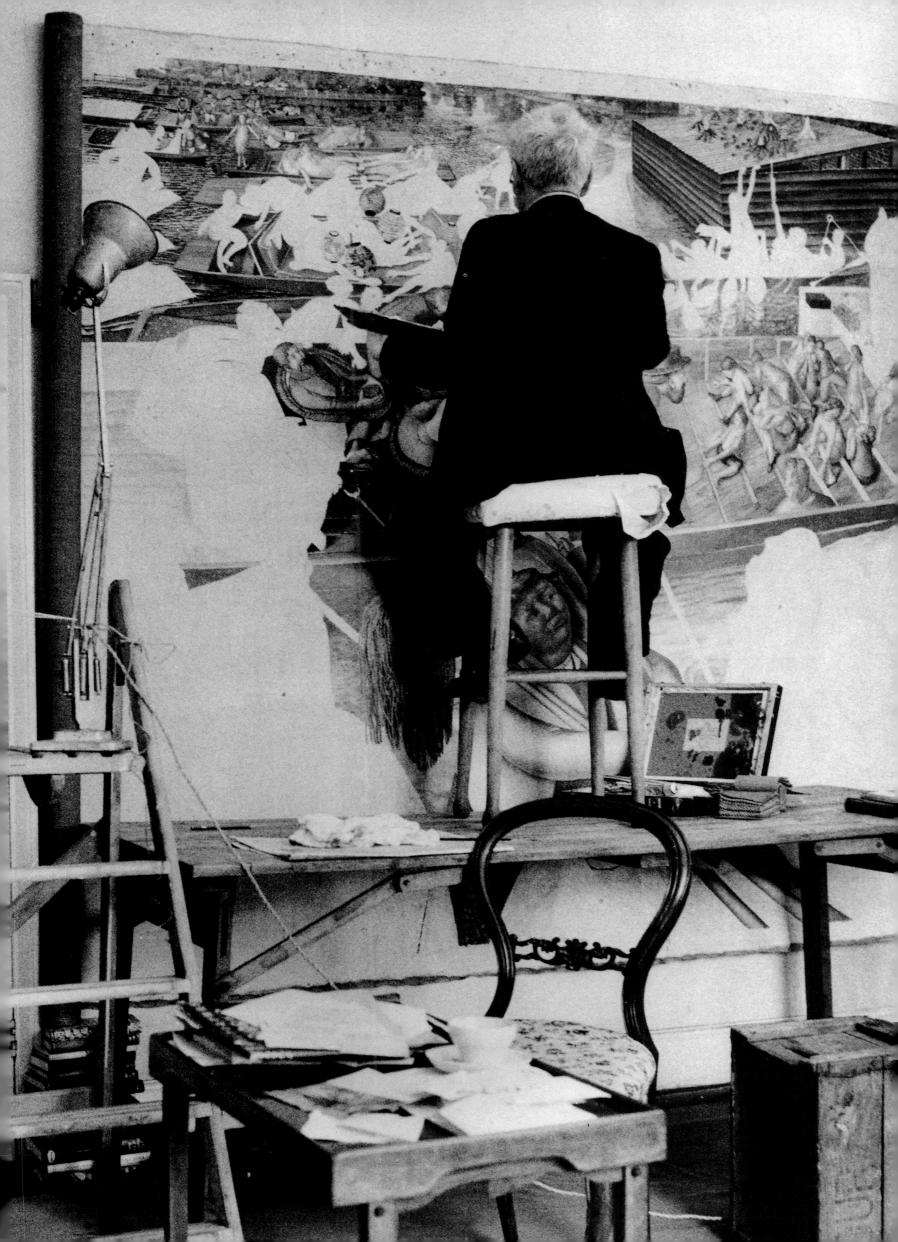

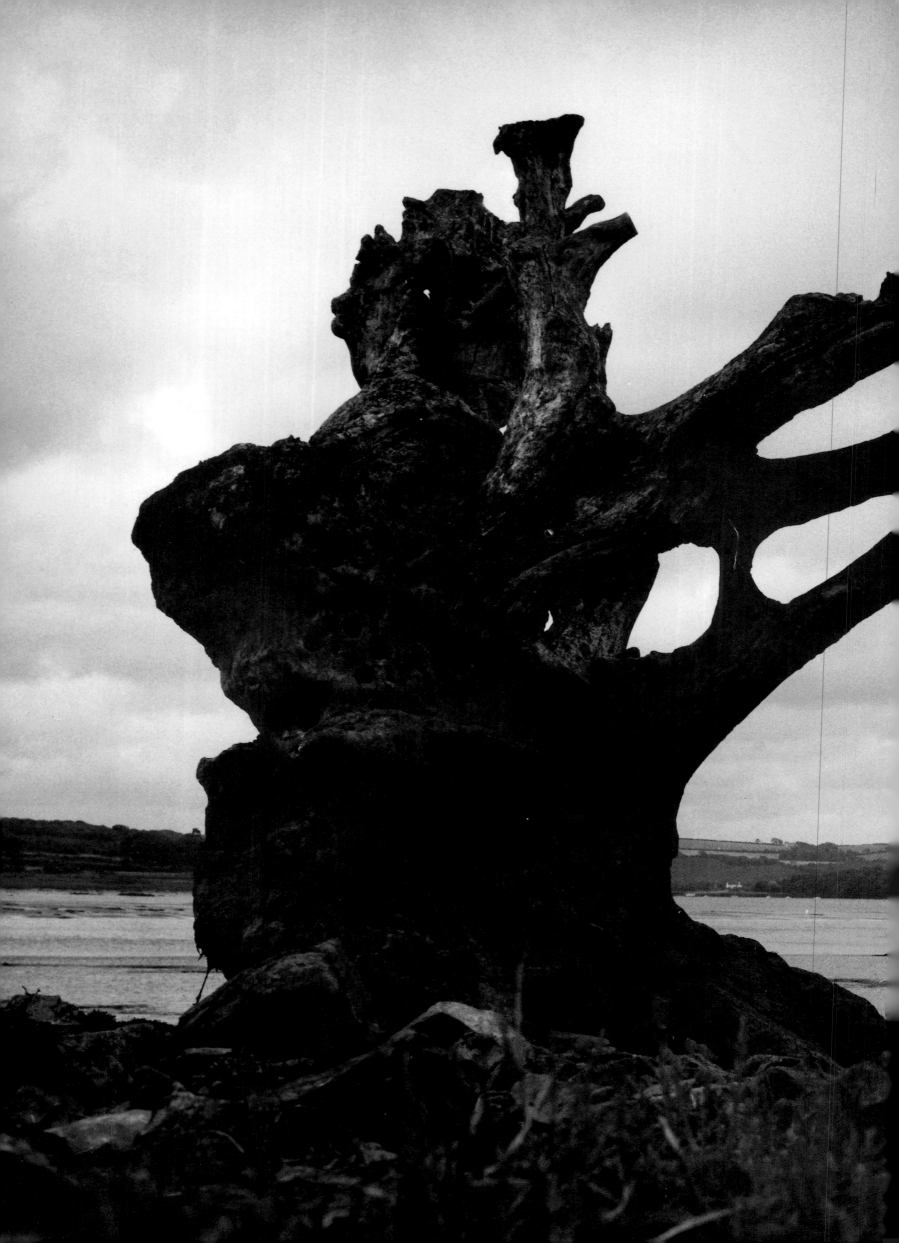

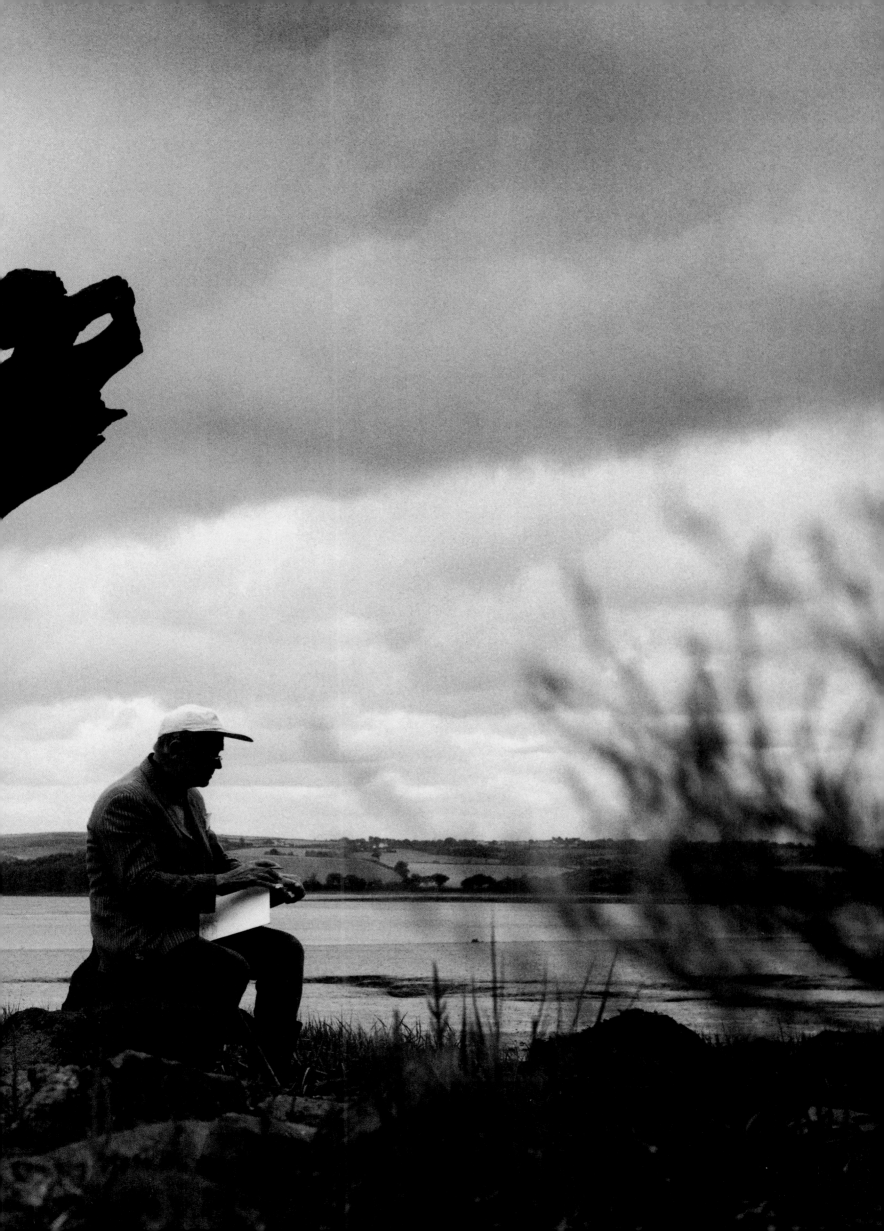

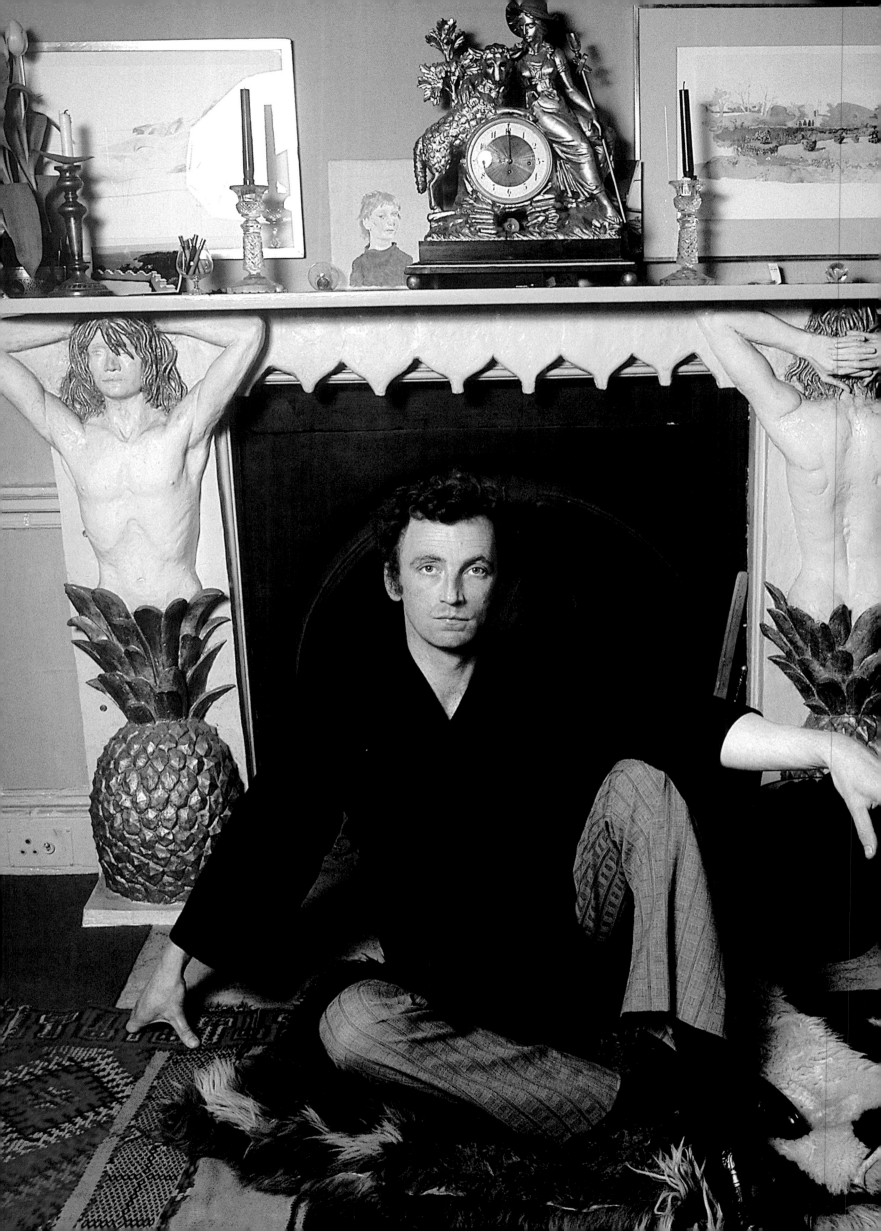

Previous pages: Graham Sutherland, painter, 1968
Graham was a good friend and I took lots of pictures
of him. This photograph shows him sketching on the
estuary at Milford Haven, always a very productive area
for him, where he could re-fashion and interpret the
landscape in his own intensely personal style. He tried
to go there most years for a short visit, throughout his
working life.

Left and below: Patrick Procktor, painter, 1970
Patrick was one of the great fashionable painters of
the 1960s and very eloquent. I photographed him in his
studio (left) against the fireplace that he'd designed
and modelled, and in my own studio (below). The
Venetian lion is in fact a photograph, a back-projection,
which I felt reflected the Renaissance influences that
Procktor expressed, with his liking for decorative
styles and costume.

Following pages: John Piper, painter, 1981
The painting in the background is a vast Piper mural,
on the wall of his studio just outside Henley-on-
Thames. It may have been for one of his theatre
designs – he was a remarkably versatile artist,
designing stained glass for Coventry Cathedral and
a tapestry for Chichester.

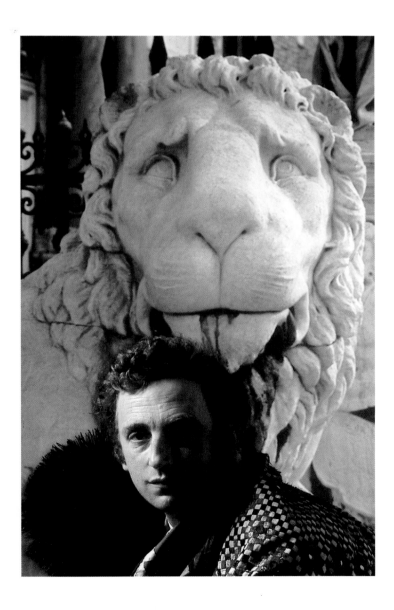

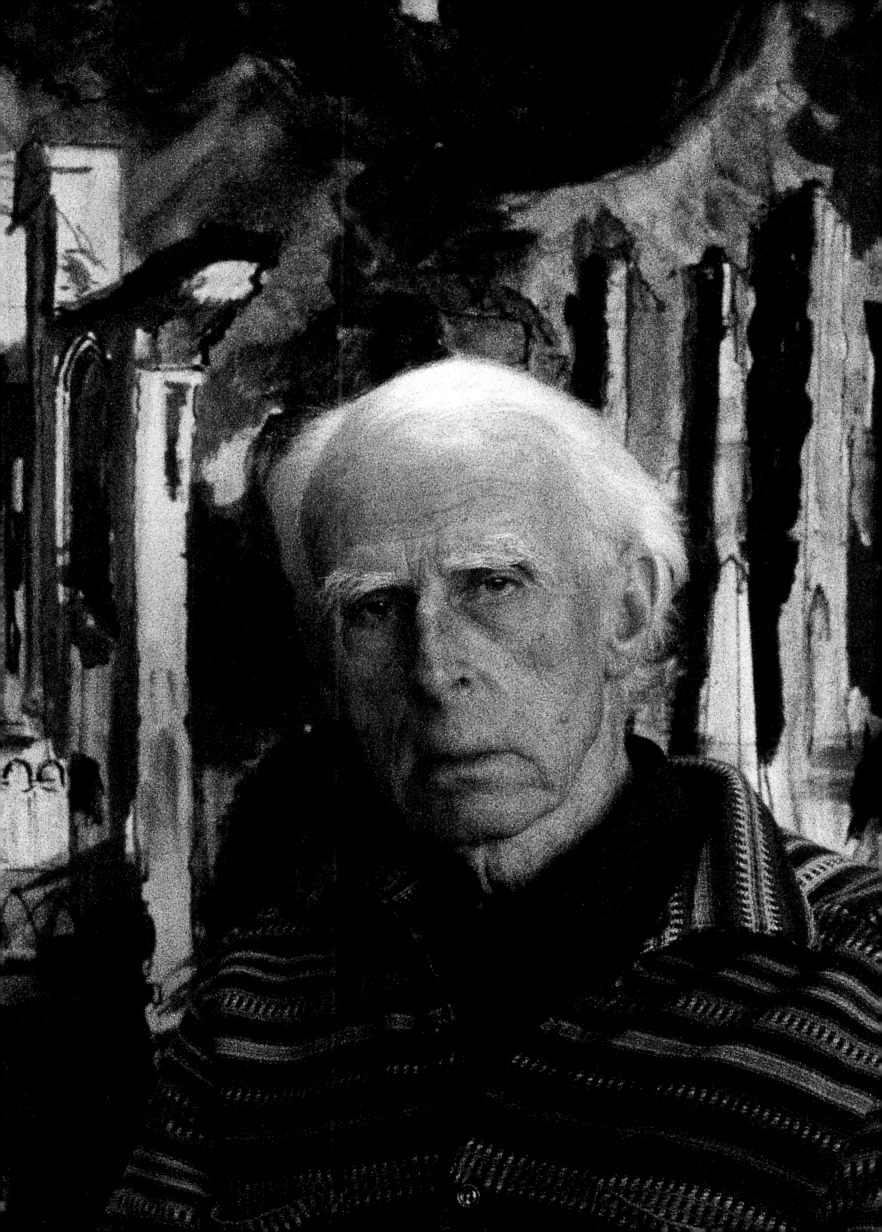

Richard Hamilton, painter, 1972
This picture, taken in Hamilton's studio, was for *Flair*
magazine. Richard Hamilton was one of the originators
of the Pop Art movement during the 1950s, with his
collages of elements taken from advertising
juxtaposed with mass-media images.

Following pages: William Scott, painter, 1963
This high-key shot reflects Scott's style of painting, a
combination of abstraction and aspects of realism. He
had been a war artist during the Second World War
and a member of the St Ives School, which was begun
in the 1930s by Barbara Hepworth and Ben Nicholson.
When I went to Scott's studio I expected it to be white
and spartan, with a few pots and pans scattered
around, and in fact it was just like that. I knew Scott
because he was a regular visitor to the Royal College
of Art. He was a small man, quietly spoken, and I
remember seeing him shortly before he died. He was
in the common room, totally on his own, and nobody
recognized him, despite the great reputation that he had.

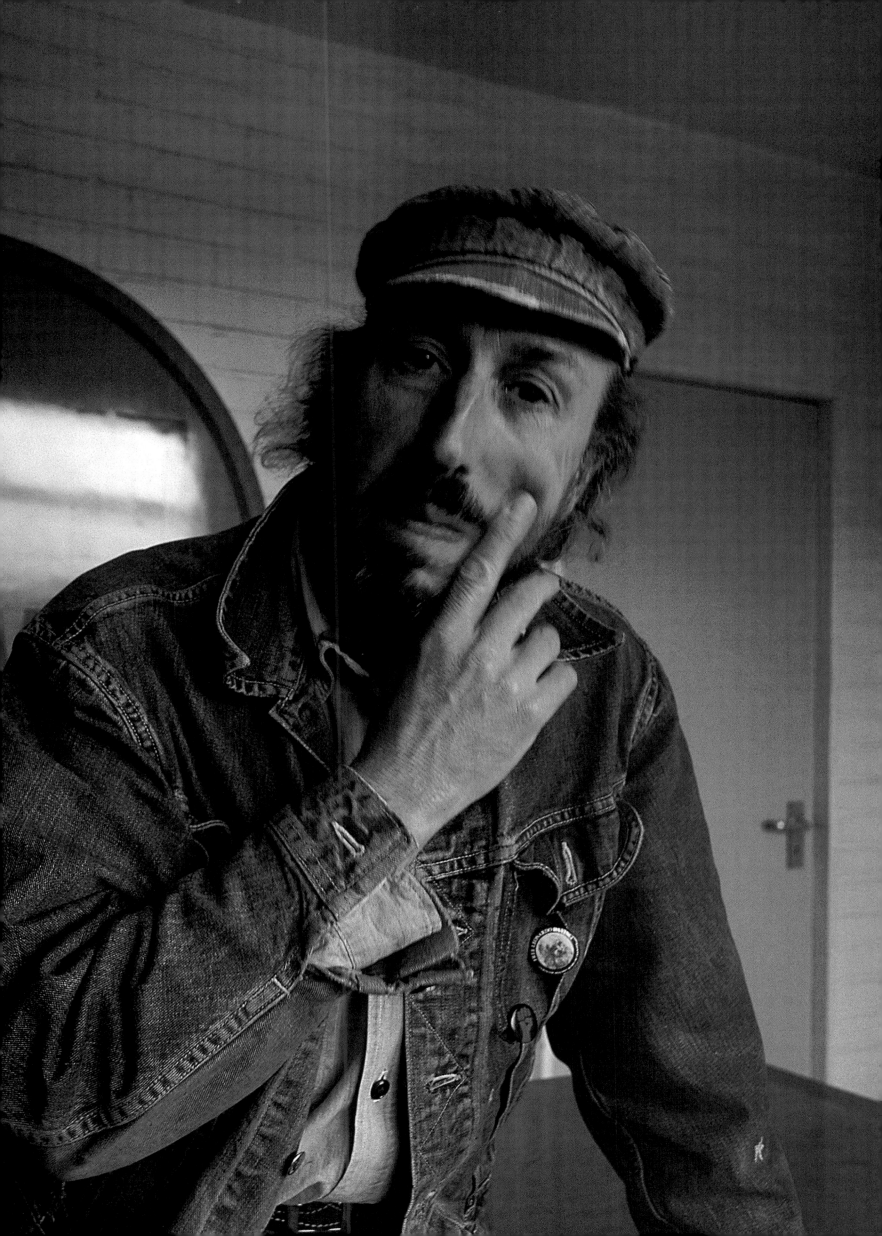

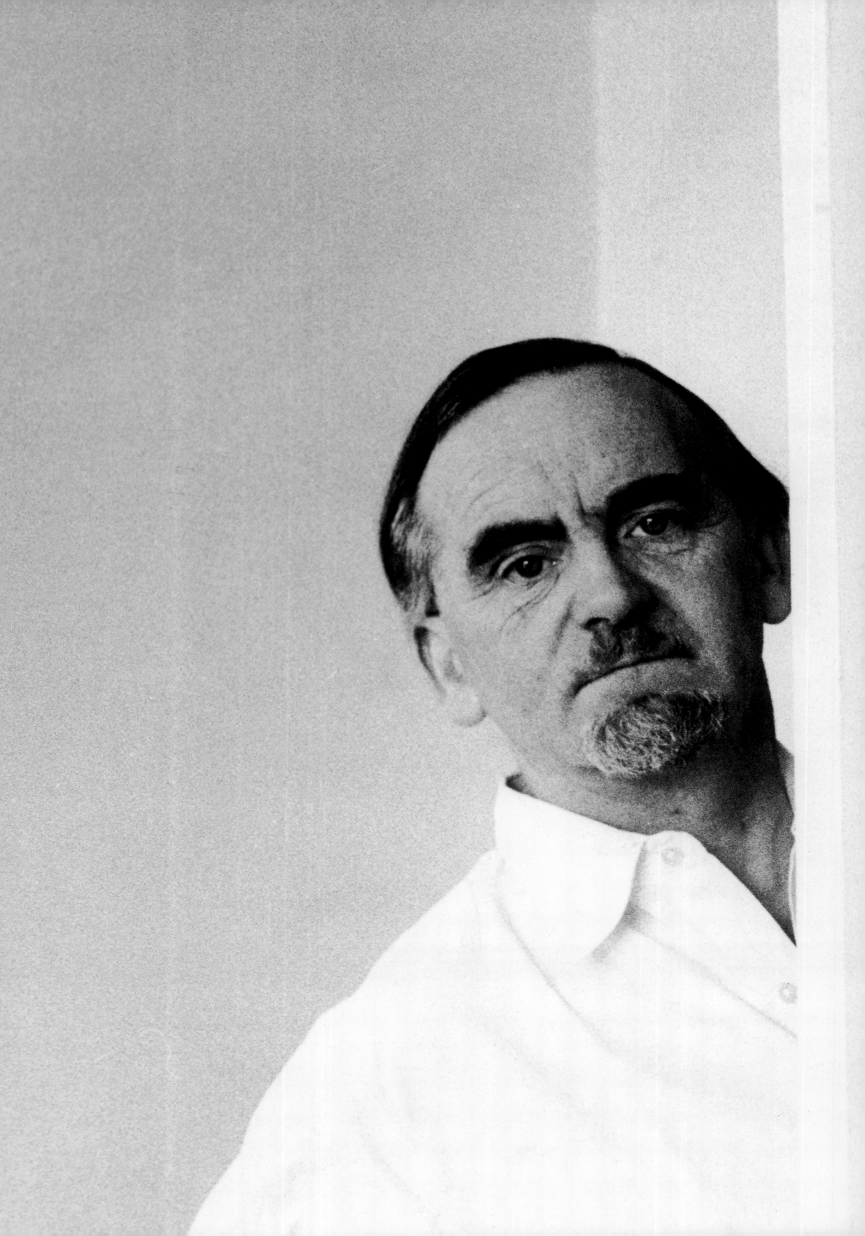

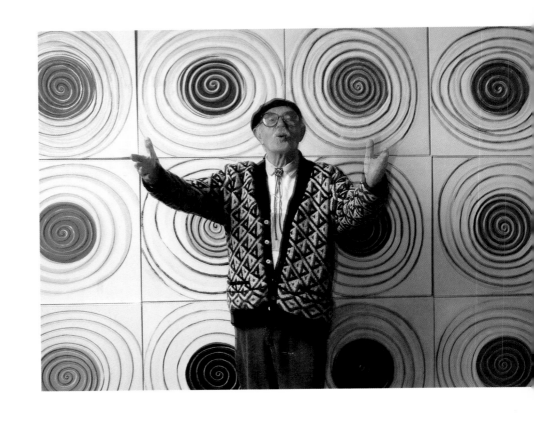

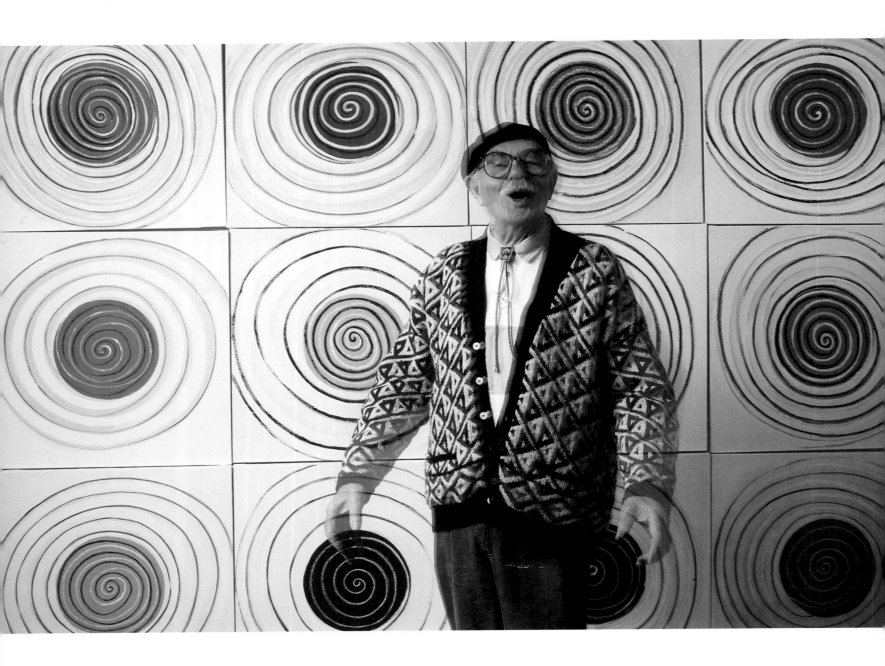

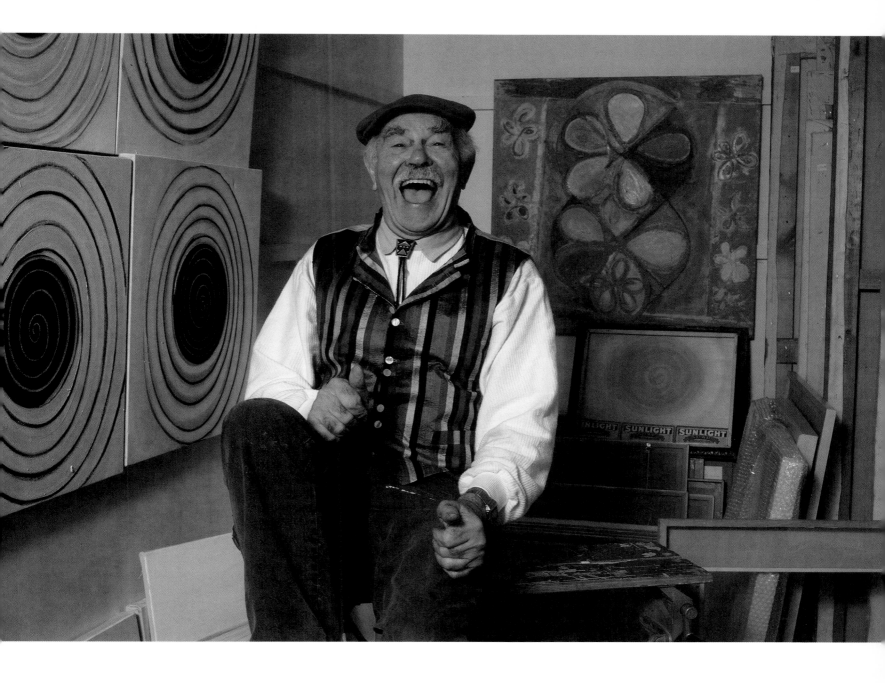

Terry Frost, painter, 1990
Frost is a kaleidoscopic, effervescent personality, in his eighties when I took this shot
and still going strong. He wears bright colours, paints bright colours and is as energetic
as ever. I photographed him in his studio overlooking Newlyn harbour in Cornwall.

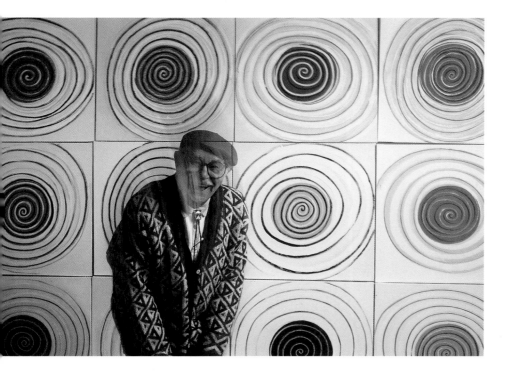

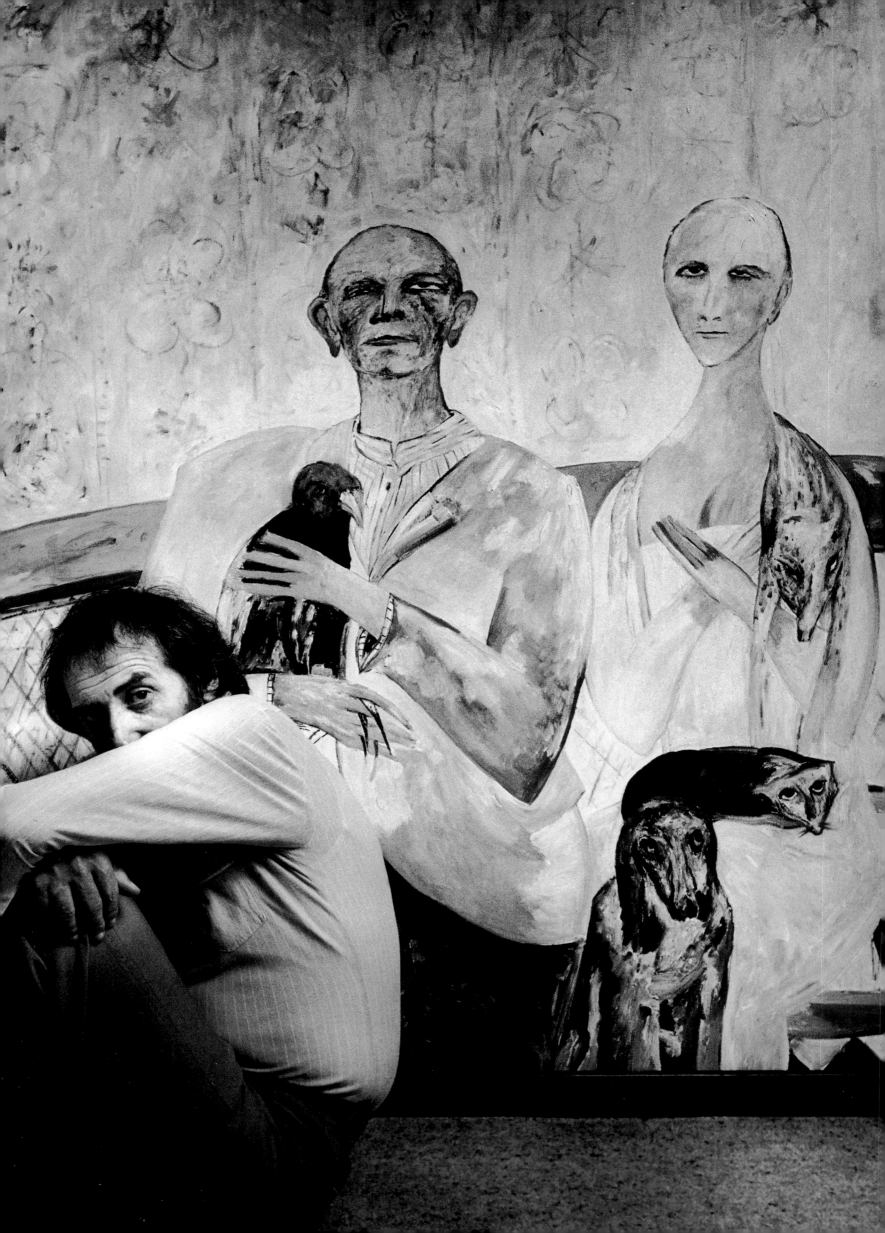

Left: John Bellamy, painter, 1987
In 1965 Bellamy was a student at the Royal College of Art and was occupying the basement of 23 Cromwell Road, which was going to be the darkroom for my new photographic course, so I reluctantly had to chuck him out. However, I bought one of his mammoth paintings for the asking price of £100, to soften the blow of having to move. I took this shot of him in 1987.

Above: Peter Blake, painter, 1962
Peter with his first wife Jann Haworth, and the curious stuffed figure they called 'Grandfather'. Blake was designing pop images with Richard Hamilton back in the 1950s. Later he founded the 'Ruralist' group of artists, living in a converted railway station at Wellow in Somerset – a romantic pastoral lifestyle that the Ruralists later abandoned.

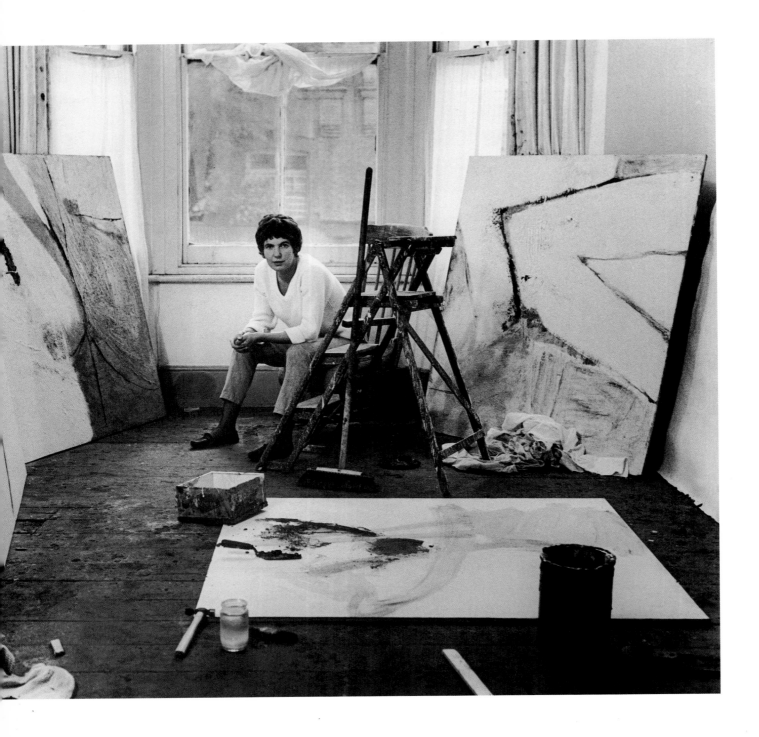

Sandra Blow, painter, 1965
These pictures were taken in Sandra Blow's Chelsea studio for the Swiss magazine *Du*. She had a technique whereby she burnt the surface of her paintings, so we wanted to show this and make it look as dramatic as possible. It was! The flames got out of hand and reached the ceiling, so we had to pour gallons of water over them, before we burnt the house down. One of the astonishing things about Sandra is that she looks as young now as ever – not a day older than when I took these pictures over thirty years ago.

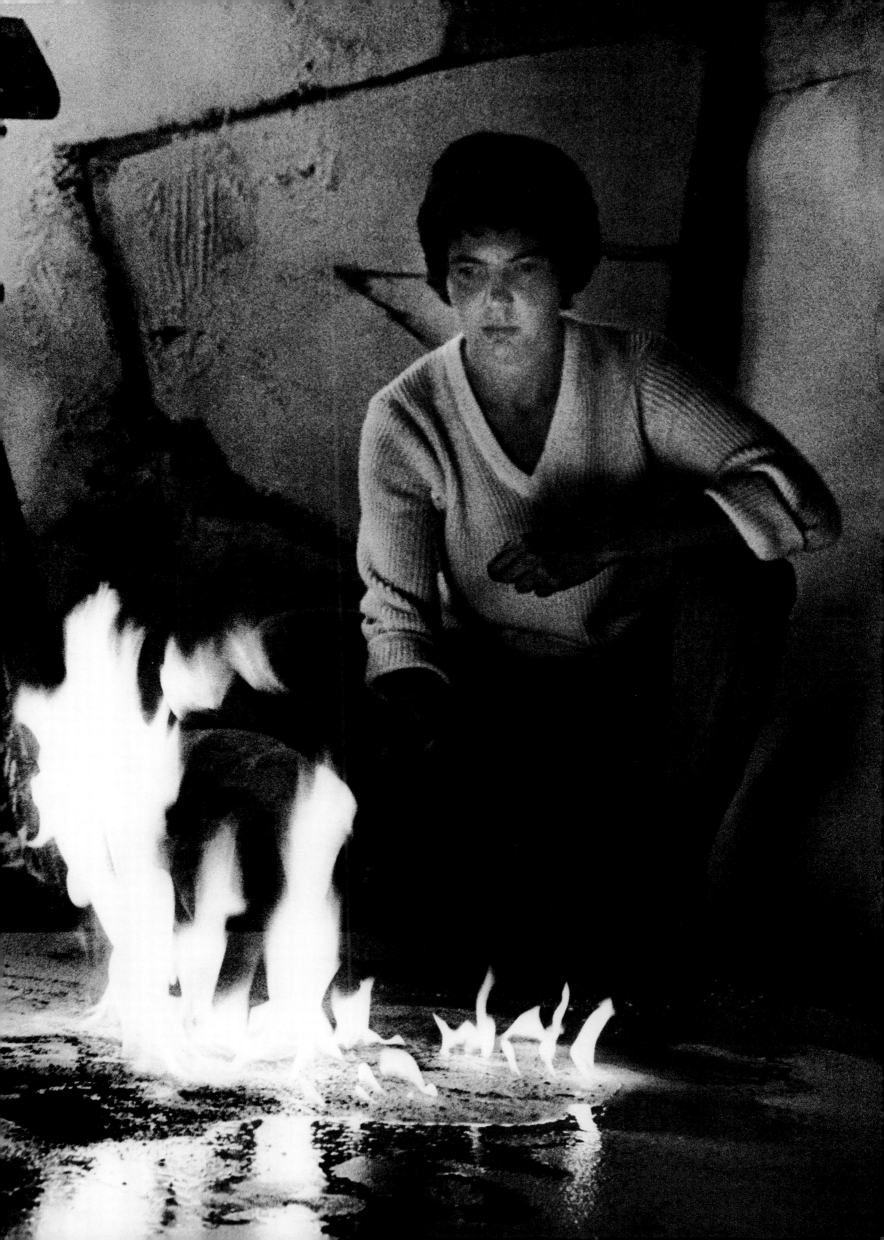

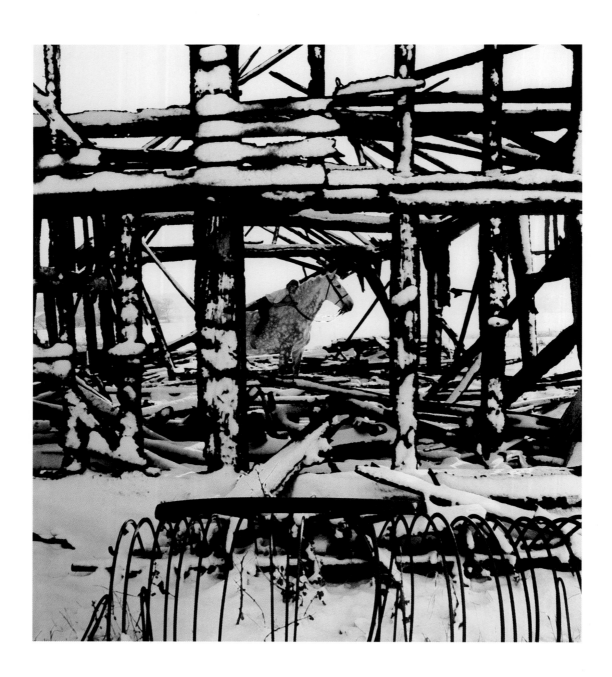

Eileen Agar, painter, 1984
I believe that at one time Eileen Agar modelled for Picasso, and she certainly knew all the artists of his generation. She was a member of the English Surrealist group and exhibited at the International Surrealist Exhibition in 1936, along with Salvador Dali. She was eighty-five when I took this Surrealism-inspired picture in her studio (right). I then matched this shot with one of my favourite photographs, of a girl rider on a piebald horse in the snow (above).

David Hockney, painter, 1972
These pictures of Hockney were taken on an
assignment for *Flair* magazine, in his studio in
Bayswater. He was extremely cooperative and friendly,
and was certainly striking in appearance at the time –
the big library spectacles, the striped shirt and the
brilliant corn-yellow hair. I remember he told me that
he dyed it with Lady Clairol bleach. He later used the
picture of the taps in his film *A Bigger Splash*.

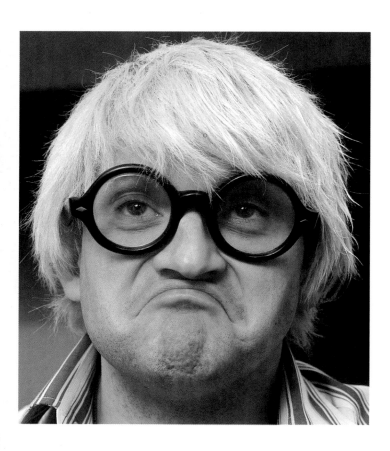

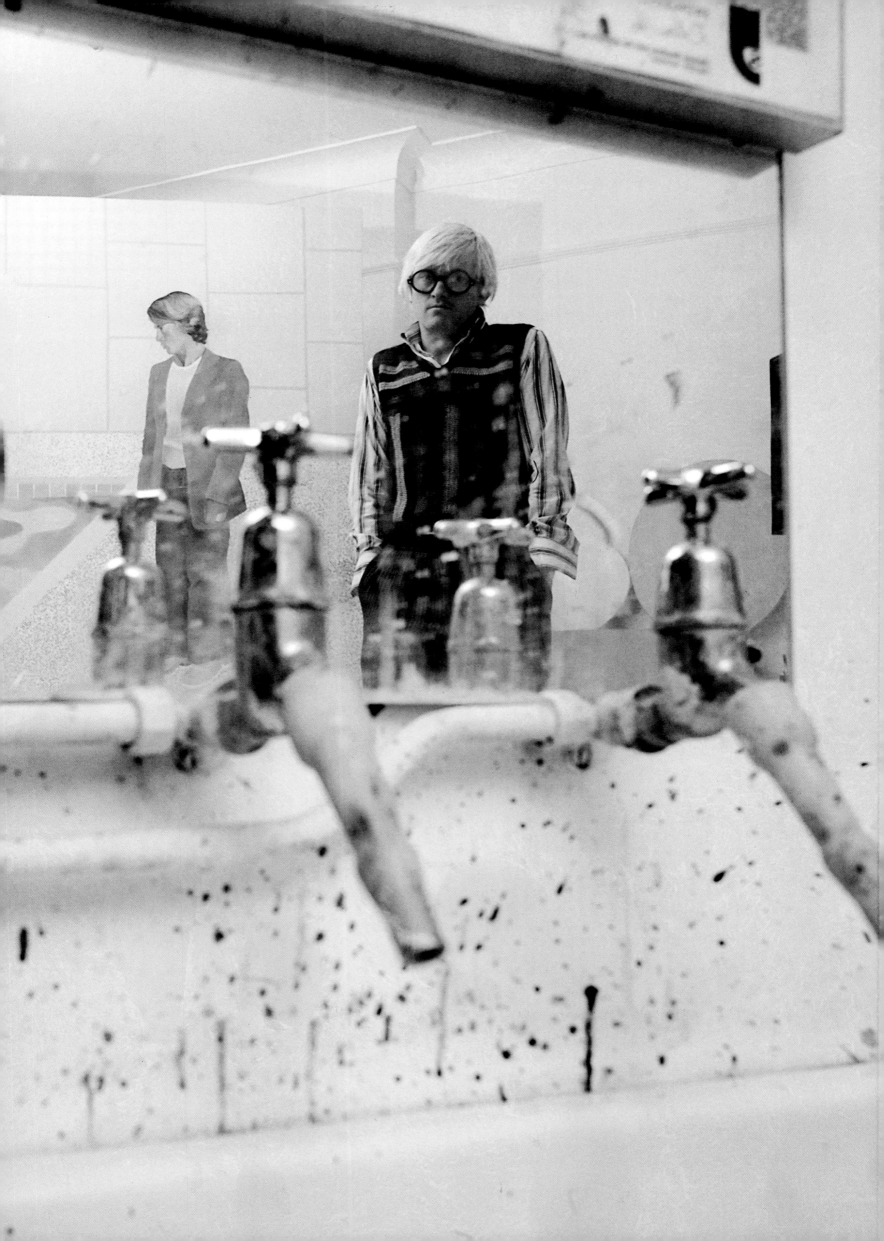

Francis Bacon, painter, 1969
Francis was moody, and to really get on with him you had to enjoy his lifestyle, spending afternoons drinking and exchanging abuse with Muriel Belcher, owner of the Colony Room club in Soho. He loved drinking champagne and was incredibly generous. I often used to see him waiting in the queue for the bus to South Kensington, where he lived, and he was a frequent visitor to the Senior Common Room at the Royal College of Art. When I photographed him he'd just accidentally burnt down his studio, so Robin Darwin, rector of the RCA, let him have a studio in the college, which is where I took these shots.

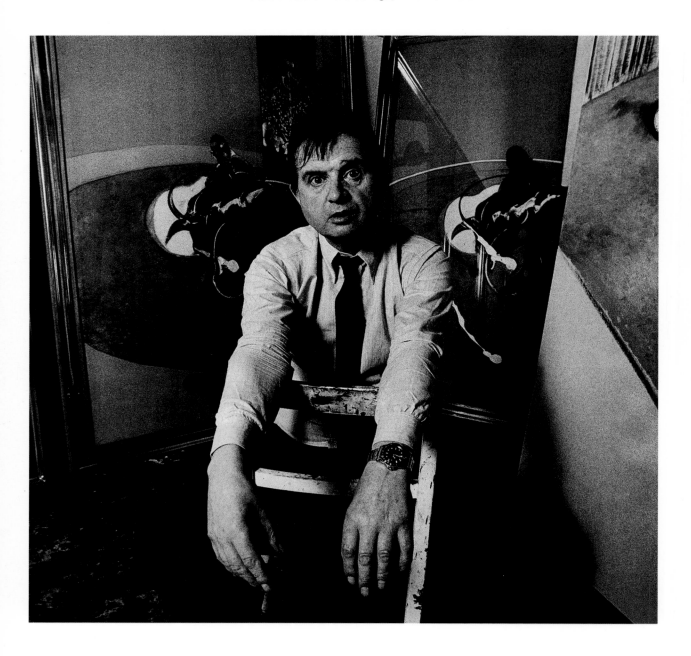

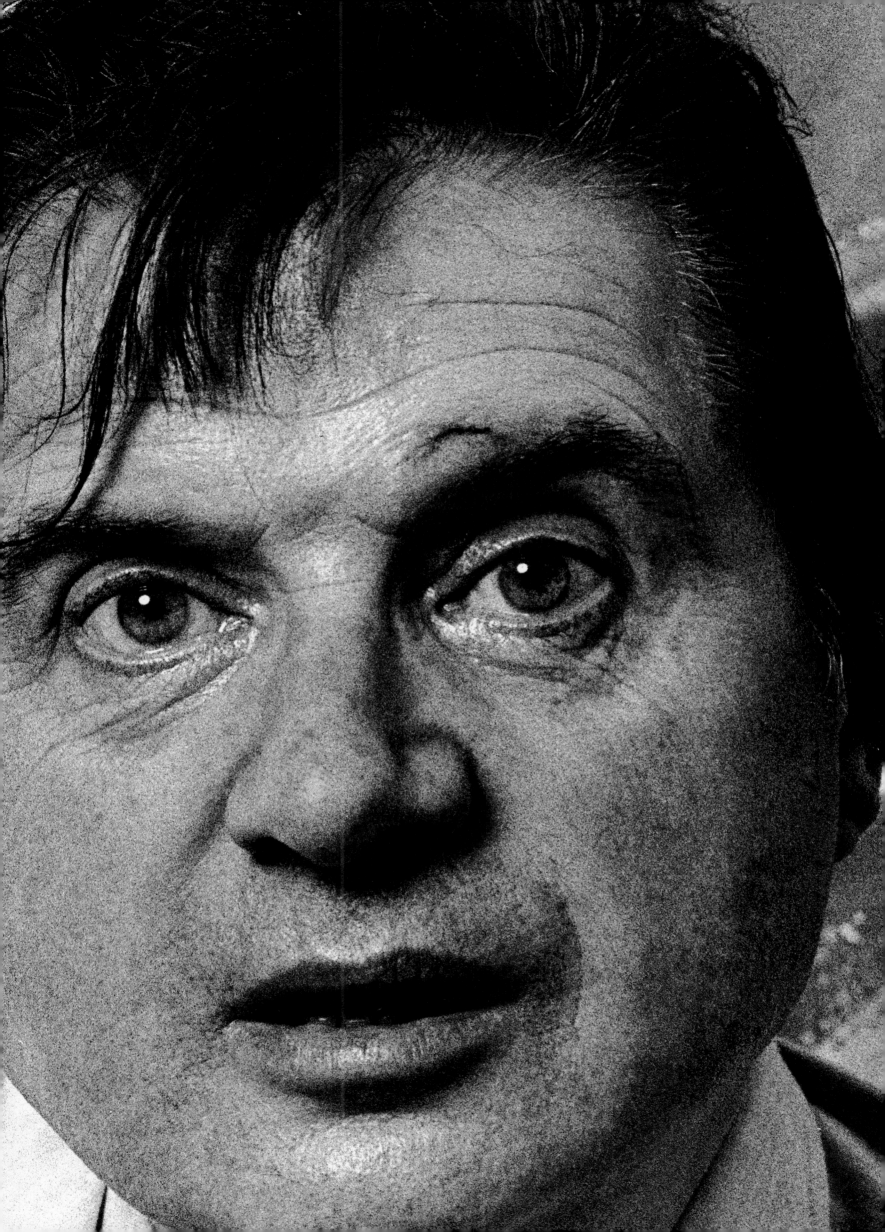

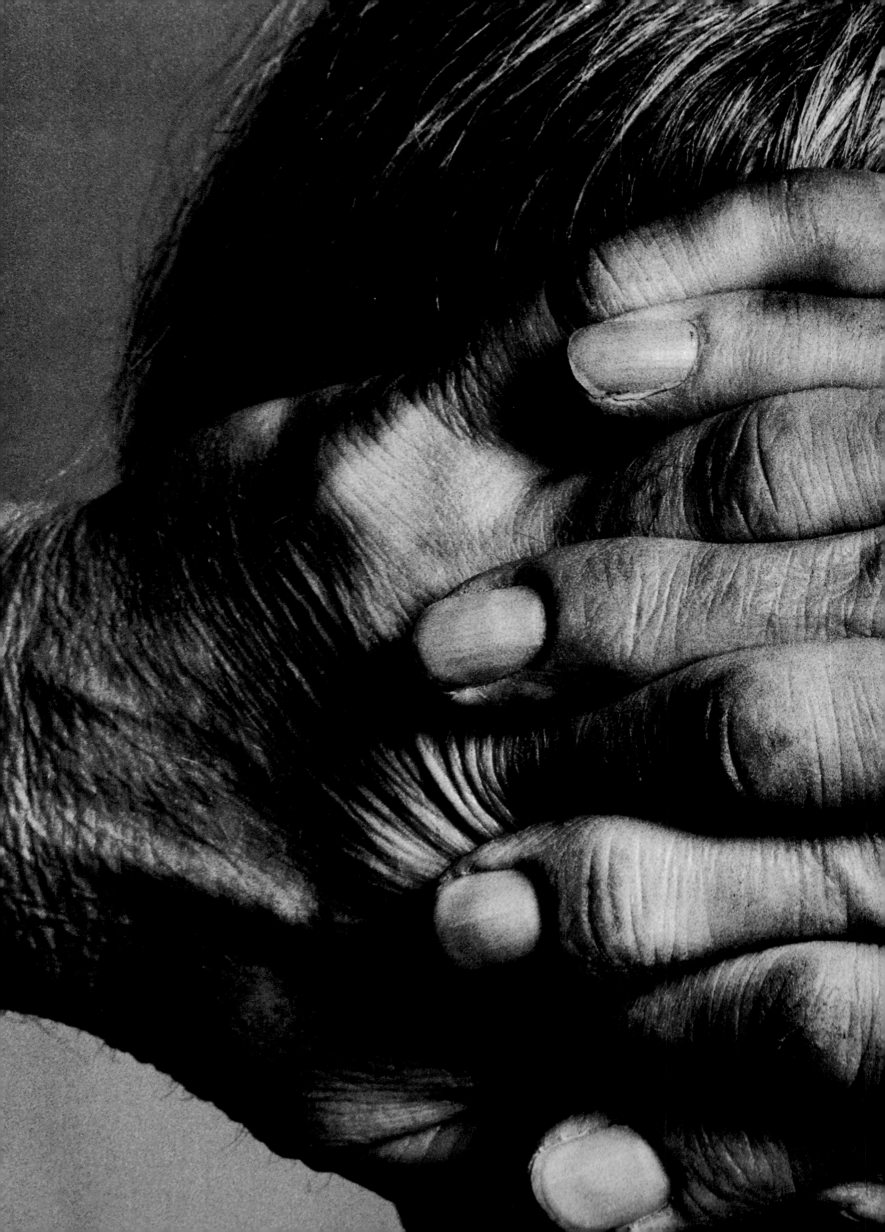

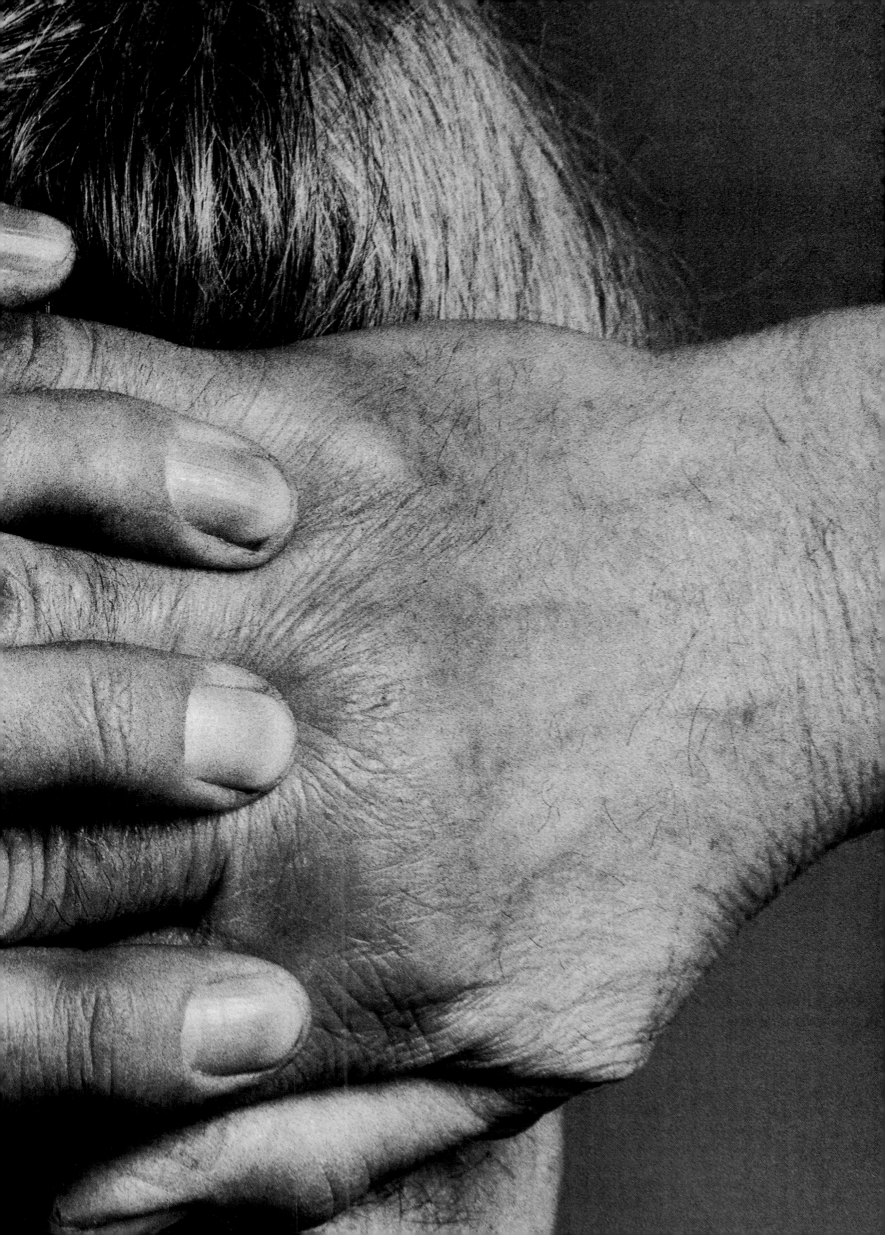

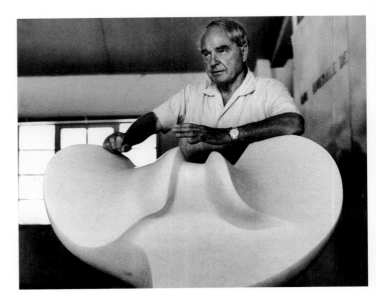

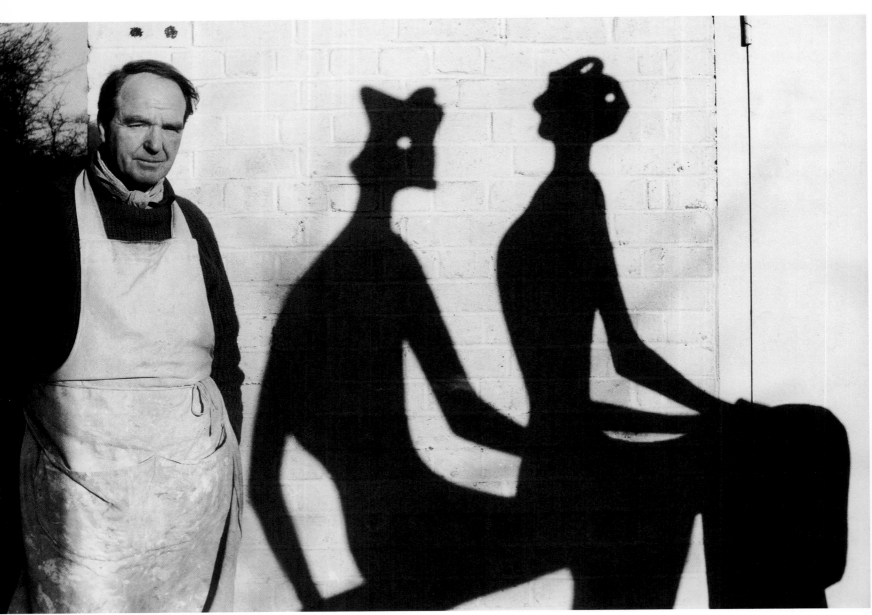

Previous pages, above and right: Henry Moore, sculptor, 1953–60
I knew Henry Moore for nearly forty years and saw him most weekends. I met him through a fellow student and have produced four books about Henry and his work. He was a wonderful man, with sparkling blue eyes and still very much a Yorkshireman, although he lived in Hertfordshire. When he sold a large piece of sculpture to someone, he'd also make them a gift of one of his drawings. However, after we'd done a book together, he gave them a copy of the book instead. It saved him, he said, quite a lot of money. The shot on the previous pages shows the hands that created so many works of art.

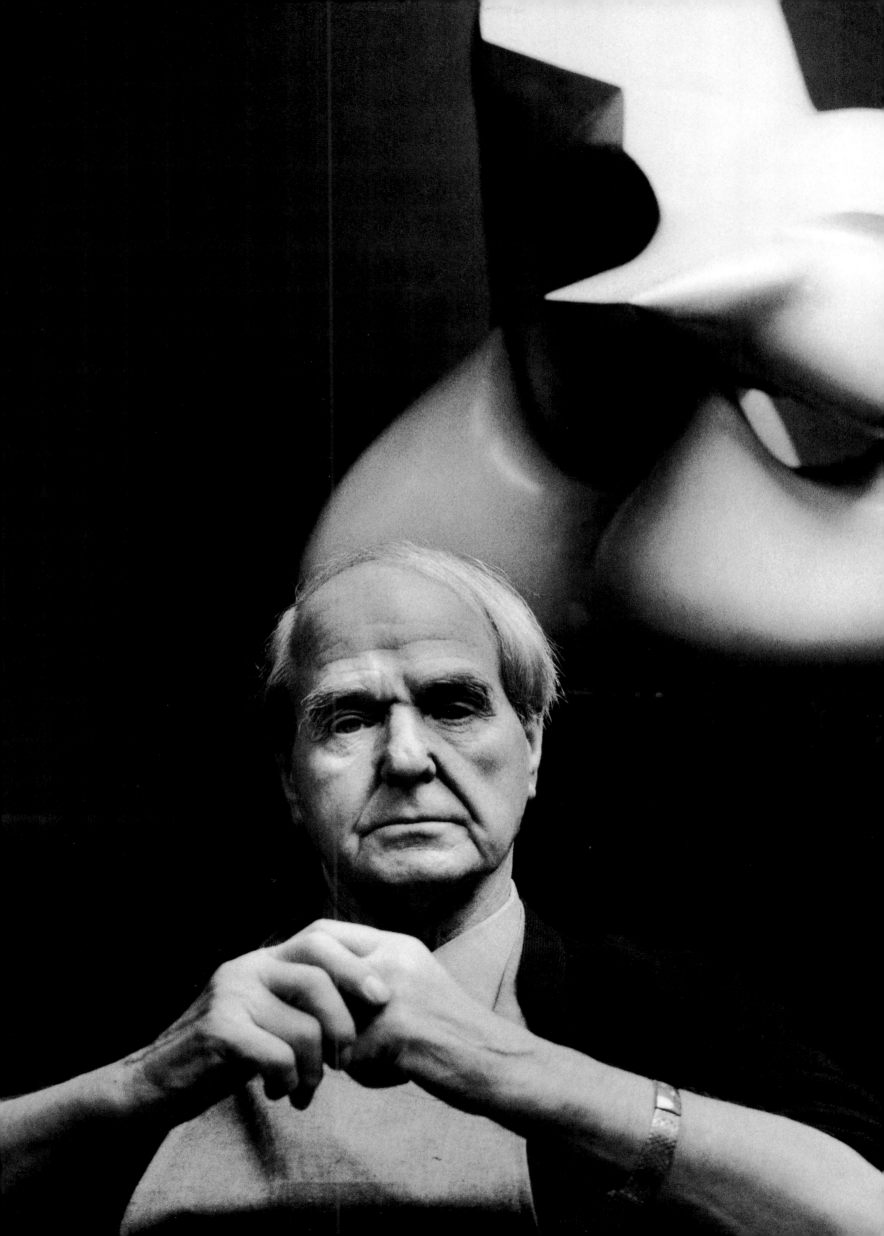

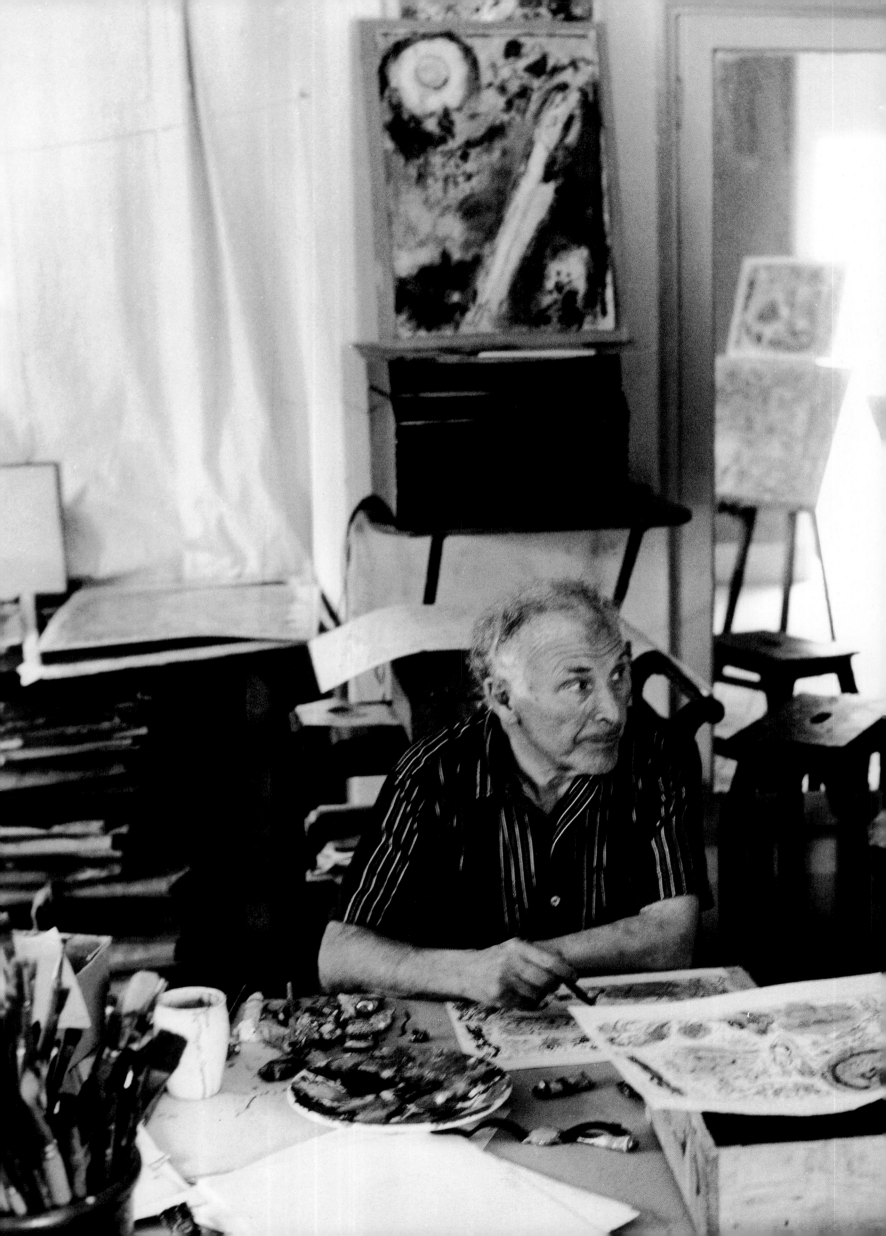

Marc Chagall, painter, 1958
Most people are happy to be photographed and are generally very cooperative. None more so than Chagall, one of the last great painters of the Ecole de Paris, whom I photographed at Saint Paul-de-Vence, in the south of France. Although he spoke not a word of English (he was, of course, Russian-born) and my dozen words of French were soon exhausted, he was so easy-going and friendly that this was never a problem. He made the whole session tremendous fun – he enjoyed being the actor, just as Picasso did – and knew exactly what I wanted to achieve.

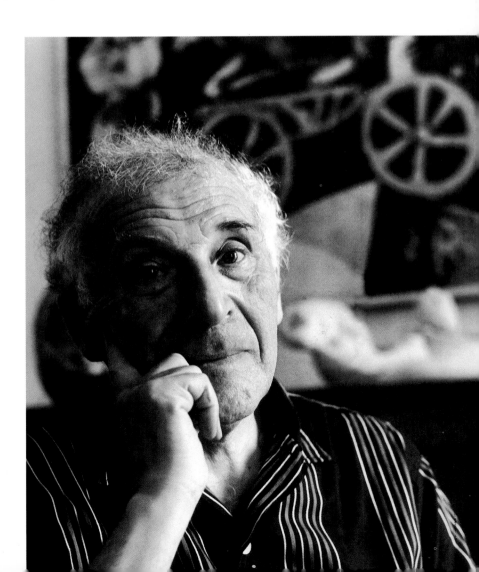

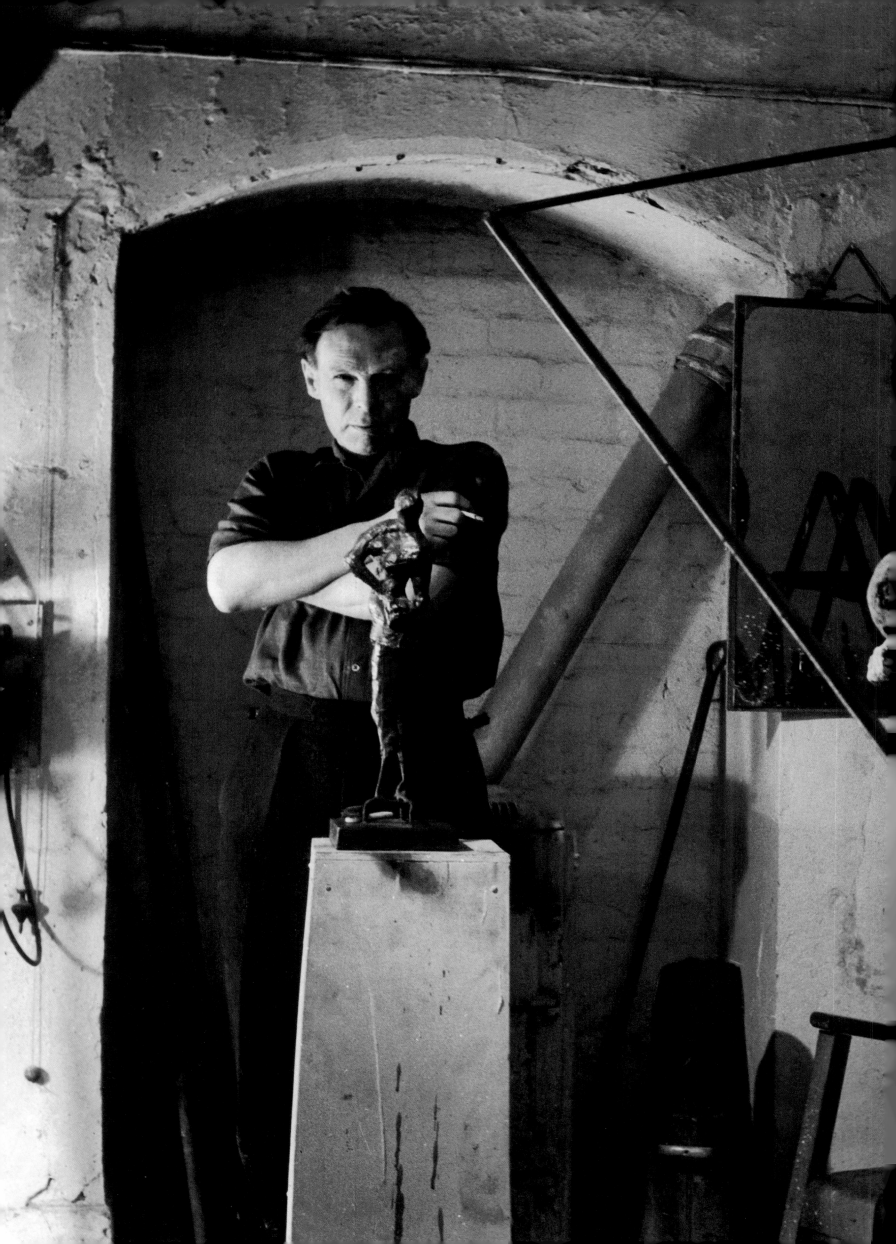

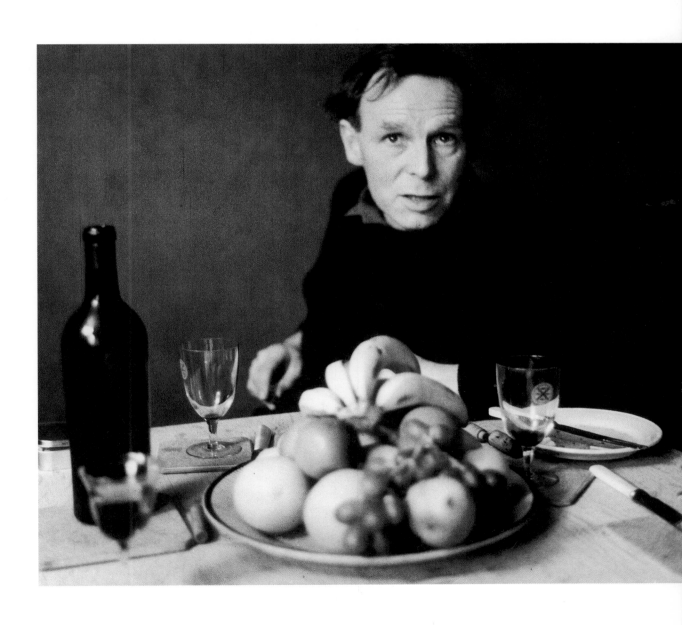

Reg Butler, sculptor, 1960
Butler was most famous for his projected sculpture, *The Unknown Political Prisoner*, even though it was never made. He was a fascinating man, with a great passion for westerns and fast cars. He drove a Jensen to the Slade School of Art (where he was Professor of Sculpture) and back every day, in record time. The picture of him with the fruit on the table was too soft, he thought, making him look like a poet. The image on the left, taken in his Berkhamstead studio, was how he liked to be seen – a powerful, dominating figure in the shadows.

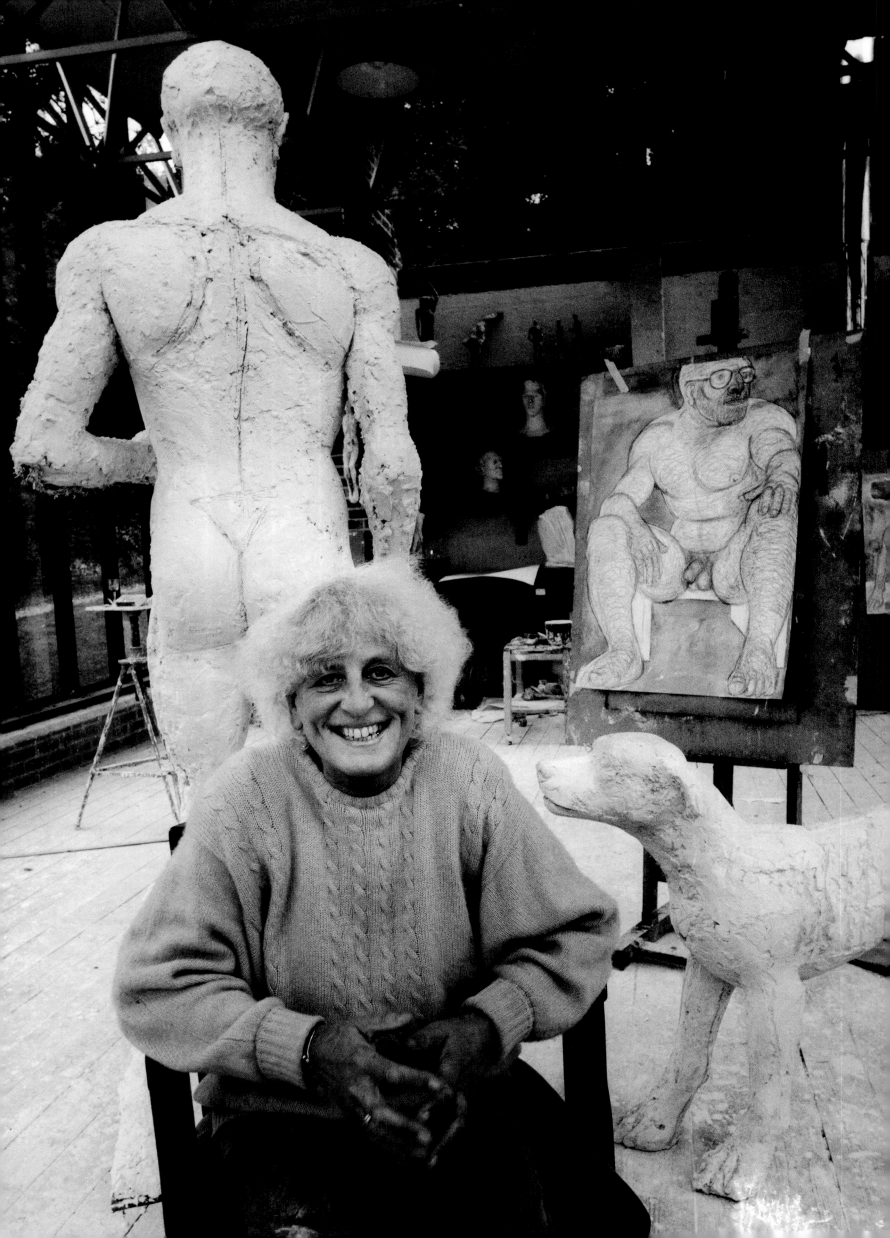

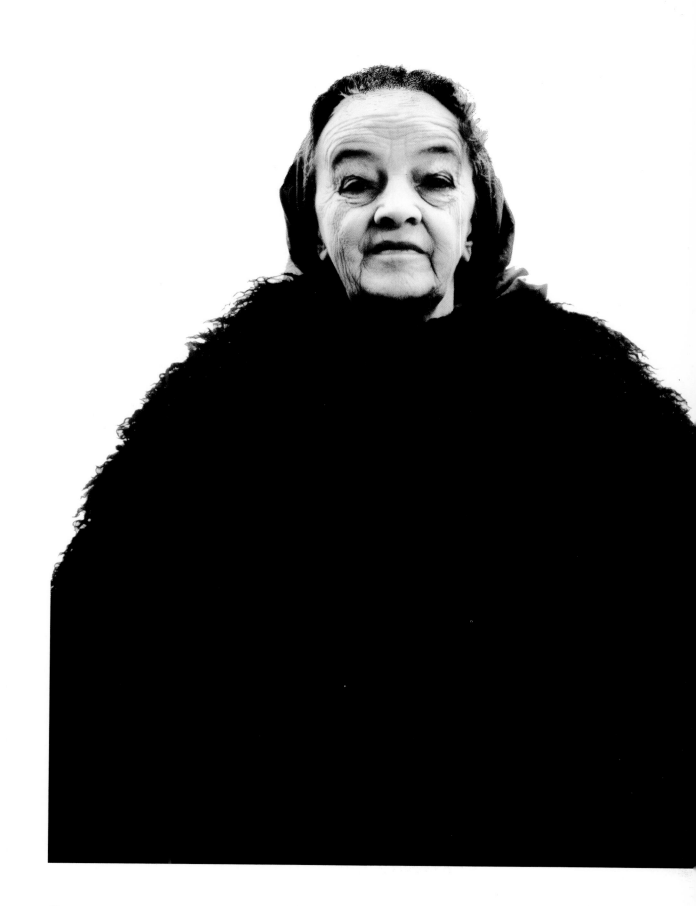

Above: Dame Barbara Hepworth, sculptor, 1970
Dame Barbara, here wearing her familiar fur coat, asked me if I would do a book on her work, like the one I had done on Henry Moore. She was lively and full of enthusiasm, yet I had the feeling she was lonely. We talked a lot about Henry, because they were old friends. Henry had told me he'd been 'a bit sweet on her', as he put it, and I think that perhaps they were sweet on each other for a while.

Left: Dame Elisabeth Frink, sculptor, 1985
Dame Elisabeth was keen that I photograph her work. We'd talked about it for some time, but then she became ill and died – prematurely; she had so many ideas that she wished to fulfil. I found it terribly sad. She was easy-going, friendly and a great fan of Henry Moore, who had taught her drawing at the Chelsea School of Art.

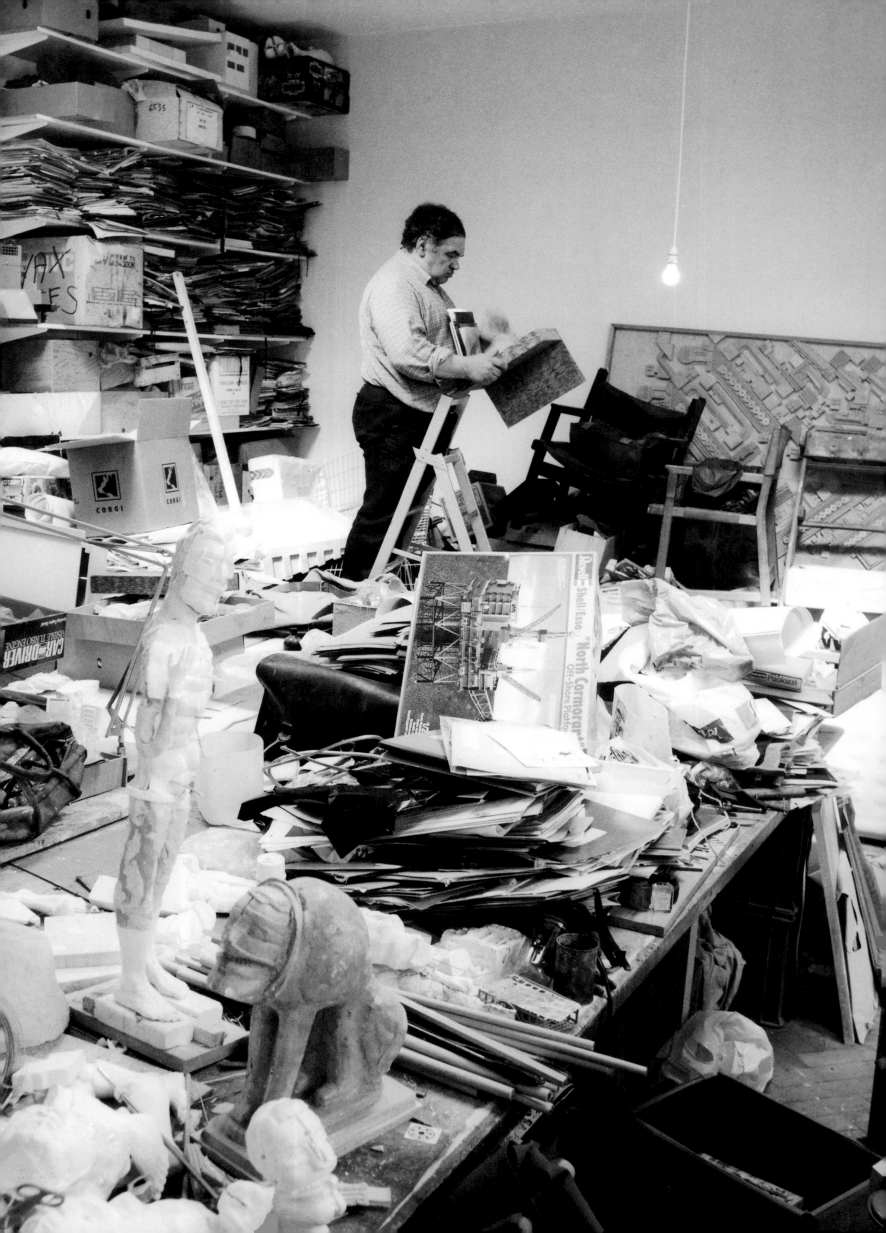

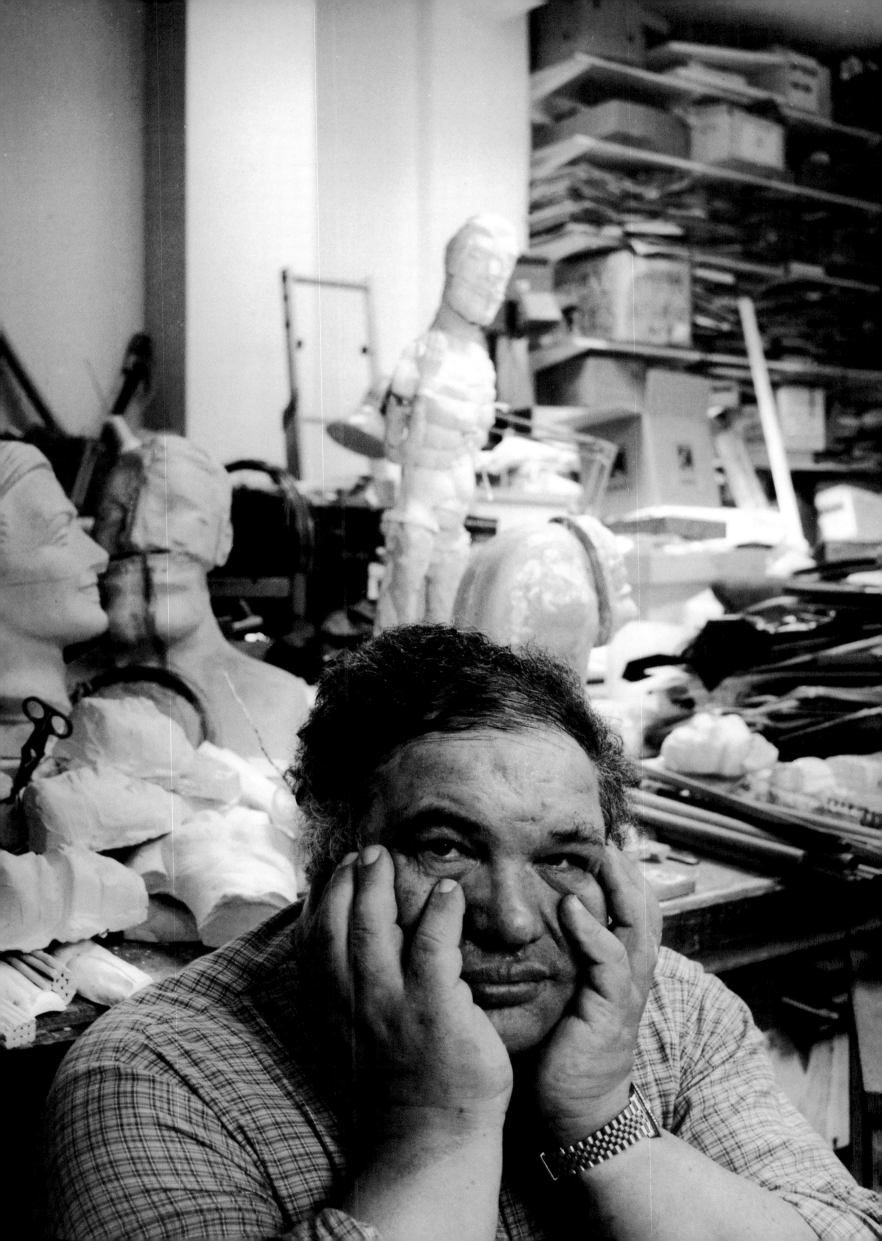

**Right: Lord Goodman,
solicitor, 1984**
Lord Goodman represented art for
the establishment, and exercised his
patronage widely through the arts.

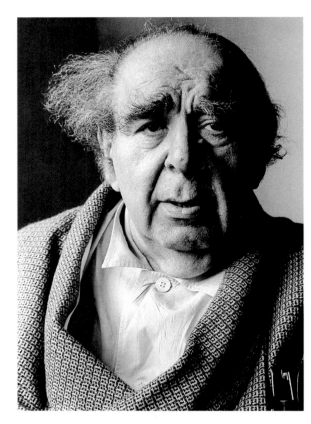

**Below: Sir Julian Huxley,
scientist, 1968**
The Huxleys lived in a small house
in Pond Street, Hampstead. Sir Julian
had a cold at the time I took this
photograph and Lady Huxley kept
coming in and fussing over him while
I was taking my pictures. Finally, and
hoping to hasten my departure, she
said, 'Mr Hedgecoe must have taken
hundreds of pictures by now.' To
which Sir Julian, with a scientist's
pedantry, replied, 'Nonsense, he
couldn't have. Each roll of film has
twelve exposures, and he has taken
about five rolls. Five twelves are sixty,
by my reckoning.' Before I left he
paid me a great compliment: he had
a copy of my book on Henry Moore,
which Henry (a friend of Huxley's) had
signed, and he asked, 'Would you
do me a huge favour and autograph
it, too?'

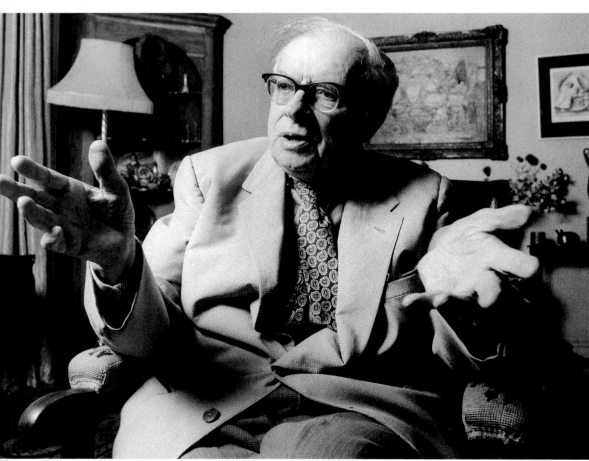

Previous pages: Sir Eduardo Paolozzi, sculptor, 1989
Eduardo could qualify as the first of the Pop Art pioneers – he has been collecting comic and
magazine material for collages since 1947. He couldn't pass a skip without looking for items that
he could salvage and which might give him inspiration – hence the fantastic clutter of his studio
in Chelsea. An inveterate worker, he is extremely generous to both students and friends.

Right: Sir Roland Penrose, painter, 1967
Sir Roland, who died in 1984, was one of the original members of the International Surrealists. He
was an art collector, especially of modern art and of examples of the Cubist movement. His house
was crammed with works of art – Picasso, Braque, de Chirico, and so on. He was cooking his lunch
at the time of my photograph, boiling some cabbage, and the steam was flowing over an early
Cubist Picasso hanging above the stove. He got me the job of photographing all of Picasso's
sculptures – a fascinating task to undertake.

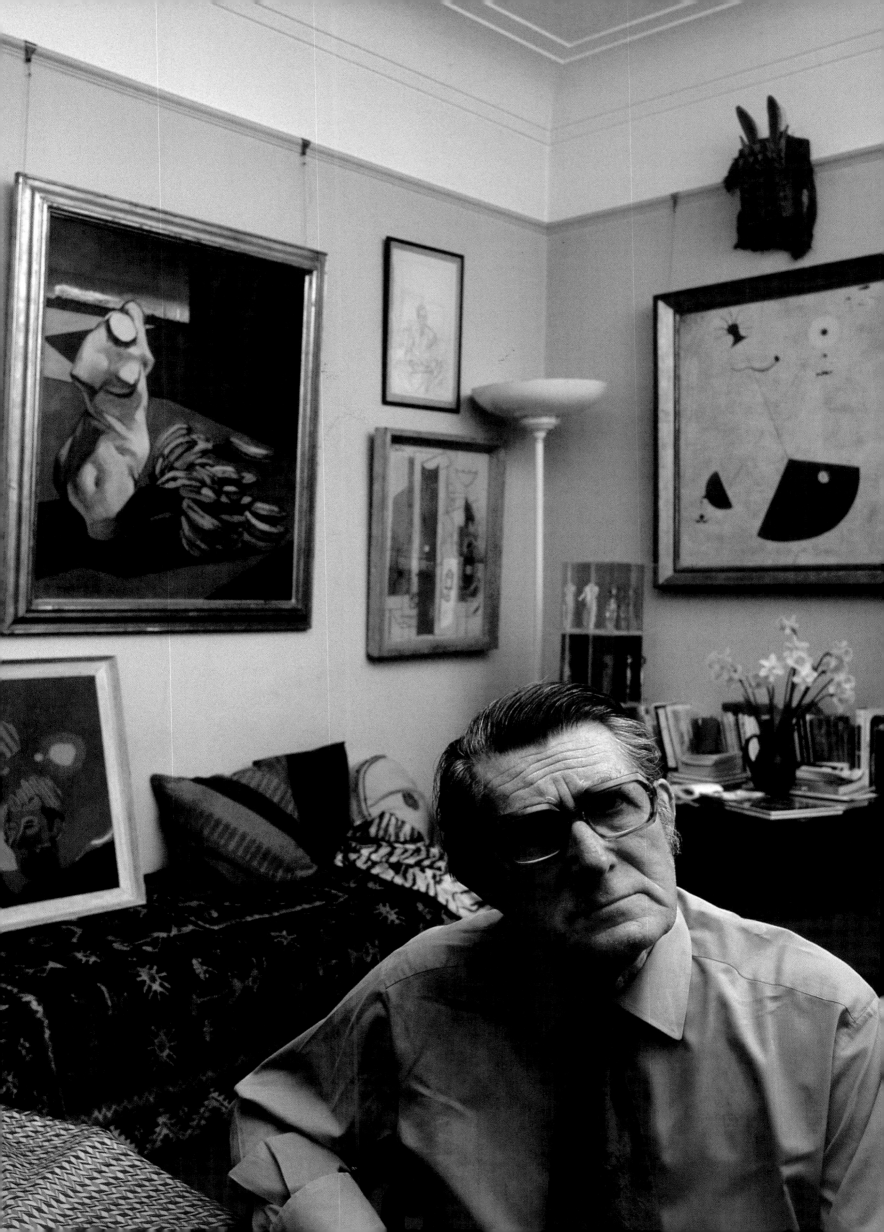

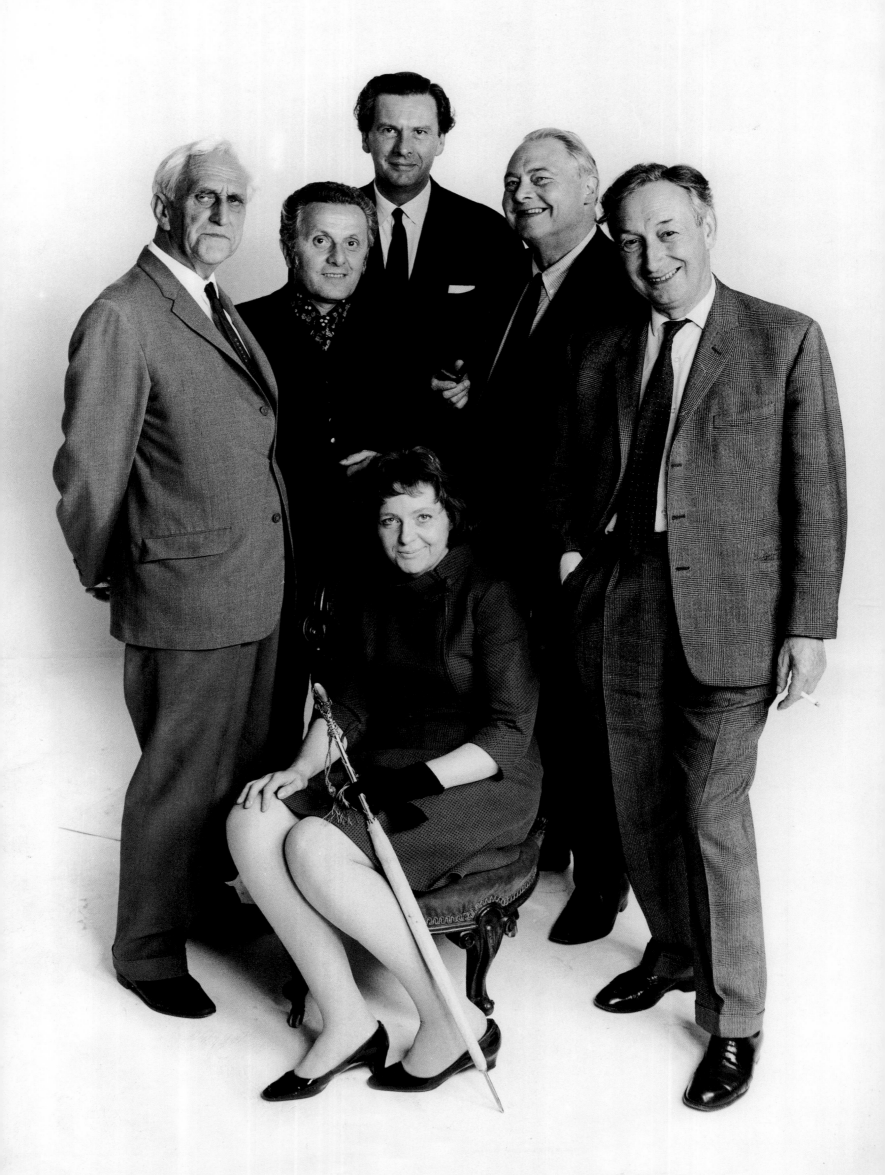

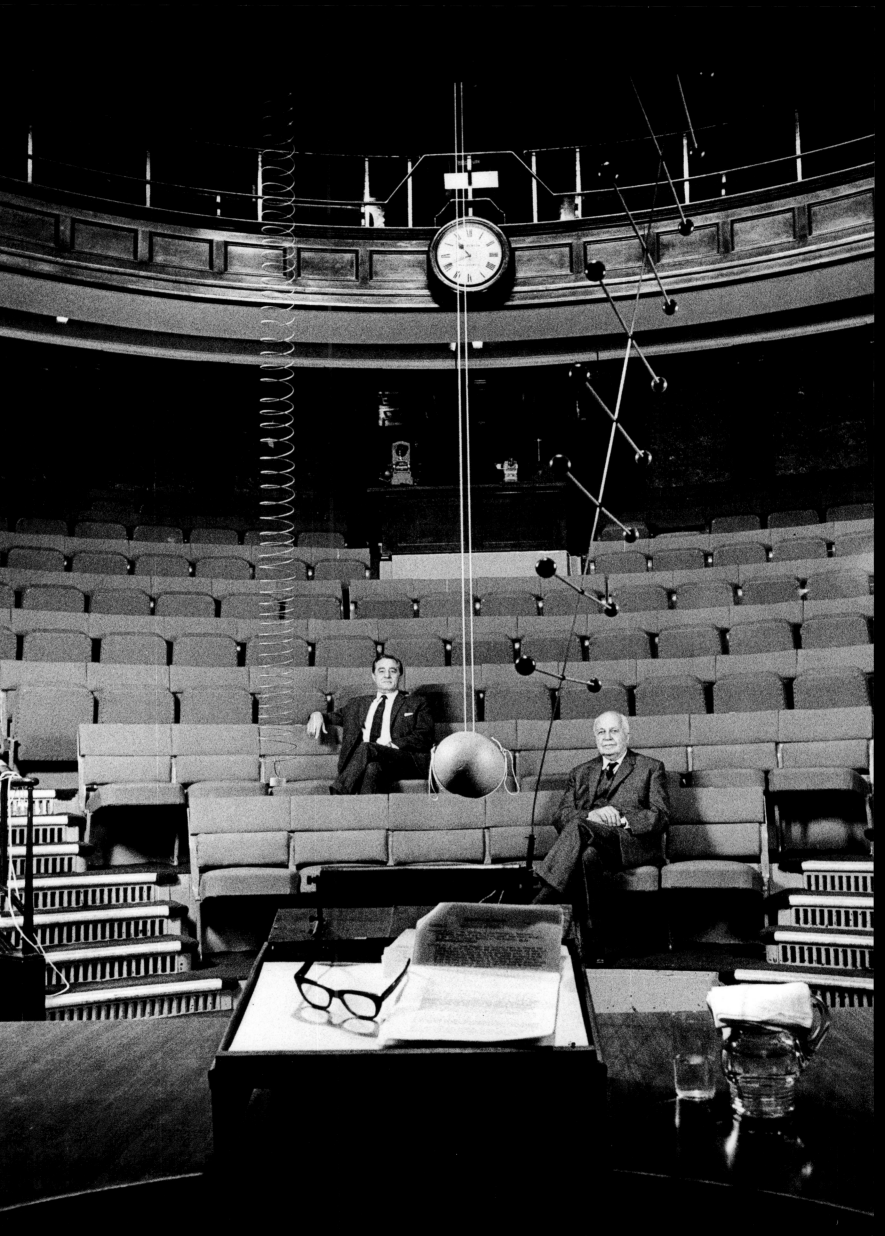

Previous pages, left: The Humanist Society, 1966
This picture of the Humanist Society was done for the *Observer* magazine and shot in my studio. Seated: Brigid Brophy. Standing, left to right: Kingsley Martin; Leo Abse, MP; Ludovic Kennedy; Lord Francis Williams; Professor A.J. Ayer, President.

Previous pages, right: Sir George Porter and Sir Lawrence Bragg, scientists, 1964
I did a series of photographs for *Queen* magazine of Britain's Nobel Prize-winners. Several lived in Cambridge, including Francis Crick, Max Perutz and Lord Adrian. In Oxford I photographed Dorothy Hodgkin and Lord Florey. The picture of Sir George Porter and Sir Lawrence Bragg was taken at the Royal Institution of London.

Left: Professor Colin Blakemore, scientist, 1977
A neurologist and physiologist of great repute, Blakemore was poached from Cambridge to work in Oxford, taking with him some thirty assistants. He was a charming and brilliant man, with a great knowledge of art and music. I posed him in this way, with the light and the mirror, because it relates to his main study, the mechanics of the brain.

Below: Stephen Hawking, scientist, 1978
This family group was taken over twenty years ago, long before Hawking's great publishing success with *A Brief History of Time*. I took it as one of several for the *Radio Times*, for a programme on black holes. We were neighbours and my young son used occasionally to go and play with his children. Hawking could still talk – just about – and I asked him how his disability had affected his life. He said that he considered it in some respects a gift from God, enabling him to concentrate totally on his subject, and that it had proved an advantage.

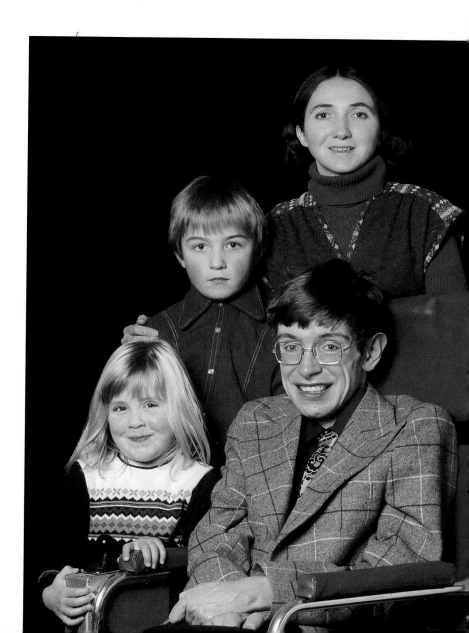

Above: Professor George Steiner, philosopher and historian, 1977
Being argumentative, Steiner seems to have upset a lot of people, and at first they wouldn't give him a chair at Cambridge. Odd, when you consider how many argumentative academics there must be in Cambridge! Perhaps he was one too many; or perhaps they couldn't bear the fact that he spoke innumerable languages.

Right: Sir A.J. Ayer, philosopher, 1962
Ayer was Wykeham Professor of Logic at Oxford and a most distinguished and influential philosopher, well known for his first book, *Language, Truth and Logic*. I took this picture for a *Sunday Times* profile.

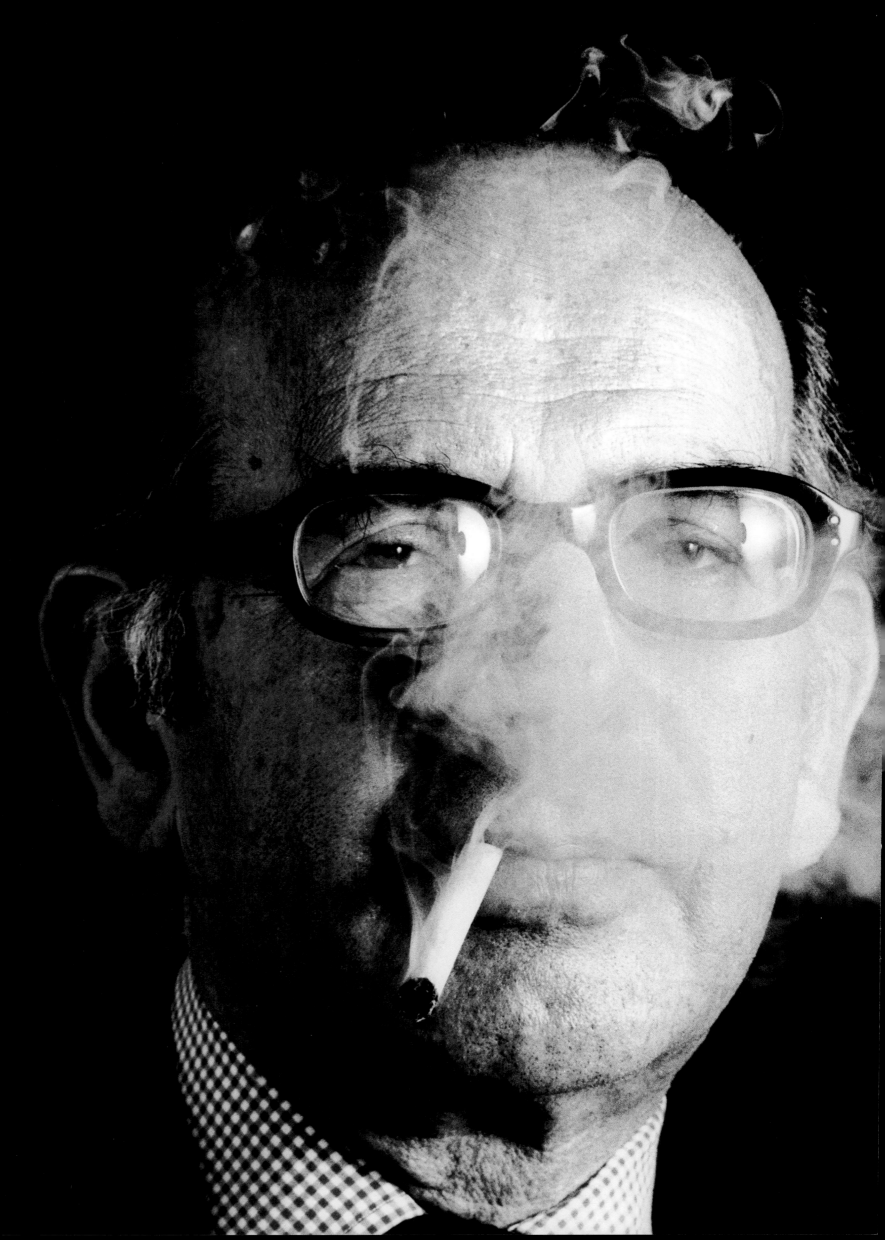

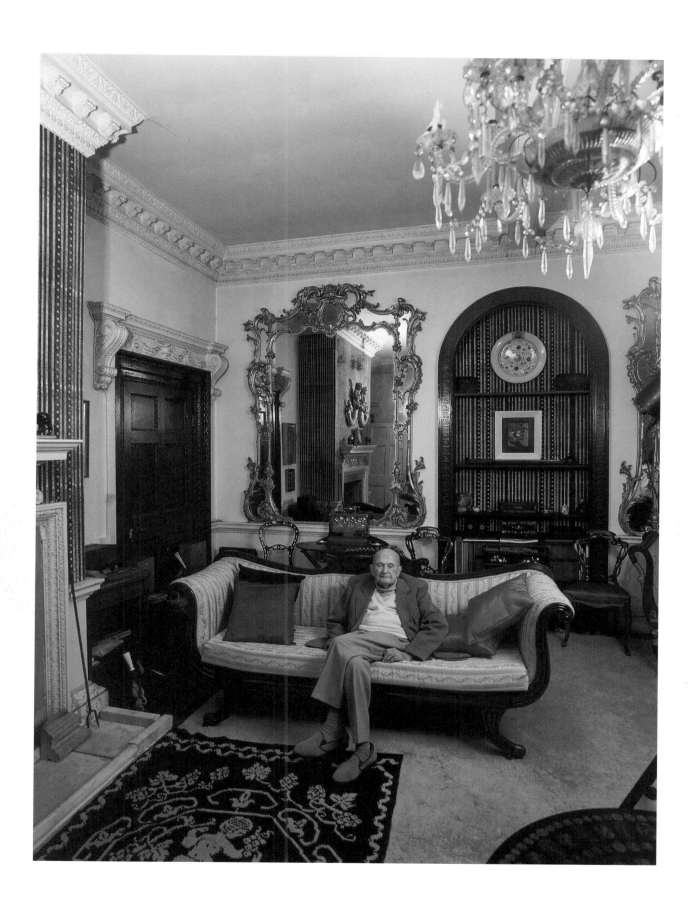

Left: Sir Misha Black, 1975

Above: Milner Gray, 1966; industrial artists and designers
Black and Gray founded the Design Research Unit in 1945, designing everything
from locomotives to buildings, posters, books, trademarks and corporate logos.
Gray was ninety-seven years of age when I took his picture.

Sir Barnes Wallis, aeronautical engineer, 1967
When I asked Sir Barnes what part of the country he came from, he replied with a smile, 'Derbyshire. Derbyshire born and Derbyshire bred, strong in the arm and thick in the head.' In fact, Barnes Wallis – in company with the engineer and later novelist Nevile Shute – had designed the airship R100. He was anti-establishment and had fought authority all his working life. When I photographed him he'd just been pushed out of his British Aerospace office to a remote part of Brooklands aerodrome, mainly because he was pestering everyone to accept his design for a swing-wing passenger aircraft. His most famous achievement was the bouncing bomb that cracked the Mohne and Eder dams on the Ruhr in the Dambusters' raid in 1943. After I'd finished taking the pictures he took me to a small projection room and showed me a film of the bomb trials. He bounced up and down on his seat like a small boy and said excitedly, 'Look at that! It's the finest thing I've ever done.'

Following pages: Francis Bacon, engineer, 1967
Bacon invented the fuel cell that made space travel possible. I took this shot in my Fetter Lane studio. I remember him being a quiet man and very modest.

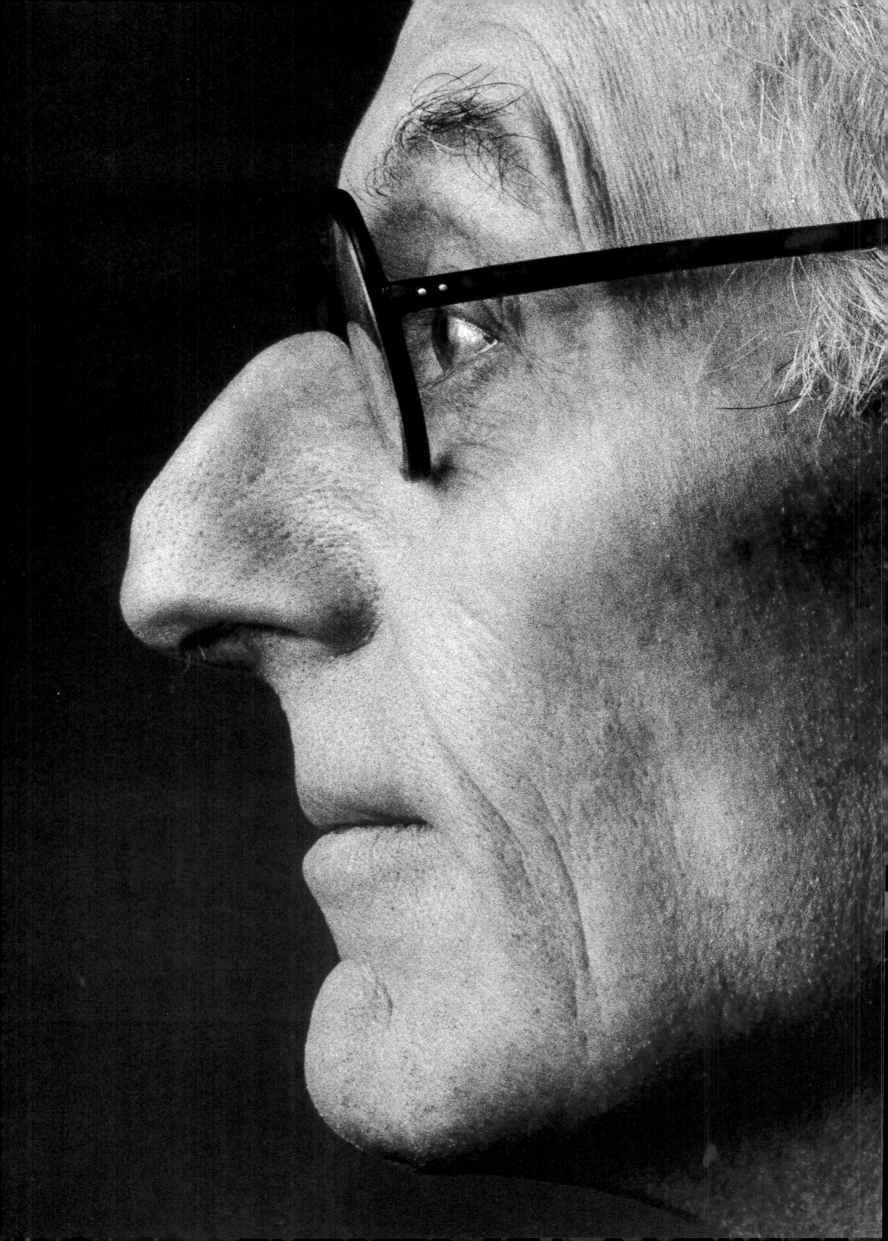

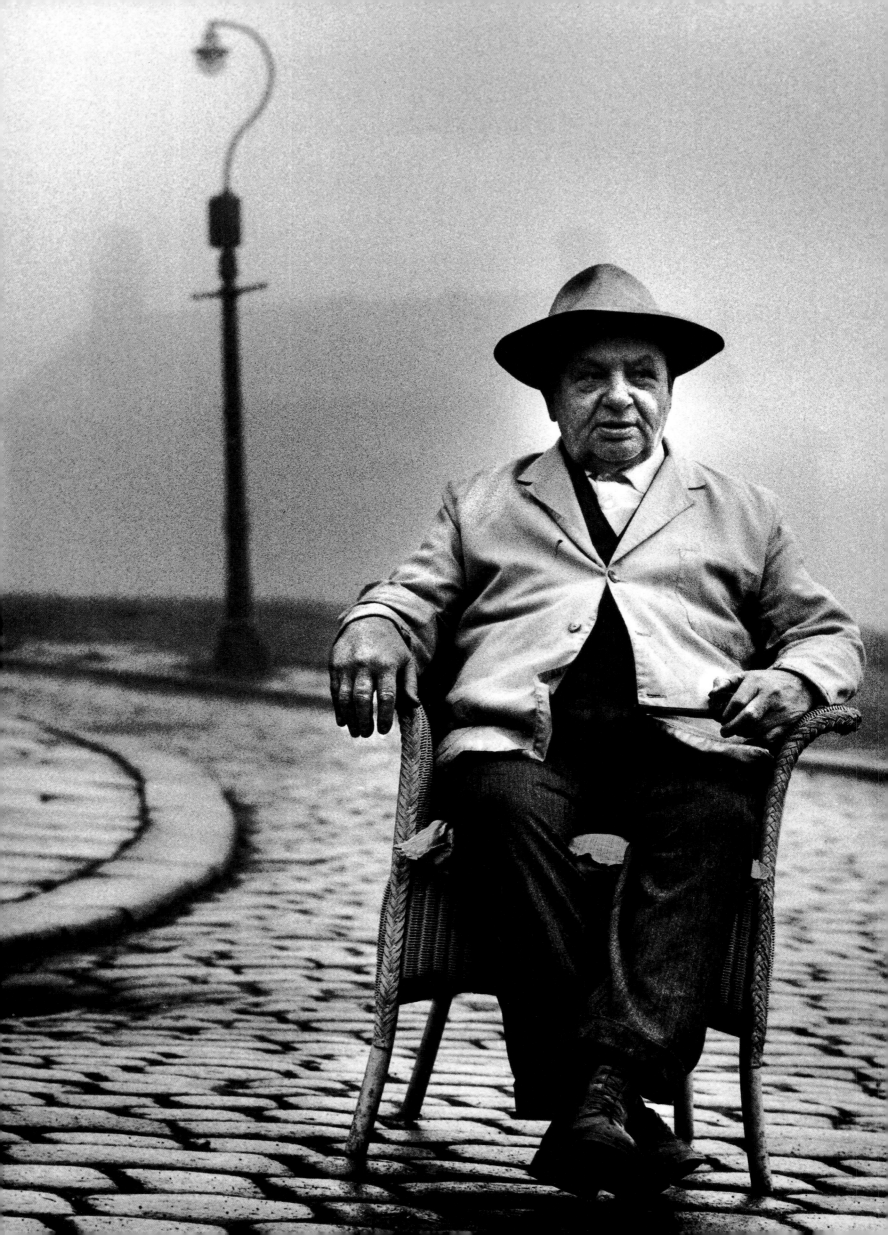

Percy Shaw, inventor, 1966
While a young man in Halifax during the 1920s, Shaw invented one thing – and one thing only – and it kept him wealthy for the rest of his life. Driving in fog late one night, he noticed how cats' eyes shone in the dark. He reasoned that a device in the road might similarly reflect car headlights. His inspiration led him to design the cats'-eye reflector. His small house on a hillside eventually expanded to a large factory, mass-producing cats'-eyes. He told me that they sold for seven shillings and sixpence each (about 70 pence in today's terms). It made him a millionaire. He still lived in the same house up a cobbled street, but now with seven Rolls-Royces, three television sets in every room tuned into different programmes, and a walk-in fridge full of beer and hams, with which he entertained his friends.

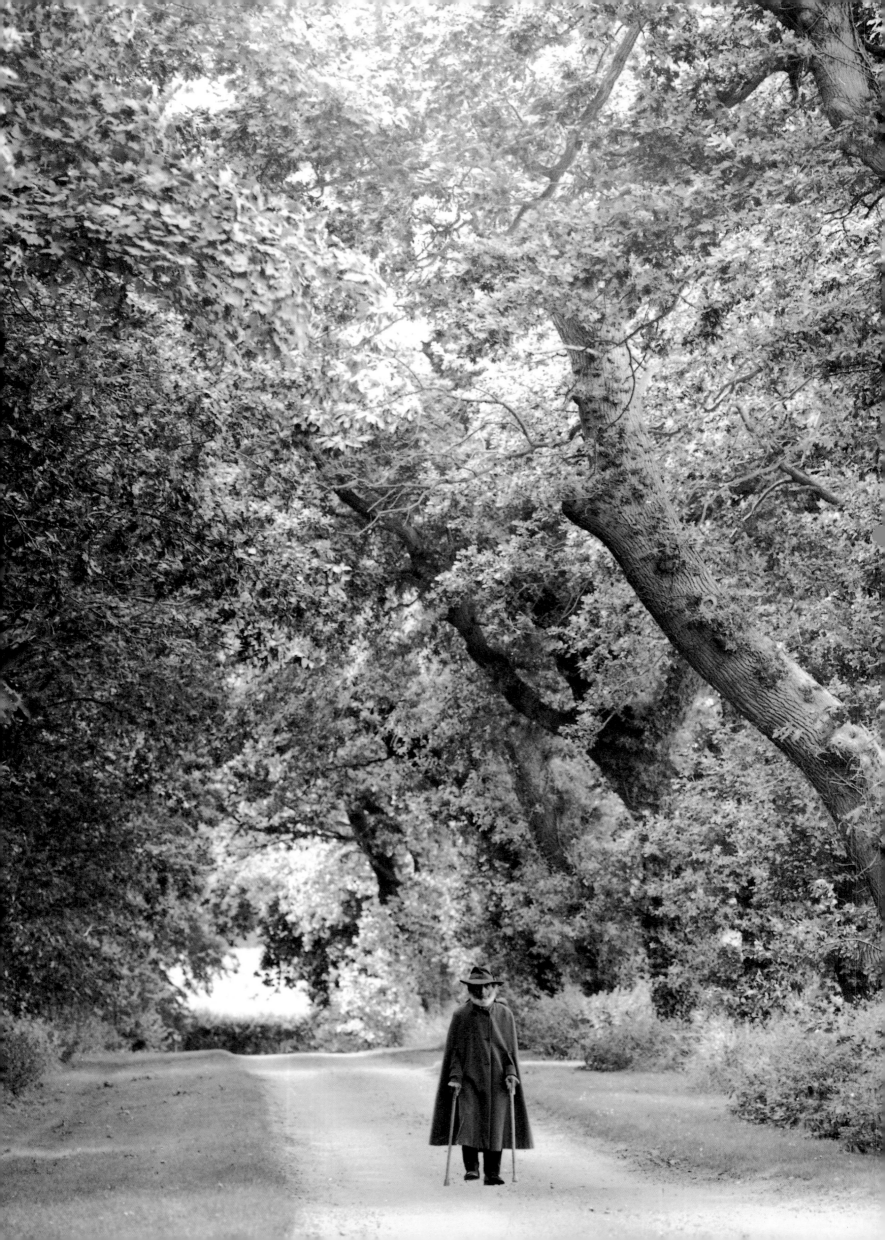

Sam Khambatta, QC, 1997
The first Indian lawyer to be appointed a QC (in 1946), Khambatta
was called to the Bar in 1929. I photographed him, now retired and
in his nineties, near his Norfolk home.

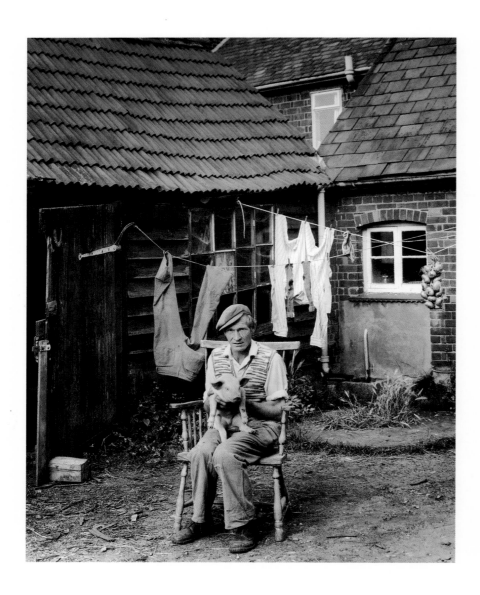

Edward Woodwood of Pulham, 1962
There's a village in Norfolk called Pulham Market, where I used to stay with a friend. We found over a score of people whose names were derived from the land and from rural occupations – Bill Bean; Mr Rope, the bellringer; Mr Pig, the farmer; Mrs Pigeon; and Mr Woodwood, wood-seller and cobbler. Mr Woodwood told me that he ate twenty herrings every morning for breakfast – raw or cooked, tails and all, and that's how I photographed him. I took the pig man with his Sunday lunch and sitting with a piglet (above); the couple (following pages) doing their weekly washing are Mr and Mrs Fairacres, smallholders.

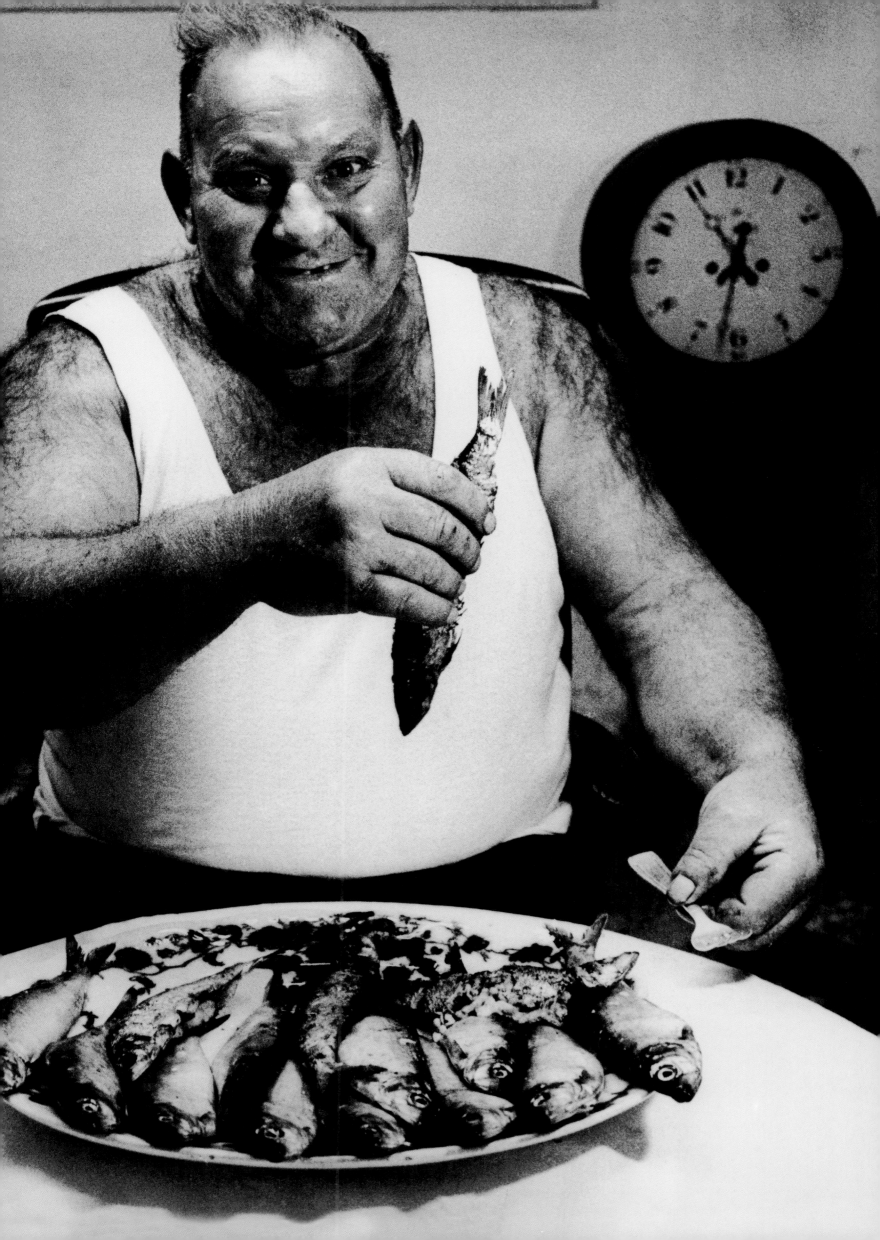

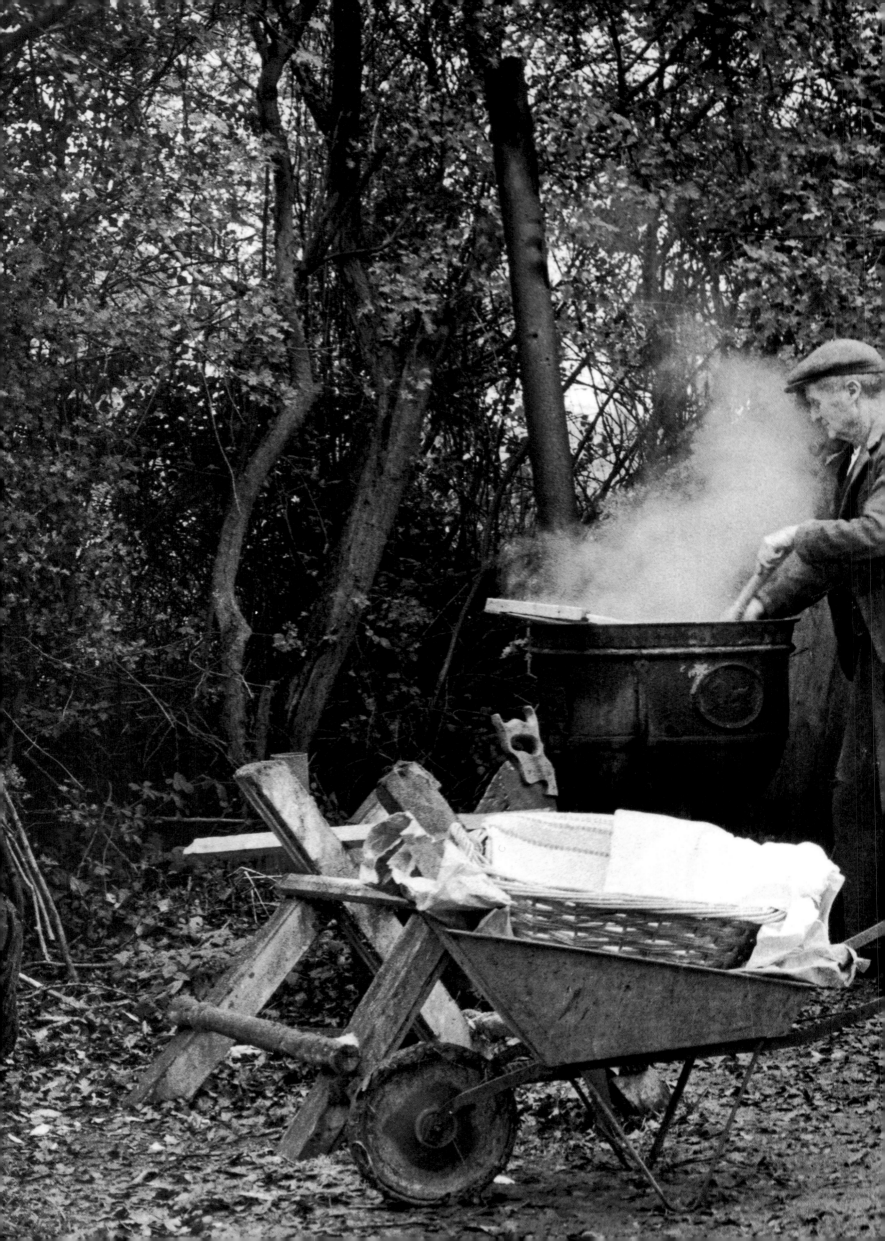

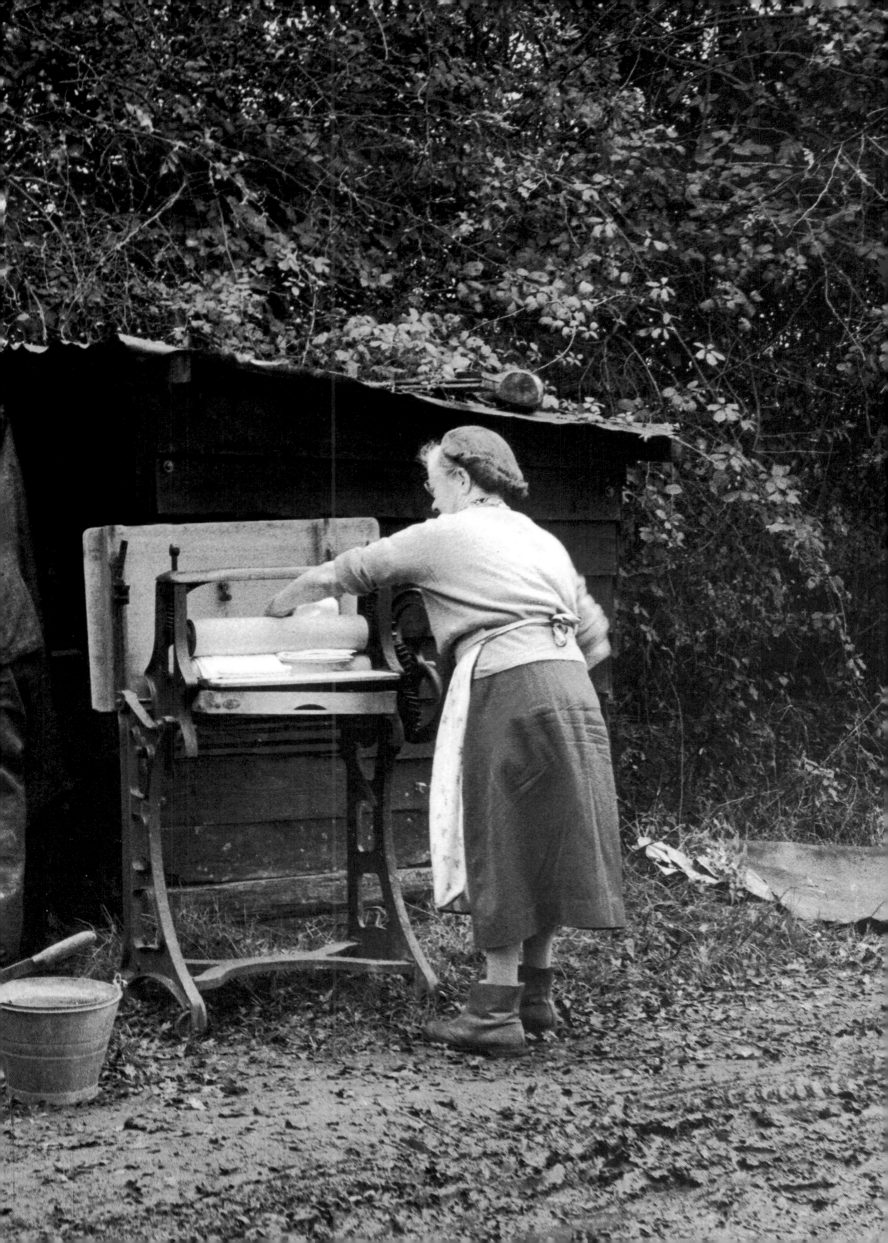

Kay Lockwood, animal benefactor, 1993
Kay is the sister-in-law of the actress Margaret Lockwood
and runs a donkey sanctuary, when she's not collecting
china animals. All the ones in the photograph came from
Harrods, and the room was packed with them. I had to
move half of the animals to get my camera and lights in.
In the picture (below) she is posing with her assistant and
one of her two Lotus cars.

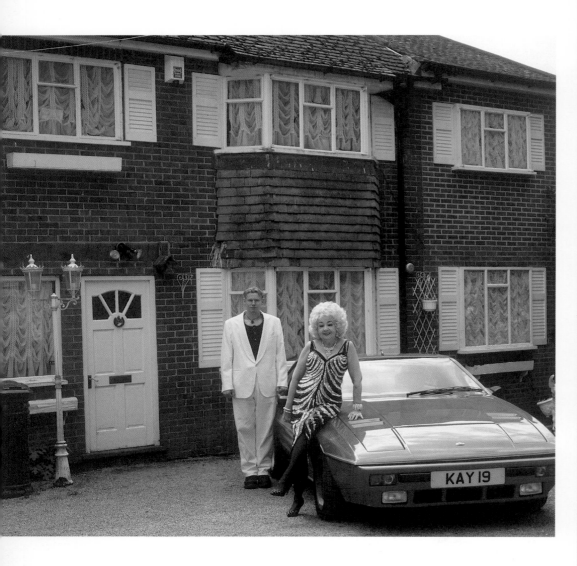

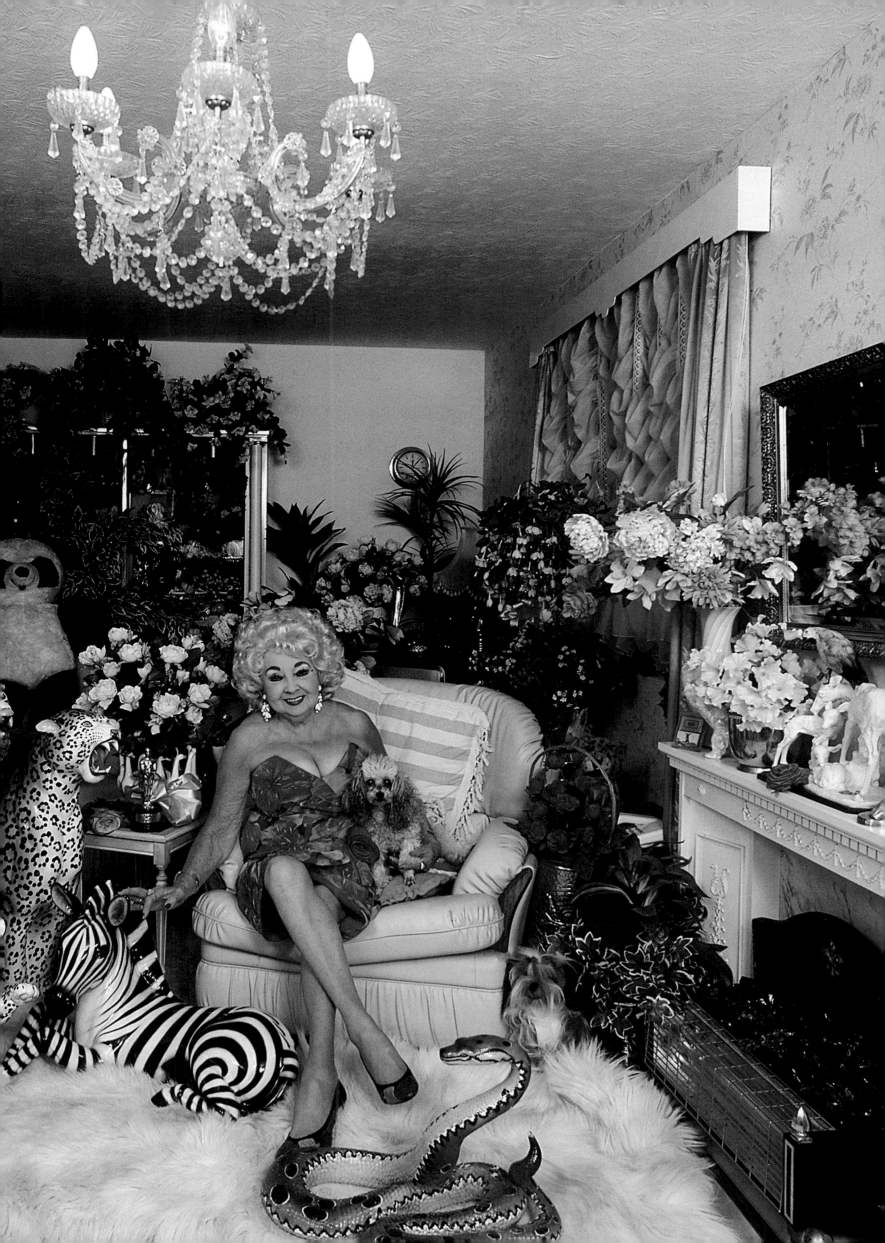

Right: Lady Diana Cooper, 1982
Lady Diana wearing one of her many fantastic hats, this one decorated with cakes and sent by an admirer.

Below: Lady Rosamund Fisher, 1987
I took this photograph of Lady Fisher with her miniature pony and monkey at Kilverstone Hall in Norfolk.

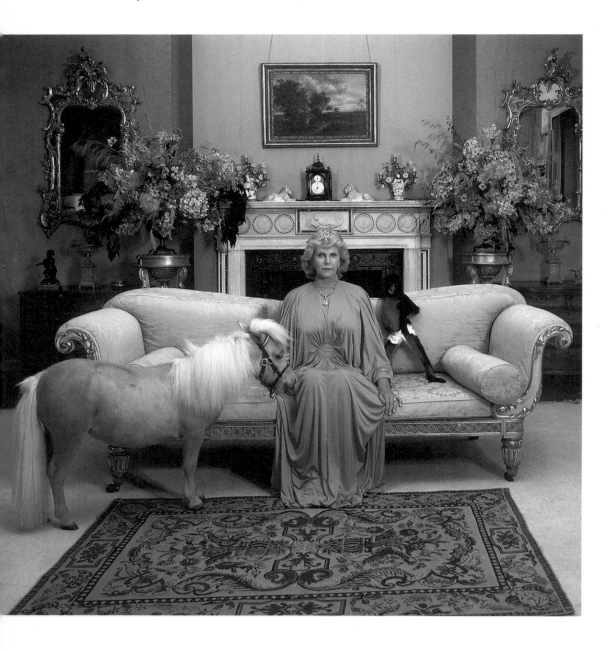

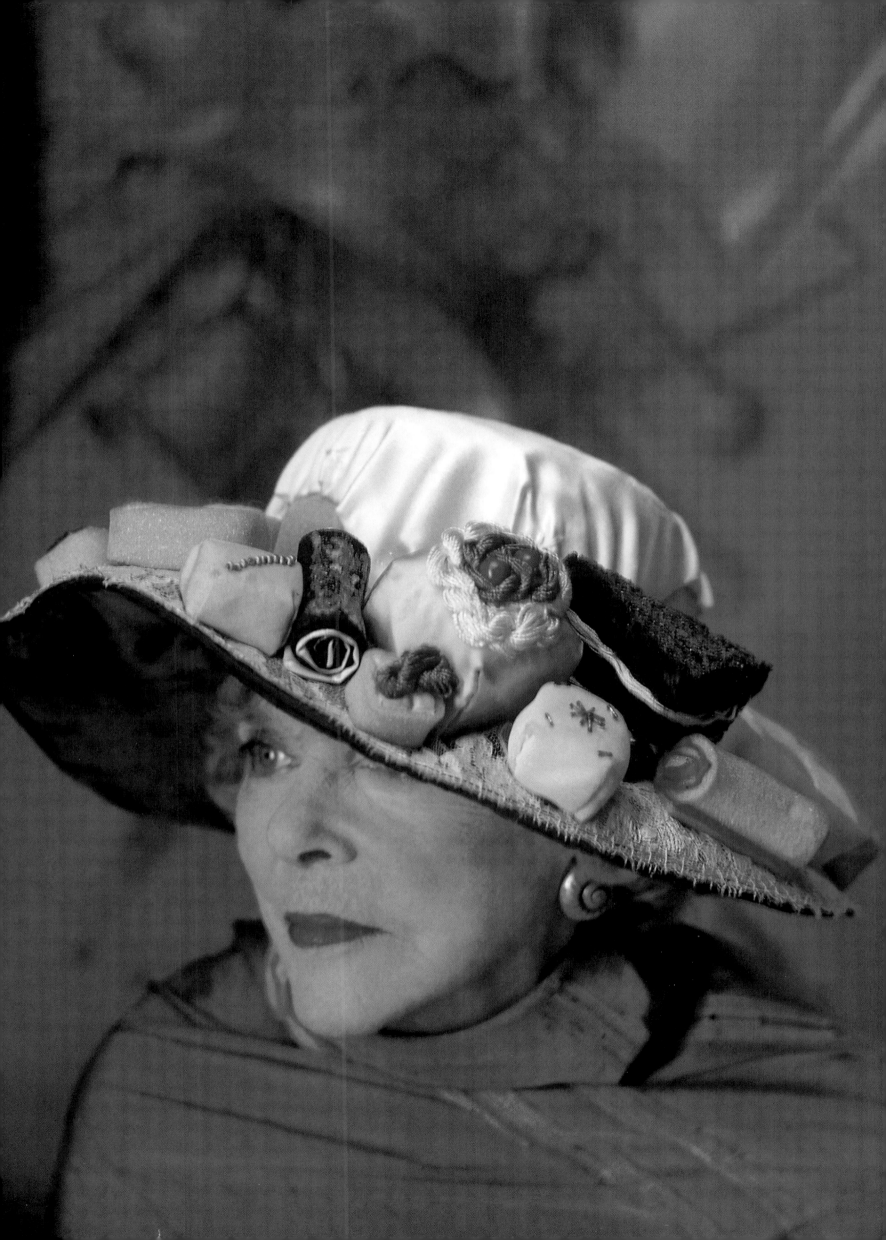

Zandra Rhodes, fashion designer, 1974
A wonderful character – vibrant and colourful – photographed
in her amazing bedroom, surrounded by upholstered cacti.

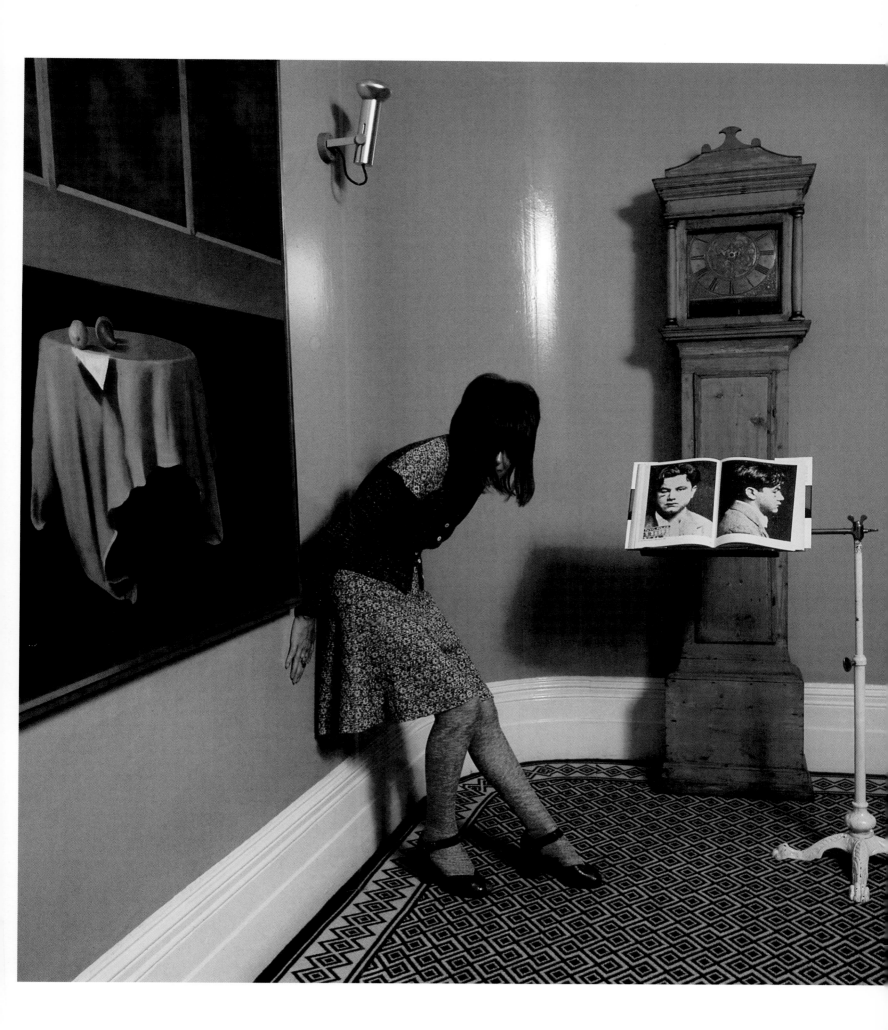

Mary Quant, fashion designer, 1964
Mary and I are old friends and I have photographed her many times. These pictures were taken for the *Observer* magazine in her Chelsea home.

Following pages: Louise from Braintree in Essex, contortionist, 1972
She could do this easily – and smile too!

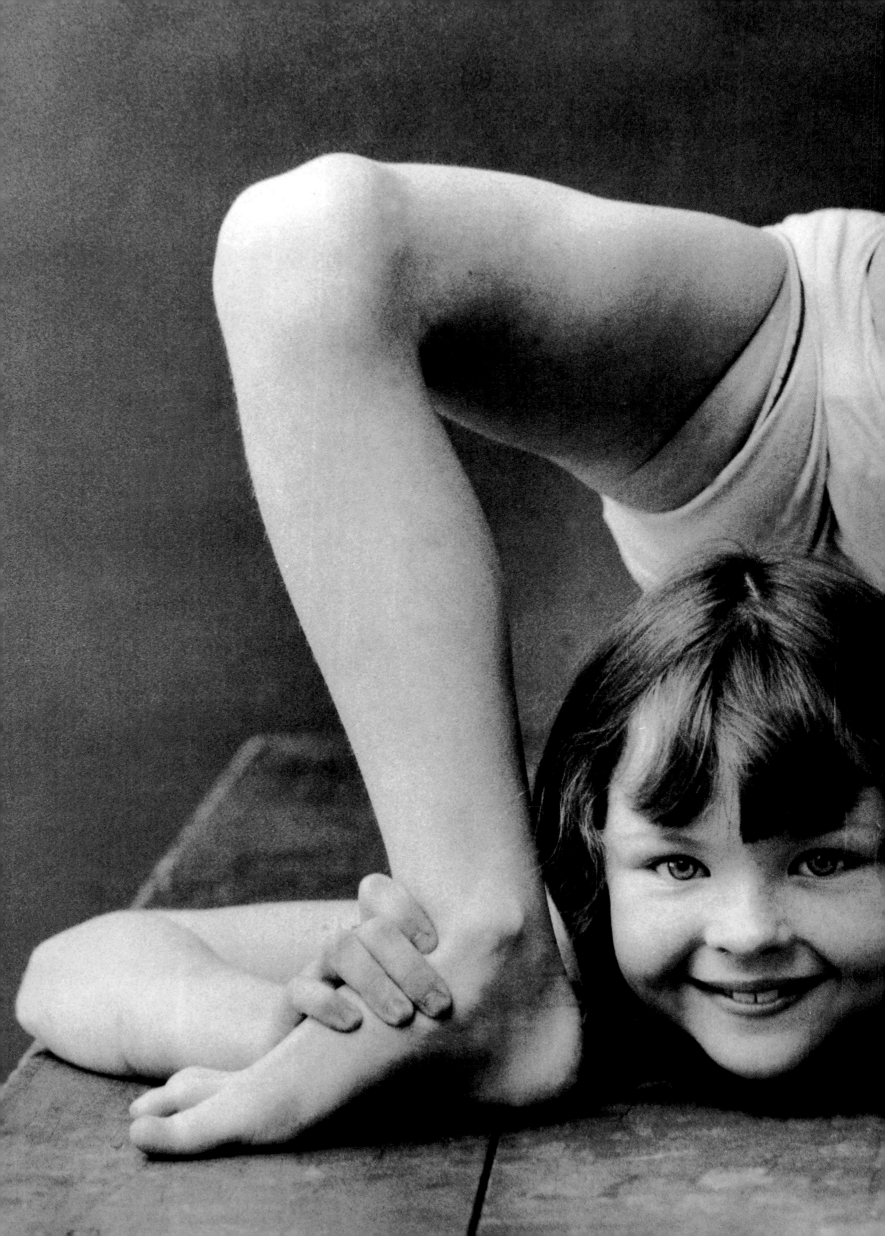

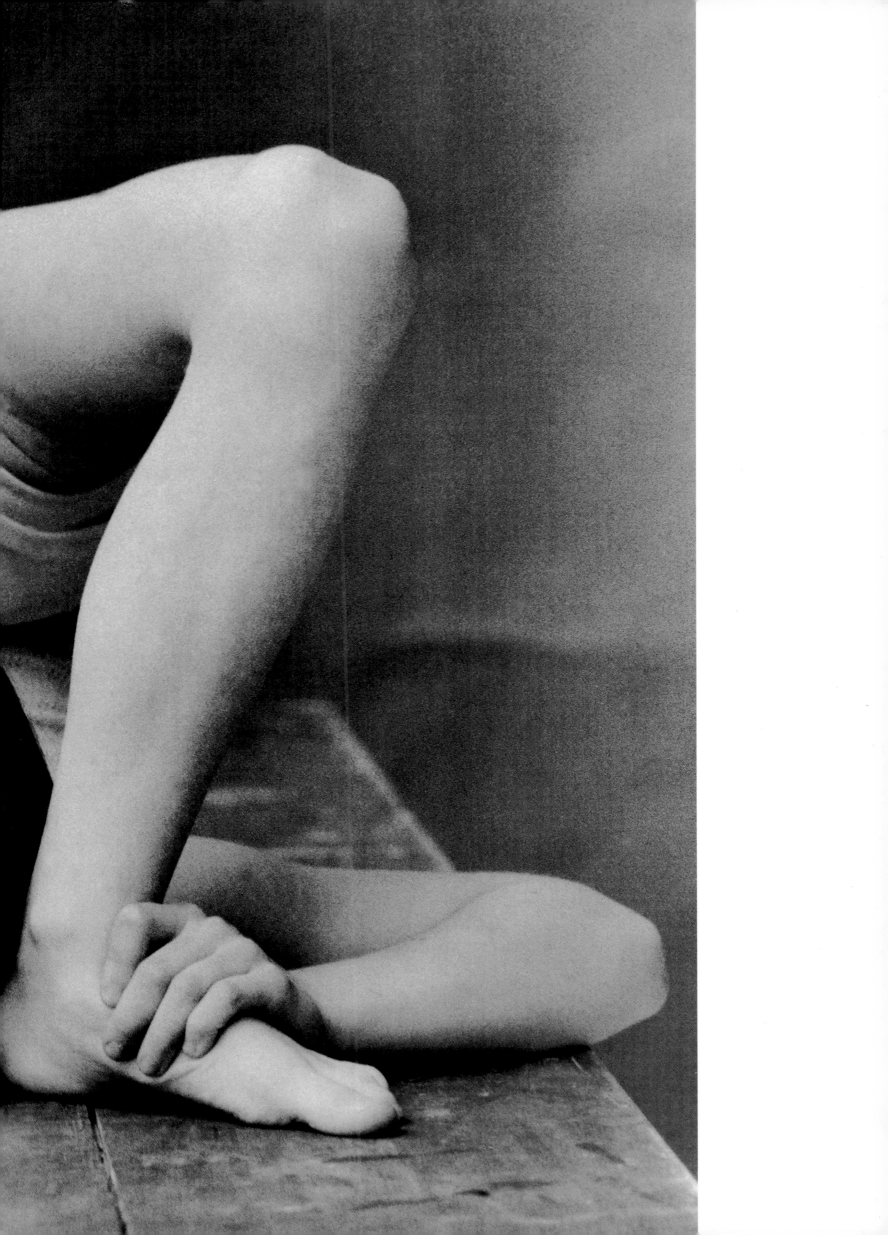

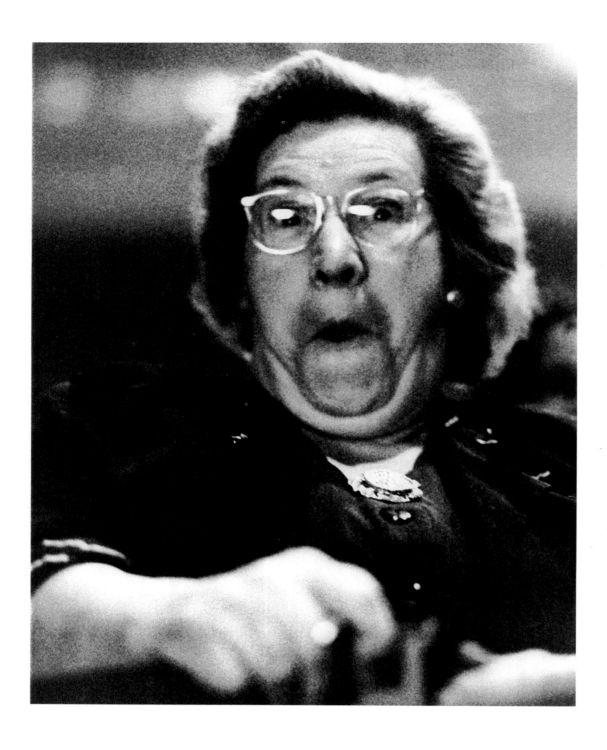

London characters, 1960s
Above: At bingo in Peckham, in 1964 when bingo was the latest rave.
Right: The vicar of Hendon; I photographed him on an assignment about the
River Thames in 1966.

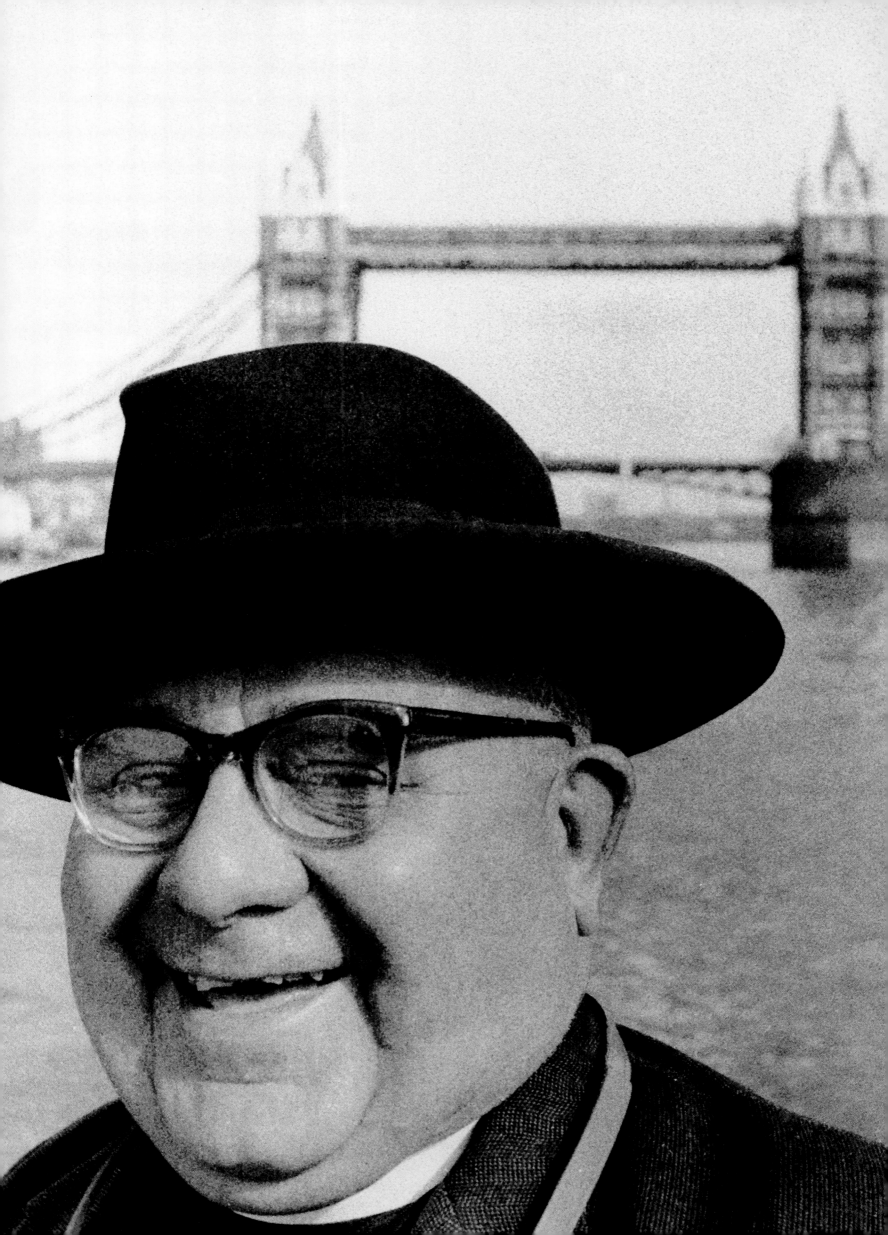

Left: John Christie, founder of the Glyndebourne Festival Theatre, 1958
Above: Professor Carl Ebert, Glyndebourne producer, 1958
This was a delightful assignment. I was invited to go on a trip to the Sarah Bernhardt Theatre in Paris with the Glyndebourne Company, who were putting on Rossini's *Le Comte Ory* and Verdi's *Falstaff*. I believe it was the only occasion that they went abroad to do a performance. It was a hilarious journey. I'd been booked to go first-class, until I discovered that the entire company – about thirty-five people – was travelling third-class, when I quickly moved in with them. I had the most marvellous time and they more or less adopted me. We all used to go out to lunch together, and they'd take over the restaurant and order one helping of every item on the menu, passing the plates round for each of us to try. They were not supposed to drink, but they did of course. Being a theatrical bunch of people, they couldn't resist dressing up. One girl came attired as a Paris hooker, and the cast persuaded her to pick someone up in the street (which she did – and got his phone number), with all of us looking out of the window, holding our sides. I knew very little about opera, but I got on with them all extremely well, especially the singer Geraint Evans. He said to me, 'We'd better make friends, because we're the only foreigners here, since we're British.' All the others were Polish and Russian, German and Swedish, and they were such a happy bunch of people. I took the photographs of John Christie and Carl Ebert on our return, in the grounds of Glyndebourne.

Alistair Cooke, broadcaster and chronicler, 1964
A fascinating person, Cooke was a very elegant and
eloquent man, who didn't stop talking and constantly
threw out remarks, mainly about current affairs.

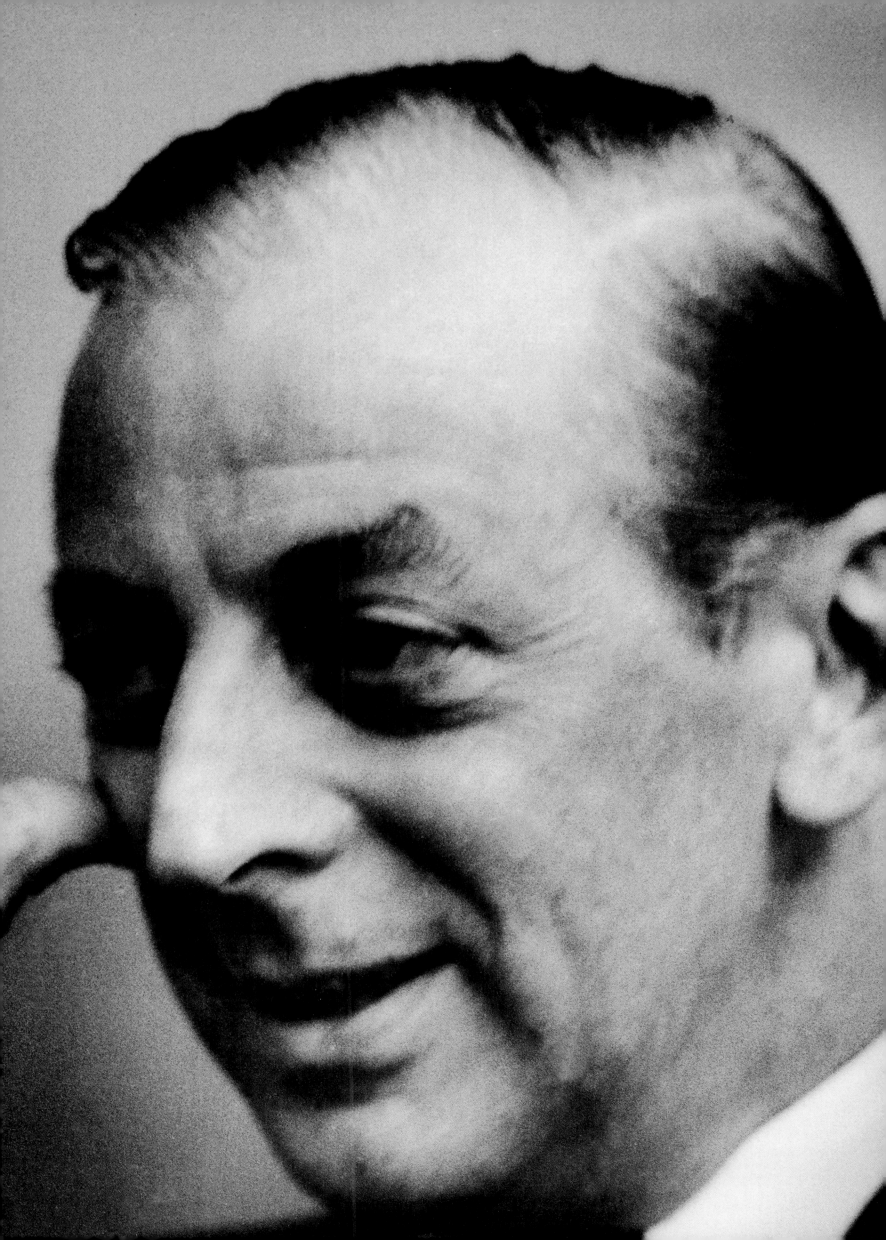

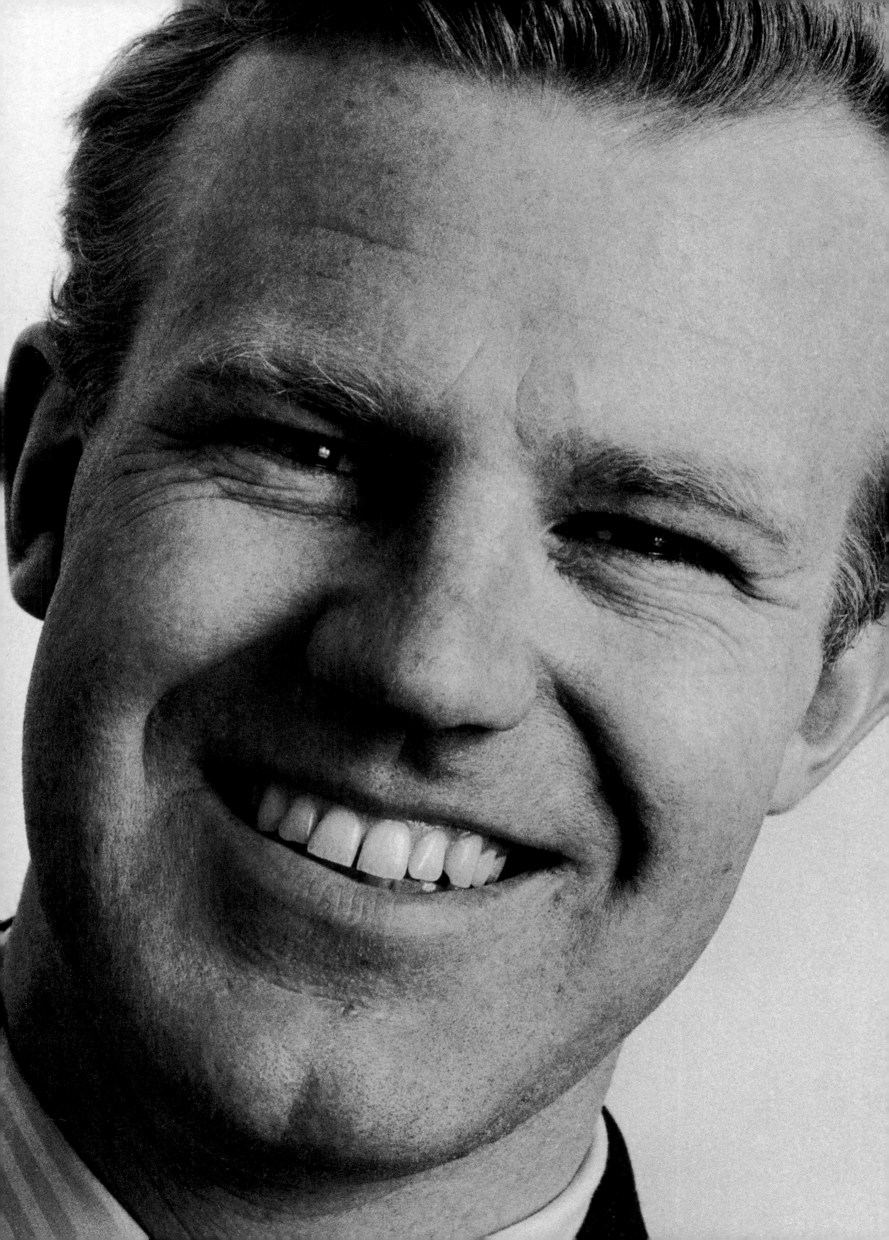

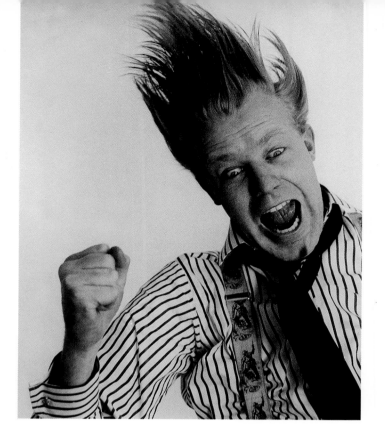

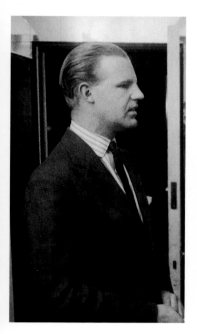

Sir Jocelyn Stevens, editor and publisher, 1957–68, Rector of the RCA, 1984–91

In 1956 I was a student at Guildford School of Art doing a photography course, when I was recommended to Mark Boxer, who had just joined *Queen* magazine (the most influential fashion and feature magazine during the early 1960s). I arranged an appointment and, when I got there, I found a young chap sorting through the dustbins outside. He smiled in a friendly way, so I asked him what he was doing. He said he was looking for some Cartier-Bresson prints that had been thrown out by mistake. I was early, so I stopped to help him. He told me that I'd find Mark Boxer upstairs. Mark, the suave and elegant art editor, looked through my portfolio and offered me a job as the magazine's resident photographer. He took me to meet the proprietor, and there to my surprise, was the young man who'd been sorting through the dustbins. With a big grin on his face, Jocelyn Stevens said, 'We've already met.' I didn't expect to stay in the job for long, but in the end I stayed fourteen years, becoming an associate editor. I not only managed to stay the course, but formed a lifelong friendship with Jocelyn.

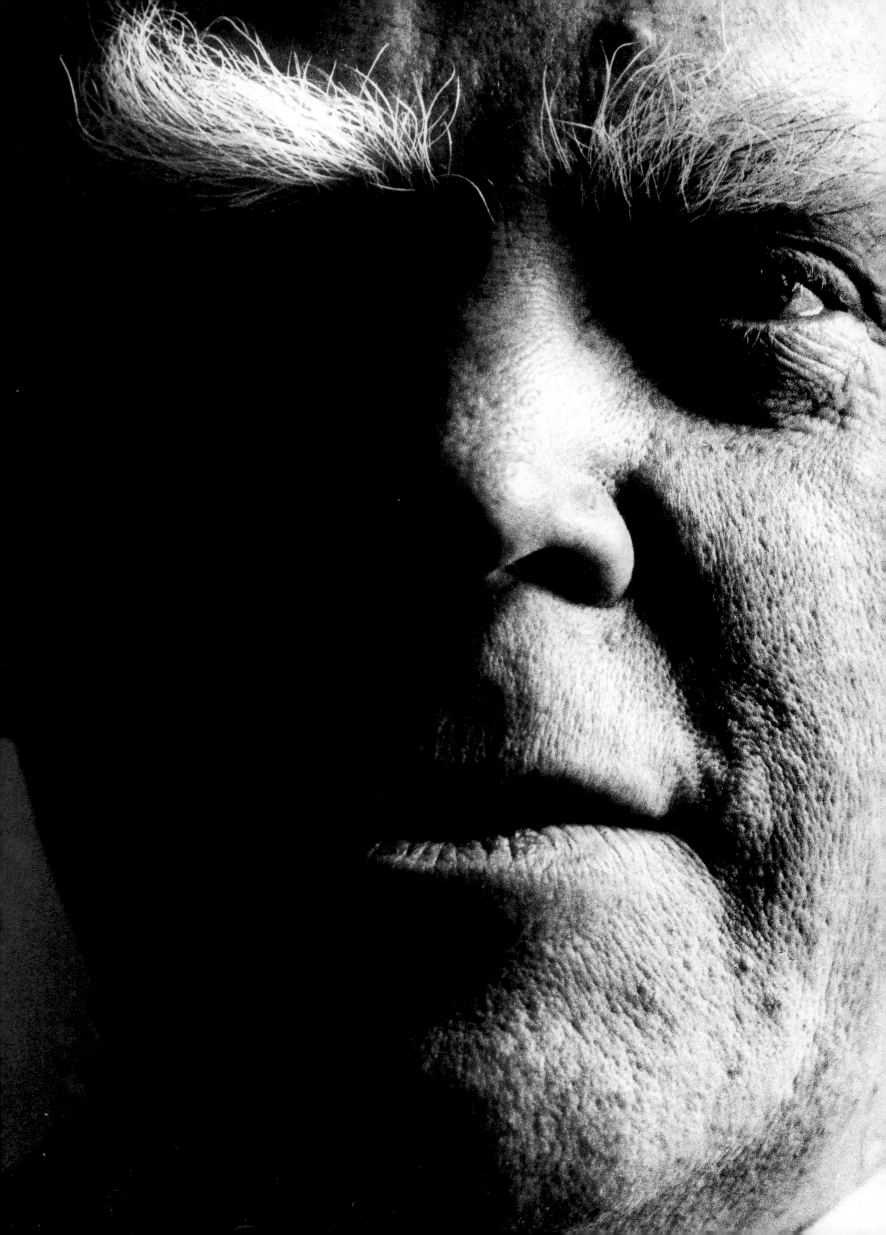

Previous pages: Sir Osbert Lancaster, *Daily Express* **cartoonist, 1962**
Two pictures from a feature on newspaper cartoonists. Lancaster worked for the
Daily Express for most of his career. He would rush into the editorial offices, about
an hour before the paper went to press, to draw his daily cartoon.

Left: Leslie Gilbert Illingworth, *Daily Mail* **cartoonist, 1962**
I somehow managed to get Illingworth's face into sharp focus after we'd left El
Vino's, the famous watering place for Fleet Street's journalists, after drinking three
bottles of champagne.

Below: Vicky (Victor Weisz), *Daily Mirror* **cartoonist, 1962**
A great political cartoonist wearing the outsize bowler that his editor-in-chief Hugh
Cudlipp sent him, because he thought Weisz was a bighead.

Carl Giles, *Daily* and *Sunday Express* cartoonist, 1962

Giles had been the cartoonist for the *Daily* and *Sunday Express* since 1943, but had started out as a film animator. When I went to see him we had tea together in the garden, where he presented me with a large bowl of the most beautiful brown eggs – he claimed that the colour of the yolks and the taste of the eggs were the best in Britain. His country pursuits earnt him the nickname 'Farmer Giles' from his fellow journalists.

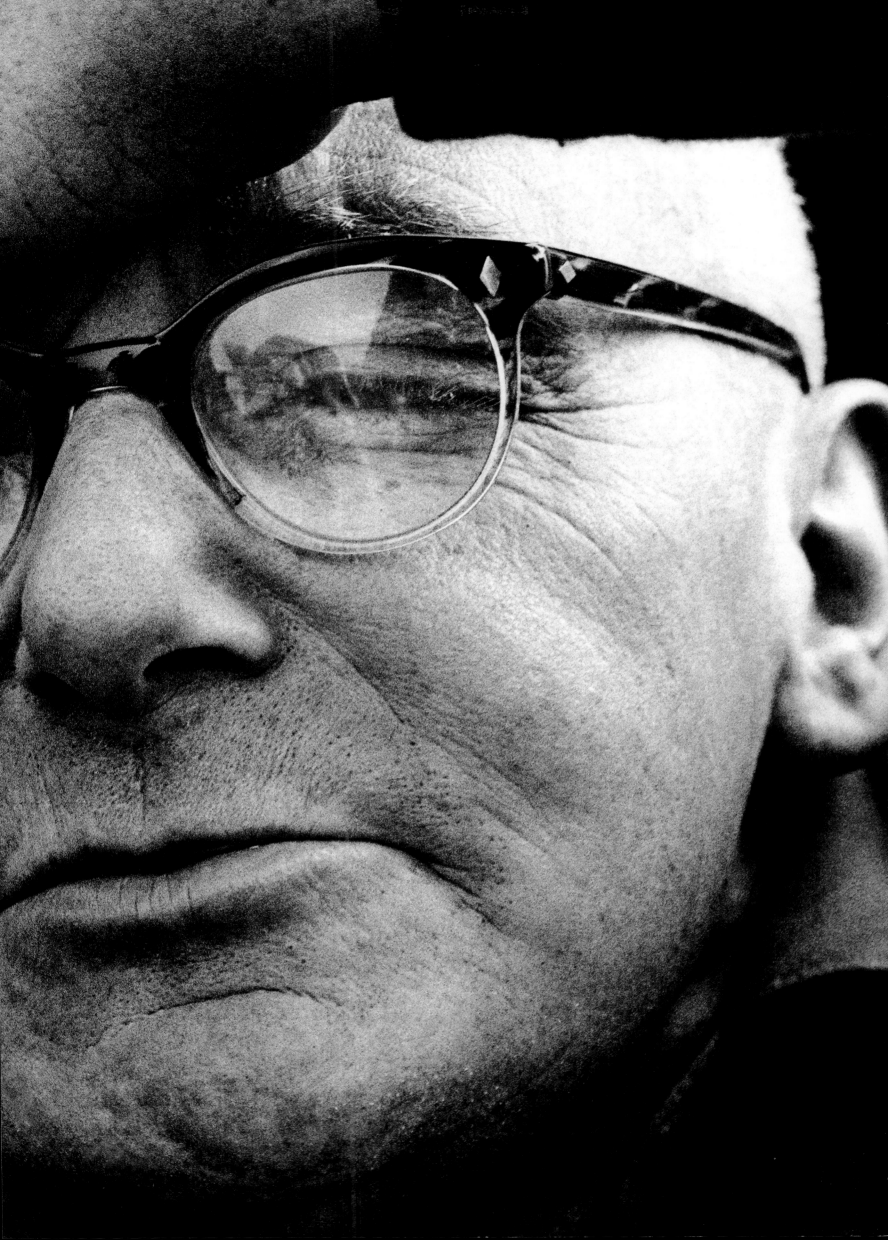

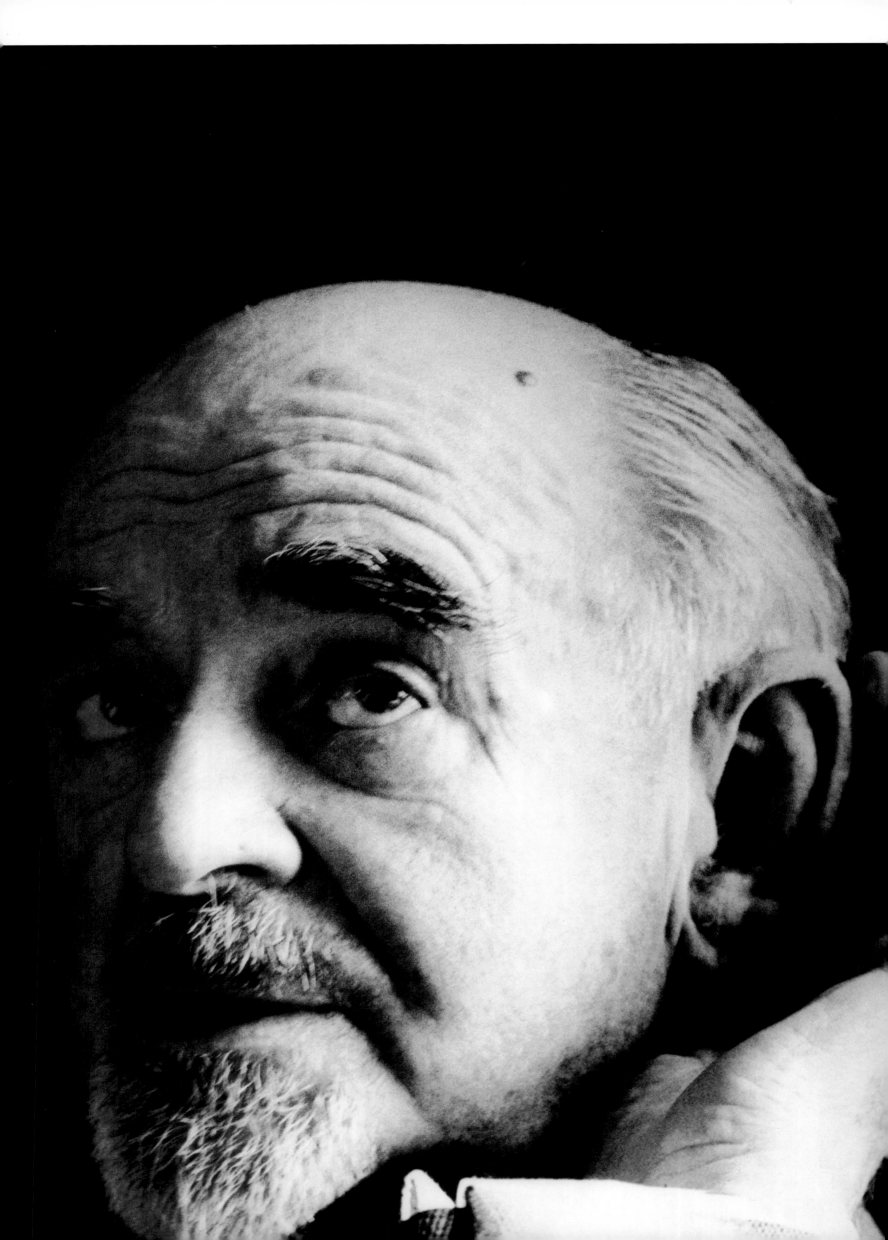

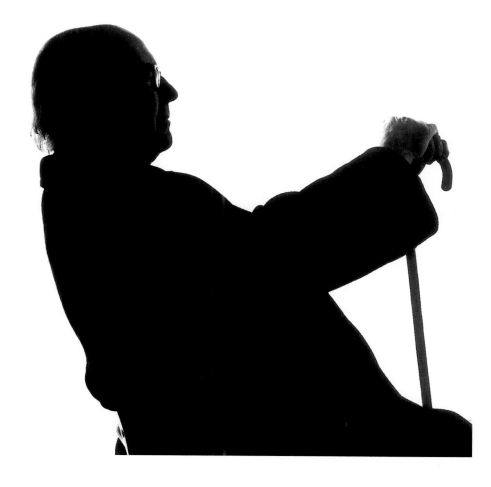

Far left: Sir David Low, *Guardian* cartoonist, 1957

Left: Edward Ardizzone, illustrator, 1968

Below: Quentin Blake, illustrator, 1999
Quentin is the children's Poet Laureate – he has illustrated all the Roald Dahl books and is a very quiet, unassuming man: an absolute gentleman.

Following pages: Paul Hogarth, illustrator, painter and traveller, 1998
Hogarth is someone I've known for many years – great fun and a highly perceptive illustrator, which is apparent in his drawings. He collaborated with Robert Graves, Graham Greene and Lawrence Durrell, among others, illustrating their works.

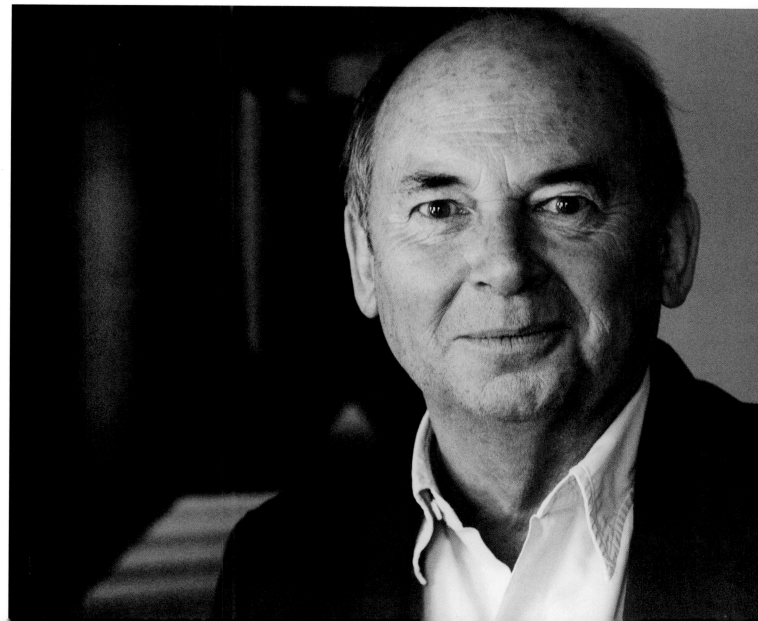

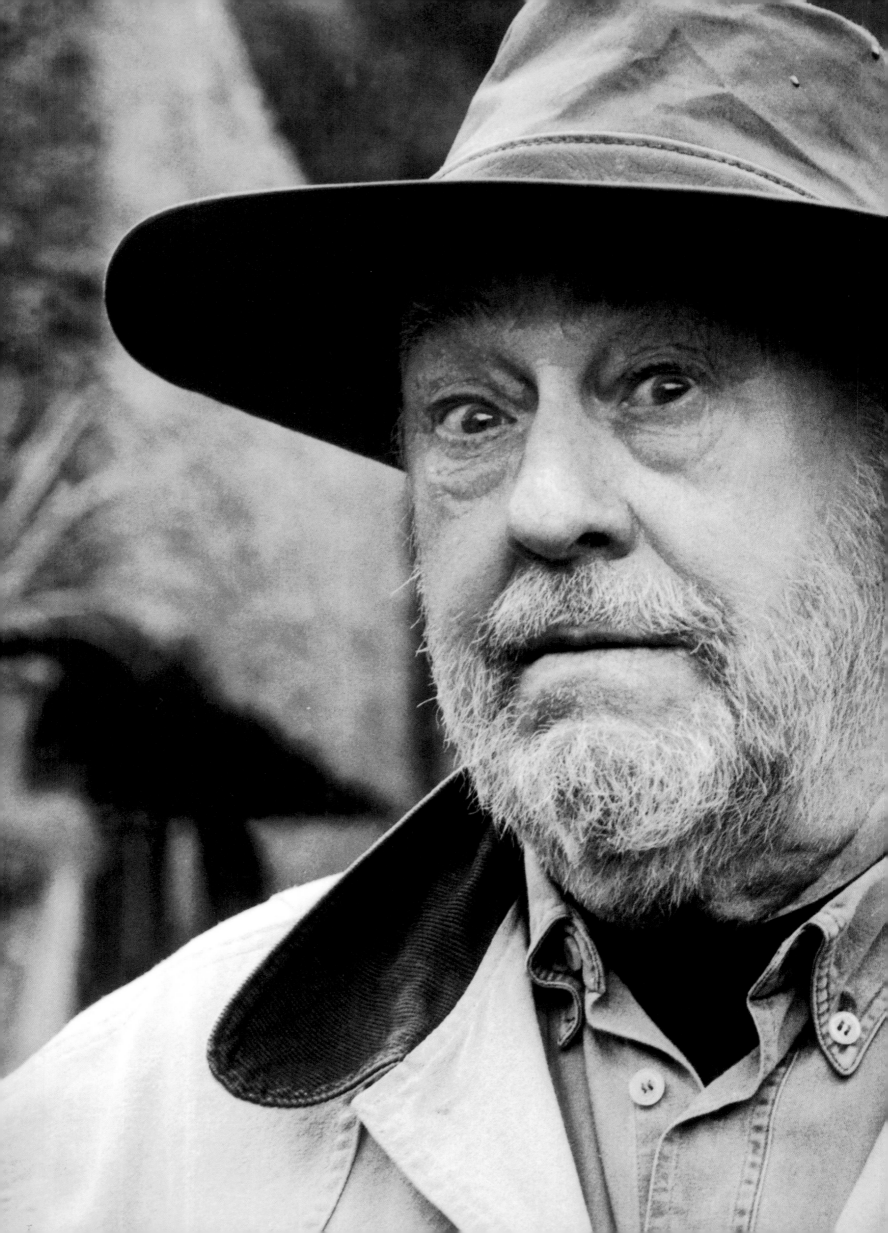

Below: Sir Roy Strong, writer and art historian, 1967
Sir Roy at his most flamboyant stage, when he was Director of the National Portrait Gallery, standing in front of a huge painting of Lord Mountbatten, at the entrance to the gallery.

Right: Sir Terence Conran, furniture designer and restaurateur, 1963
Sir Terence photographed with his wife, the cookery writer Caroline Conran.
Our paths have crossed many times, with good results.

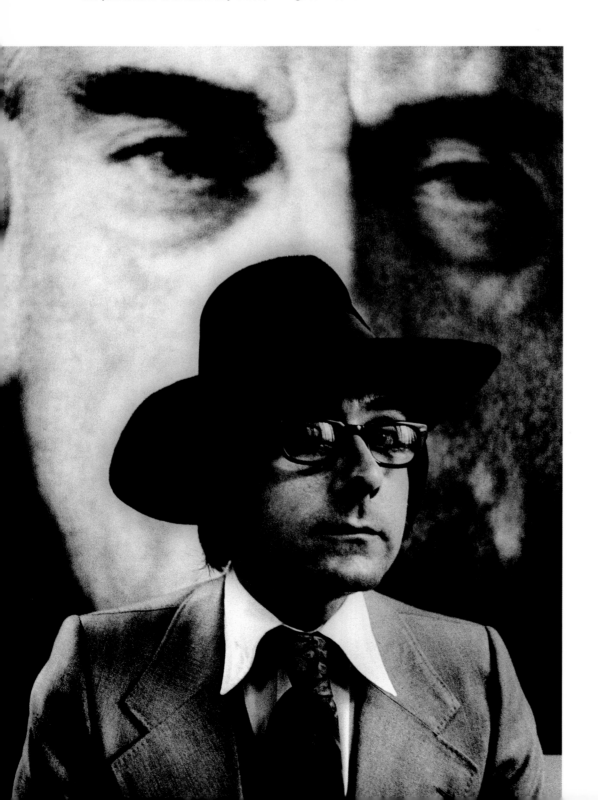

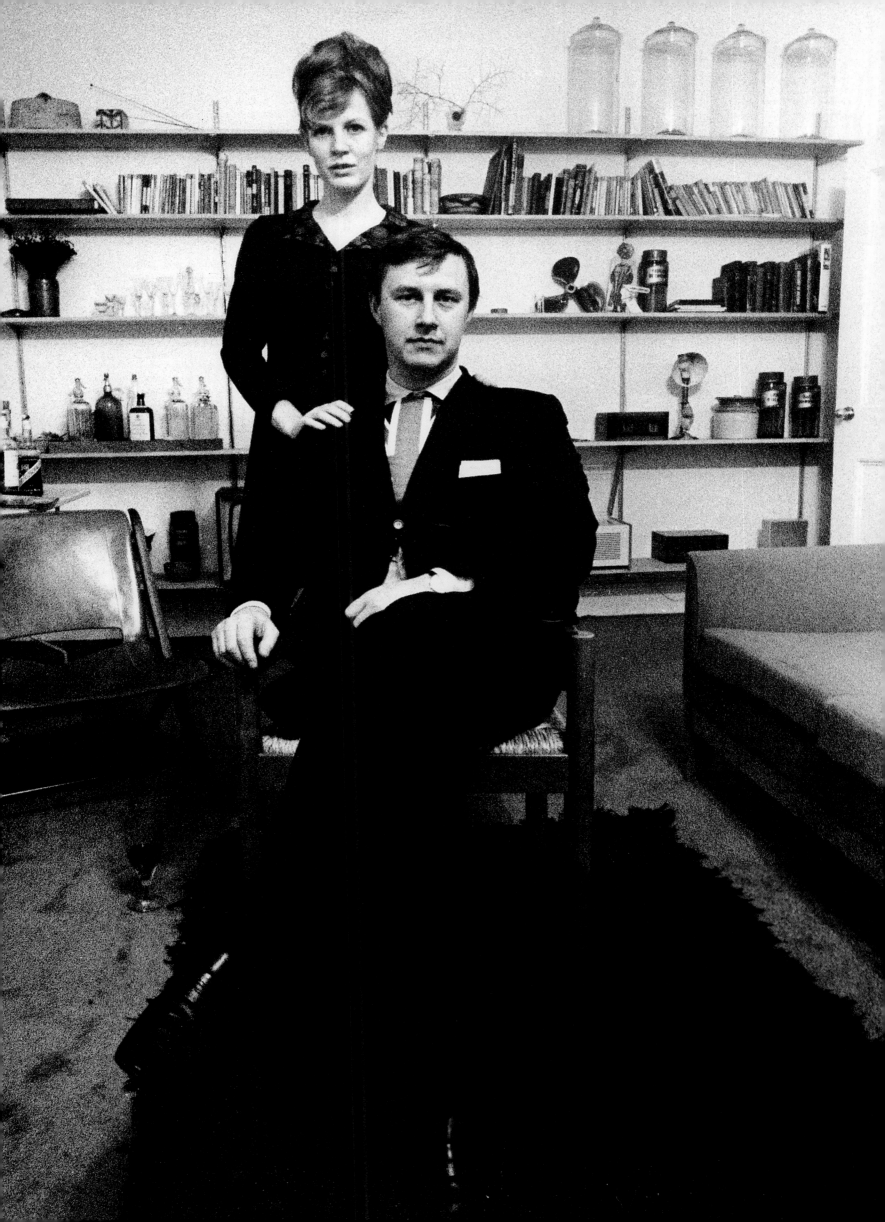

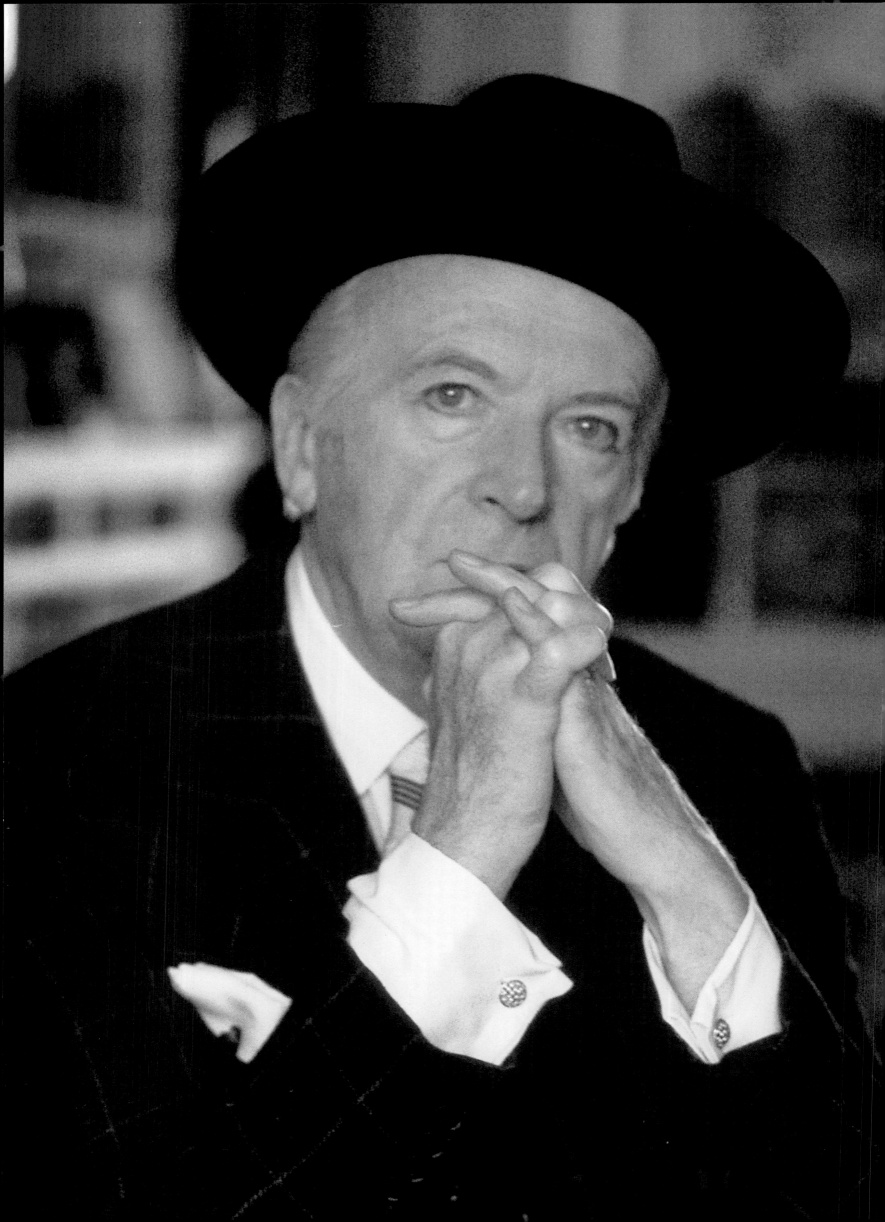

Left: Sir Cecil Beaton, photographer and designer, 1974

Below: Nicky Haslam, interior decorator, 1986
Two fashionable men about town and great party-goers. I photographed Beaton in his home in Pelham Crescent, and Haslam in a rubber suit outside the *Observer* building by Chelsea Bridge, in London.

Above: Lord Snowdon, photographer, 1958
The first contemporary photographer whom I really admired was Snowdon. He had these close-up shots in *Vogue* magazine: big, grainy portraits that were alive and vibrant. I was immensely impressed with his work. He was a close friend of Mark Boxer, and eventually we met and Snowdon asked me to do his portrait for his first book on London.

Right: Mark Boxer, art editor and cartoonist, 1958
Boxer, the art editor, offered me a job on *Queen* magazine. I went there and he seemed to be impressed by my work. He was elegant – almost a dandy – caring passionately that the colour of his tie matched his socks. He sort of adopted me at first, but later, whenever I went out to do a portrait and took the pictures back to him, he'd always ask to see the photograph I hadn't taken. He'd say: What a pity you don't have him looking up, because I wanted to put him at the bottom of the page; or: I wanted him looking left or right. It taught me to come back with at least fifty variations. It was good training. He looked for the picture I hadn't taken, not because he wanted that particular shot, but because he wanted to go one better.

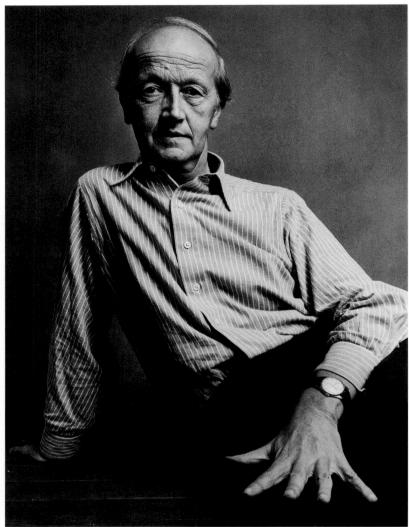

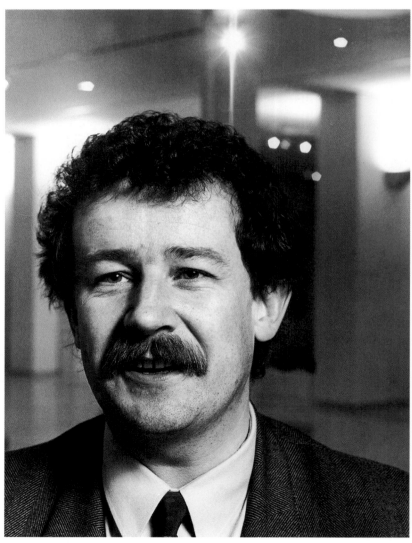

Rectors of the Royal College of Art
Above: Lord Esher gentleman, poet, intellectual and architect, Rector 1971–78

Above right: Professor Richard Guyatt, graphic designer and Rector 1978–81

Right: Professor Christopher Frayling, polymath and Rector, 1996–

Far right: Robin Darwin, Rector 1948–71
The great-grandson of Sir Charles Darwin, he totally reshaped the RCA after the war years.

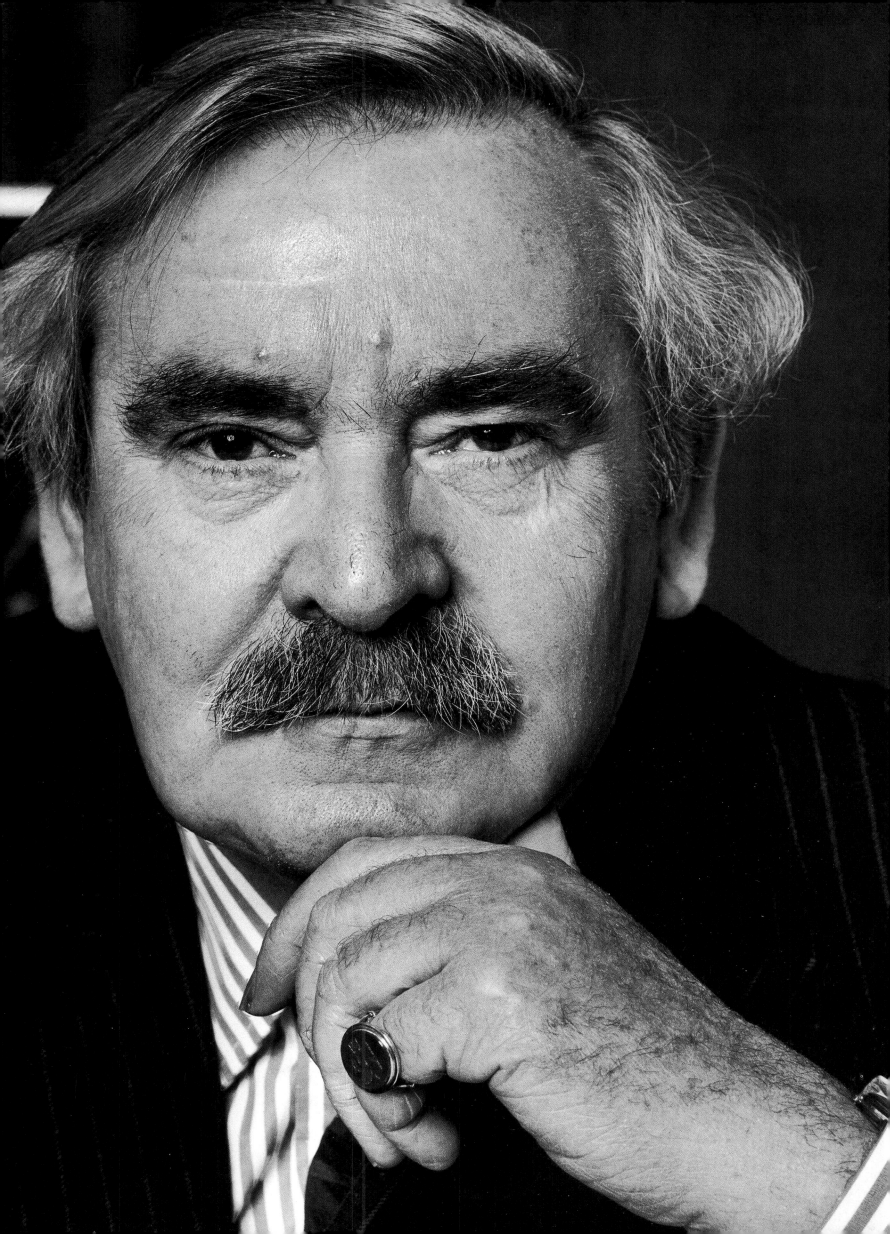

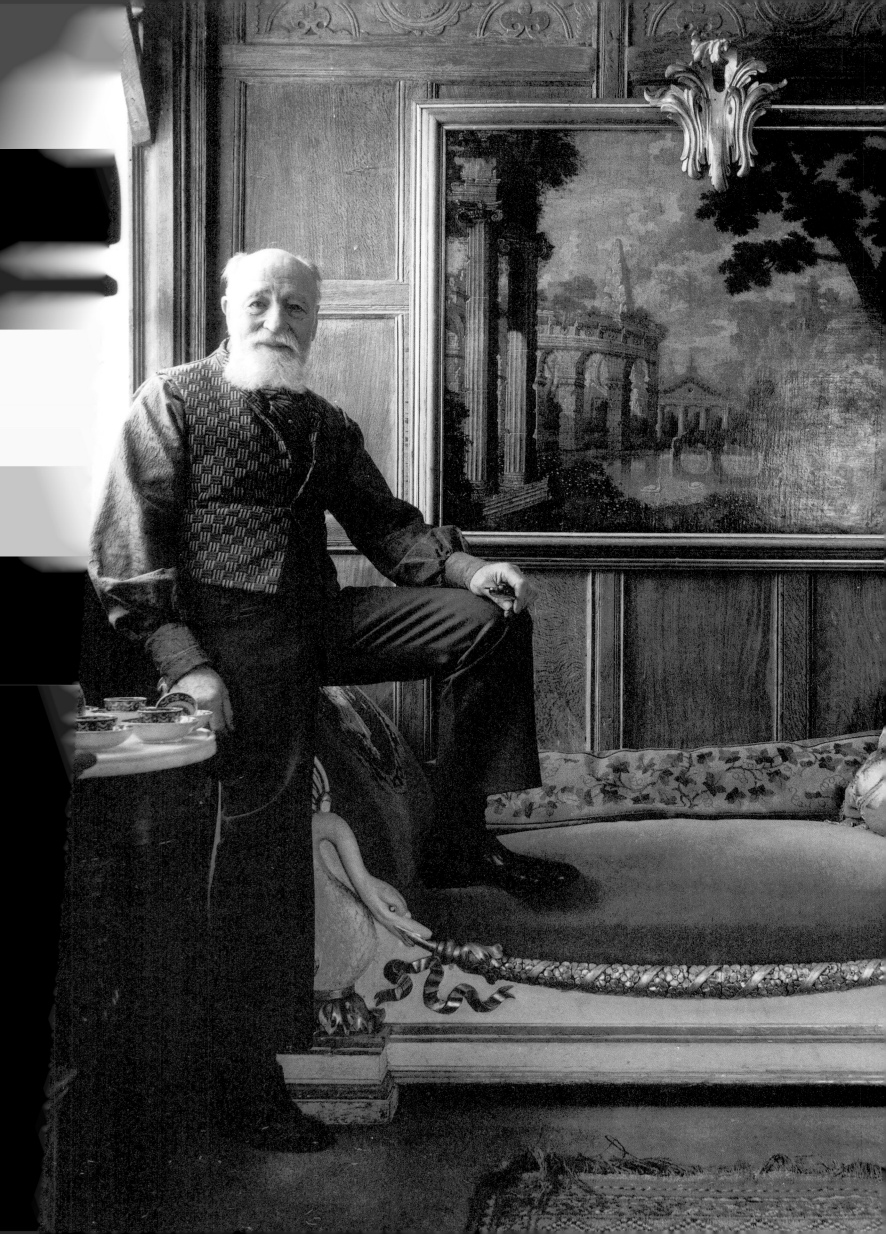

Angus McBean, photographer, 1985
McBean was the outstanding photographer of the theatrical world and a man of great style, a beautiful dresser and extremely kind. He lived in Islington, where he owned half of Gibson Square. His house was full of wonderful antiques, and he told me that, during the war, when many churches and buildings were blown to bits, he just went round helping himself to columns and panelling that were being thrown out as debris. Later he moved to Suffolk, where I took these pictures.

Sir Malcolm Sargent, conductor, 1957
I photographed Sargent in his vast apartment in Albert Hall Mansions. Instead of discussing music, he seemed more interested in his budgerigar Hughie, and it took some persuasion to get him to pose with his baton.

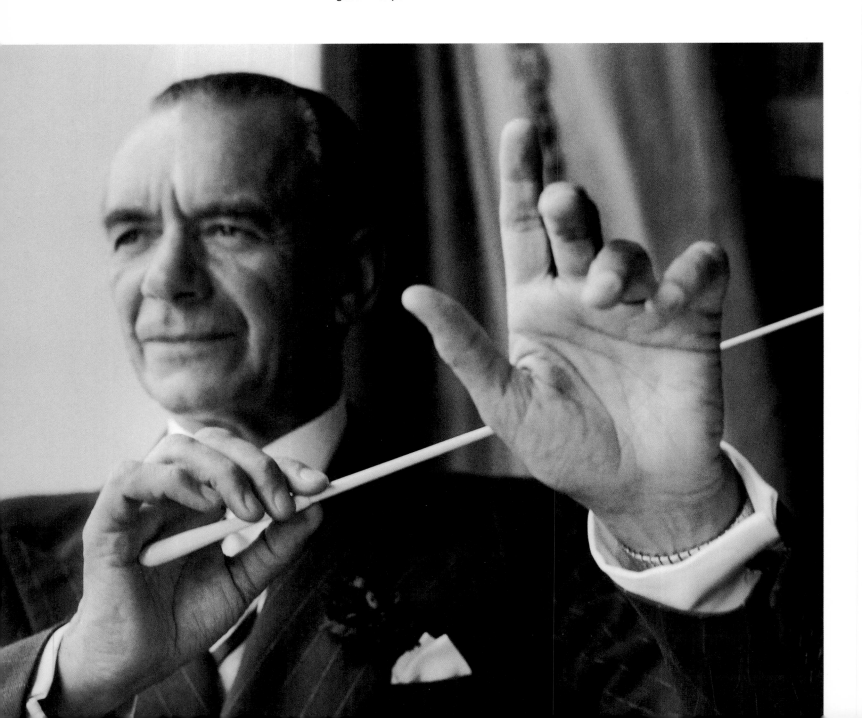

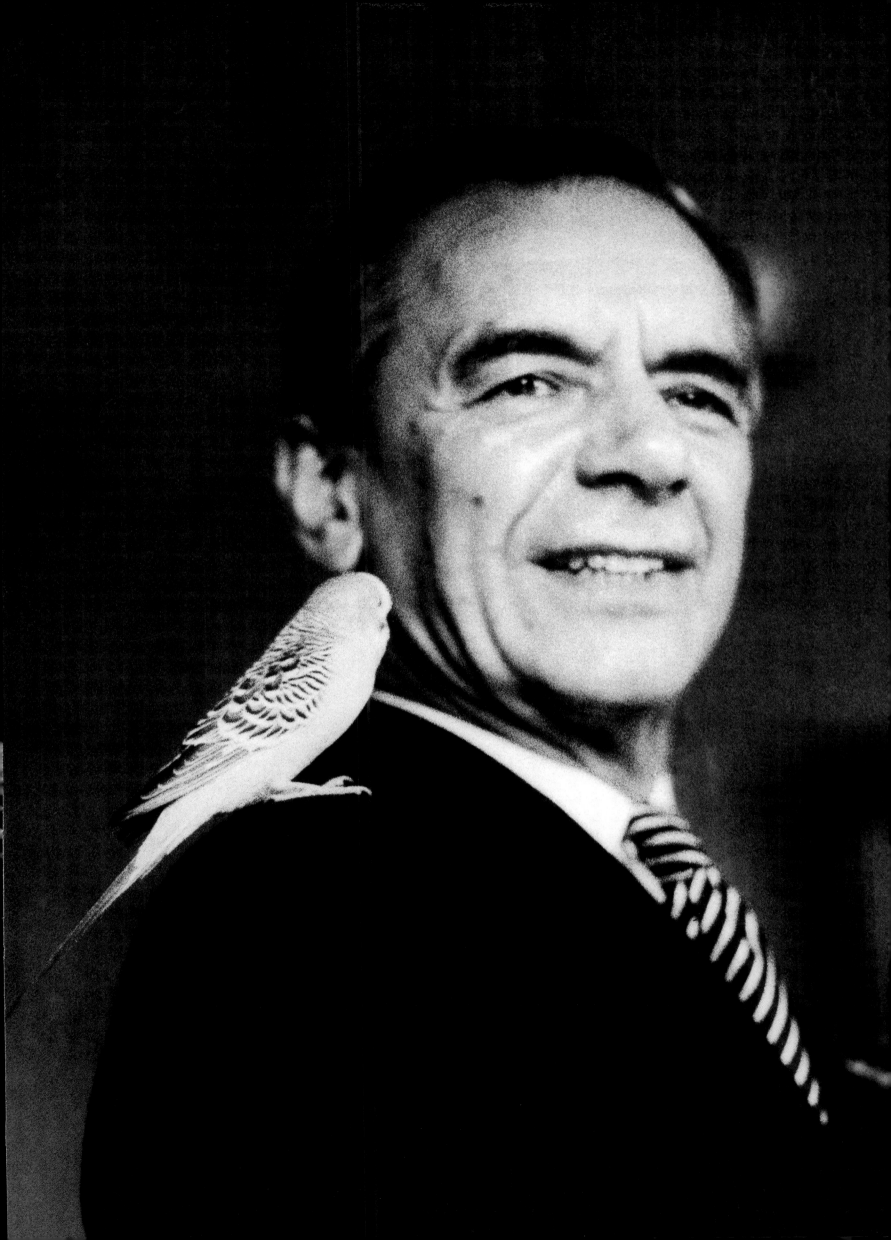

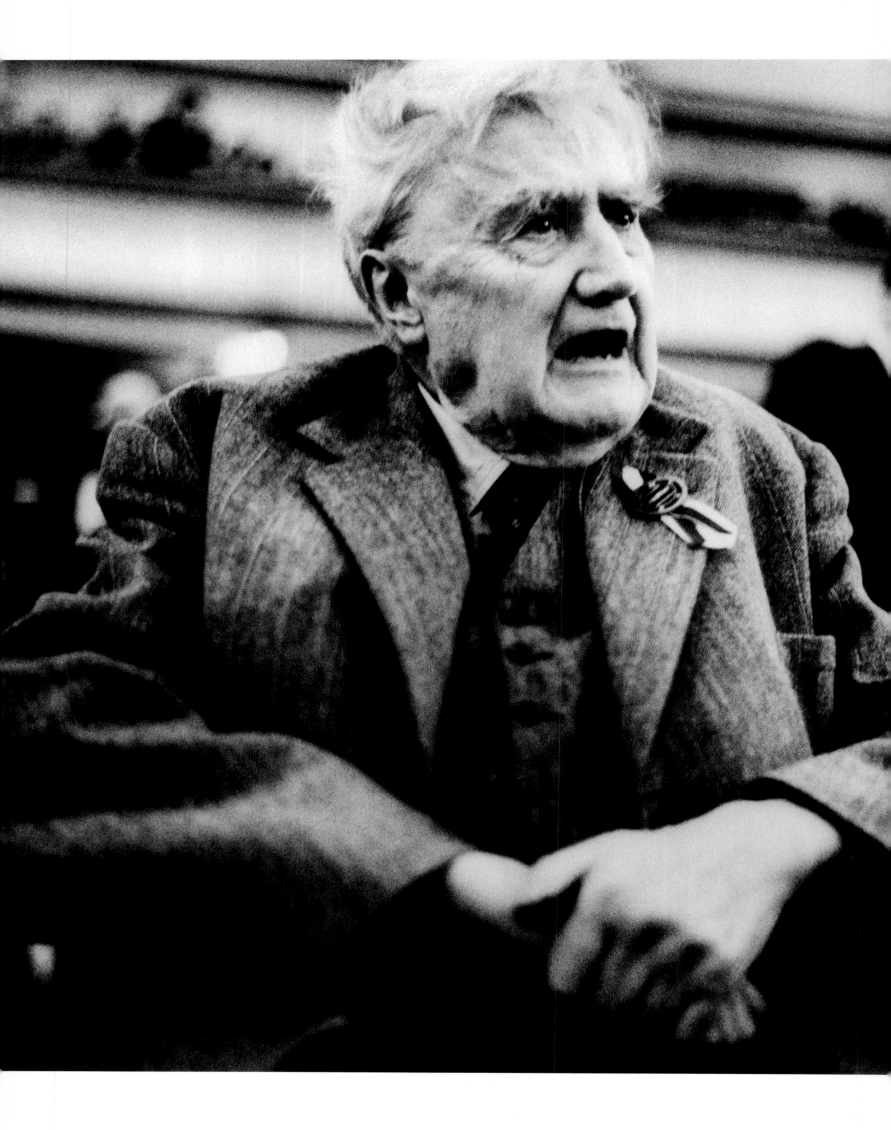

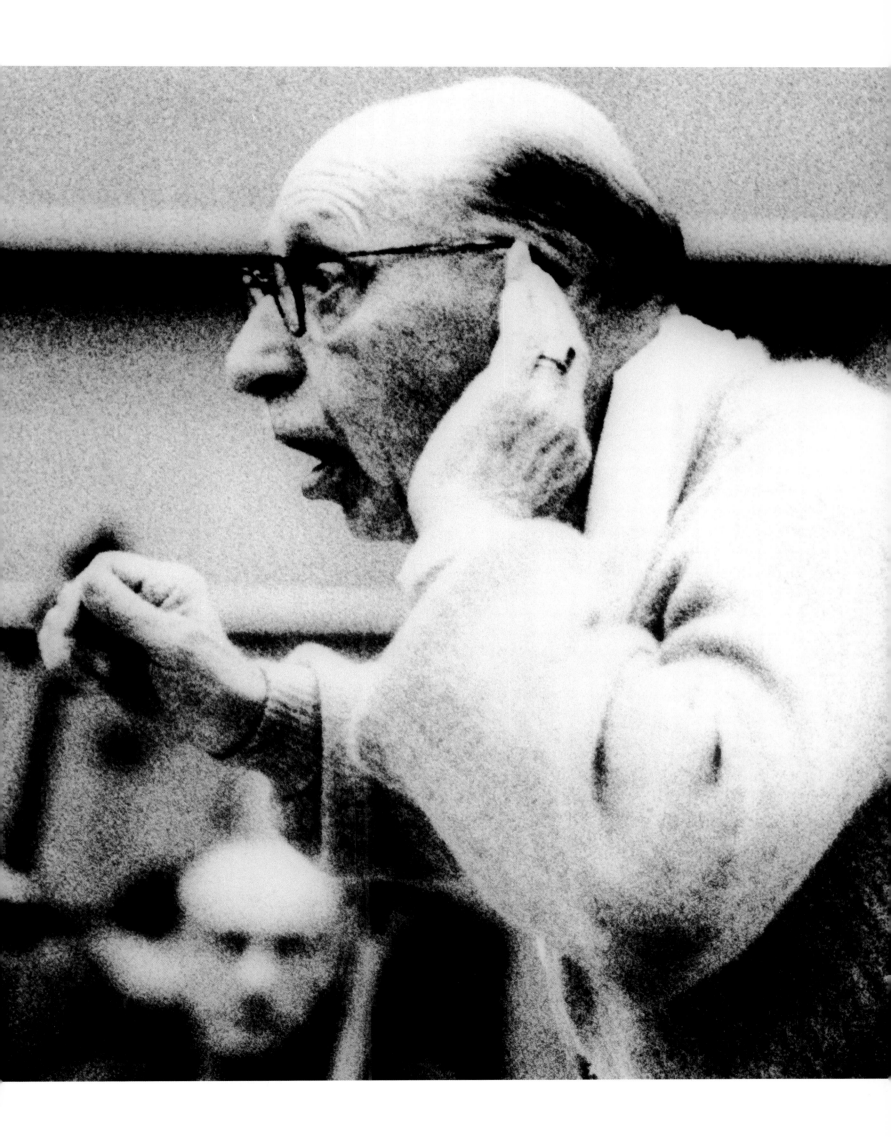

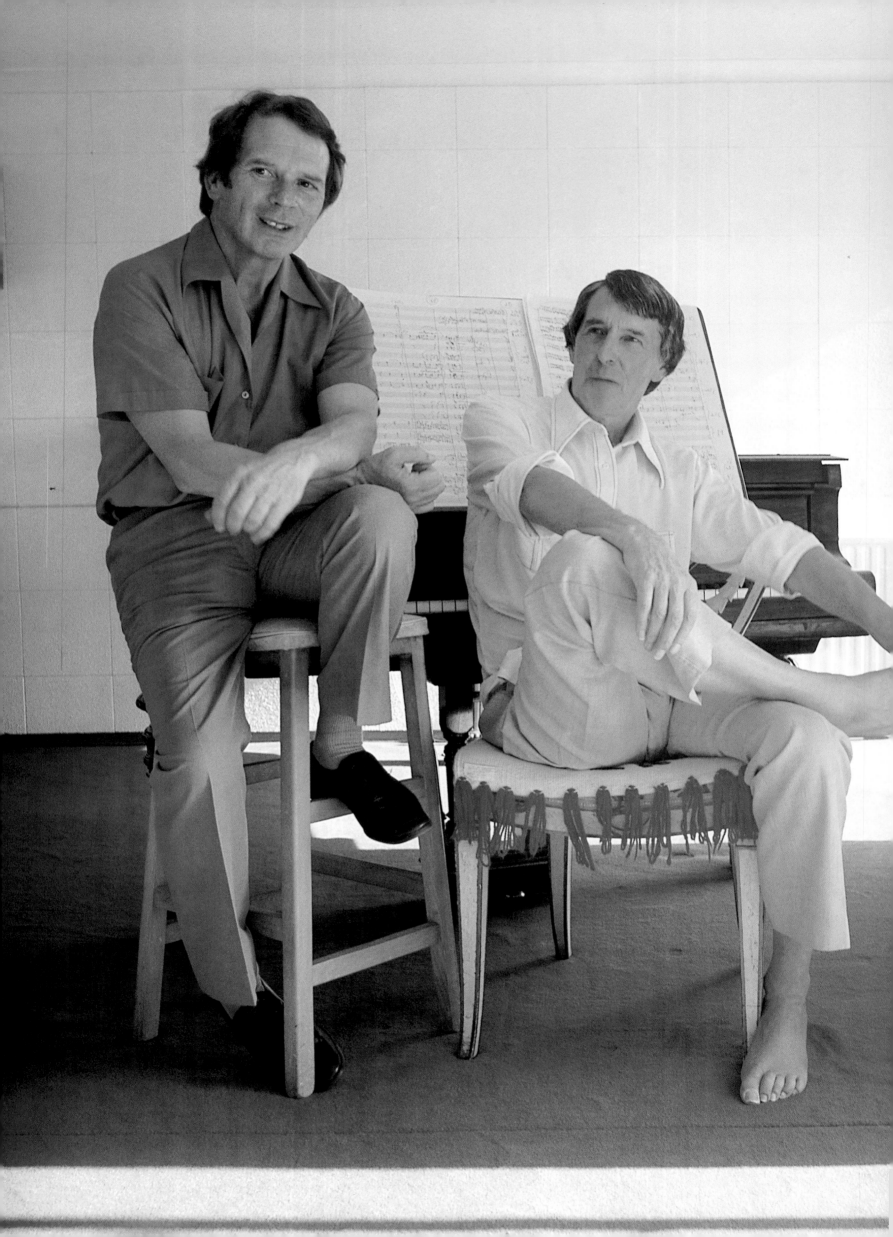

Previous pages, left: Ralph Vaughan Williams, composer and conductor, 1957
At the time of this picture Vaughan Williams was rehearsing a performance in Dorking, near his home, of Bach's St Matthew Passion. He died in 1958 after a remarkably long career – his Sea Symphony was first performed in 1910. I went to the hall where the rehearsals were taking place and found the composer sitting with his wife in the stalls. She asked me to sit next to her, then passed me a sweet and started chatting. I could see out of the corner of my eye that Vaughan Williams was getting agitated and beginning to shout instructions to the performers – he could be quite irascible. Suddenly he yelled out. I was anxious to get some shots of the action, but all I got was more sweets, so I climbed over the seats and knelt directly in front of him, positioned my camera and just held it there. I didn't say a word, but waited for the right moment. Bang on cue, he yelled out again – and I got my picture.

Previous pages, right: Igor Stravinsky, composer, 1961
The week I went to take pictures of Stravinsky I was given a Contax camera by Jocelyn Stevens. It was a 35mm SLR with a 1.4 lens – an unheard-of speed in those days. It meant that you could get action shots in weak light without using flash, provided you had suitably fast film. Taking pictures in a dimly lit concert hall was a perfect opportunity to try it out and I was delighted with the results. I got a few good shots of Stravinsky conducting – the cupping of the ear to catch stray notes was characteristic of him and, like Sir Thomas Beecham, he conducted with his eyes.

Left: Sir Michael Tippett, composer; Antony Hopkins, composer, conductor and broadcaster; 1976
This picture was taken for the cover of the *Radio Times*, for a series looking back at thirty years of the Third Programme.

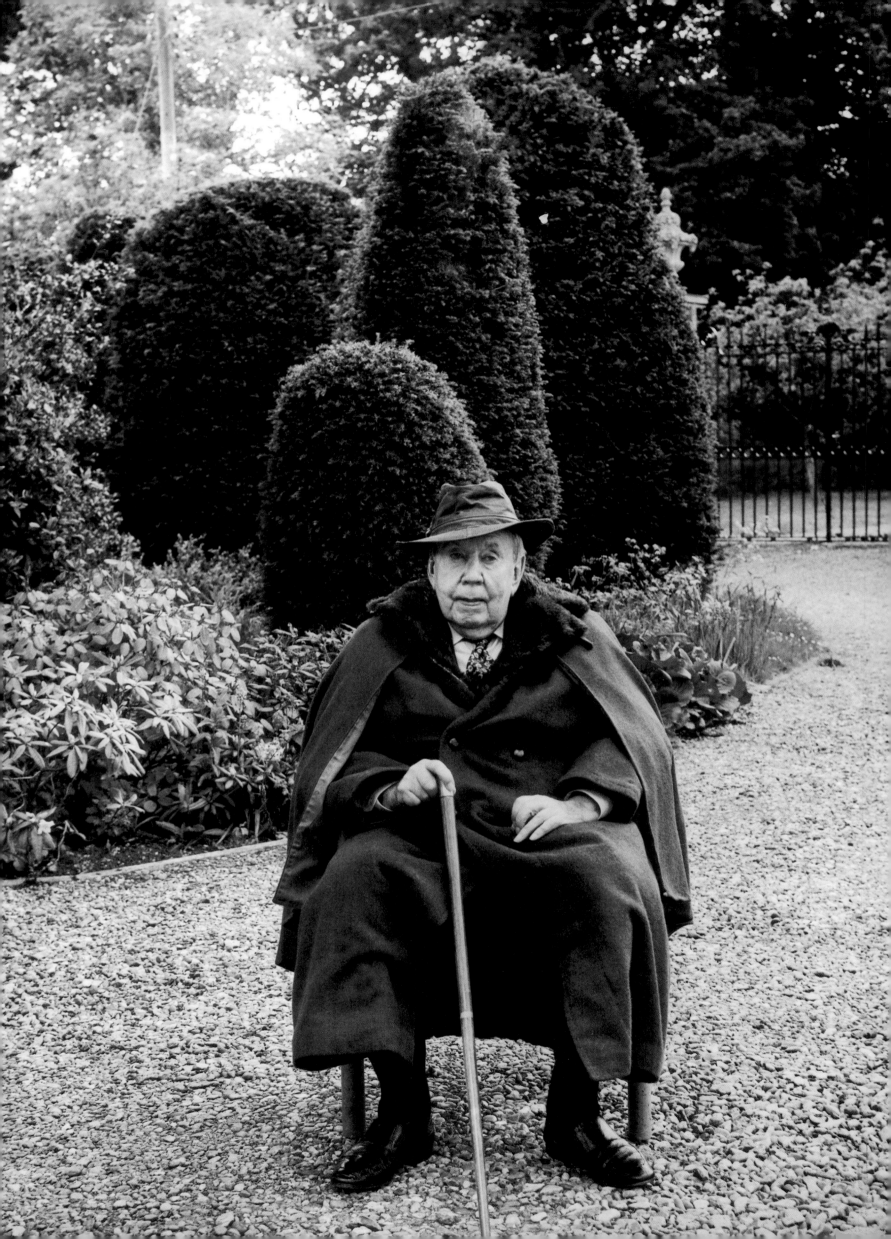

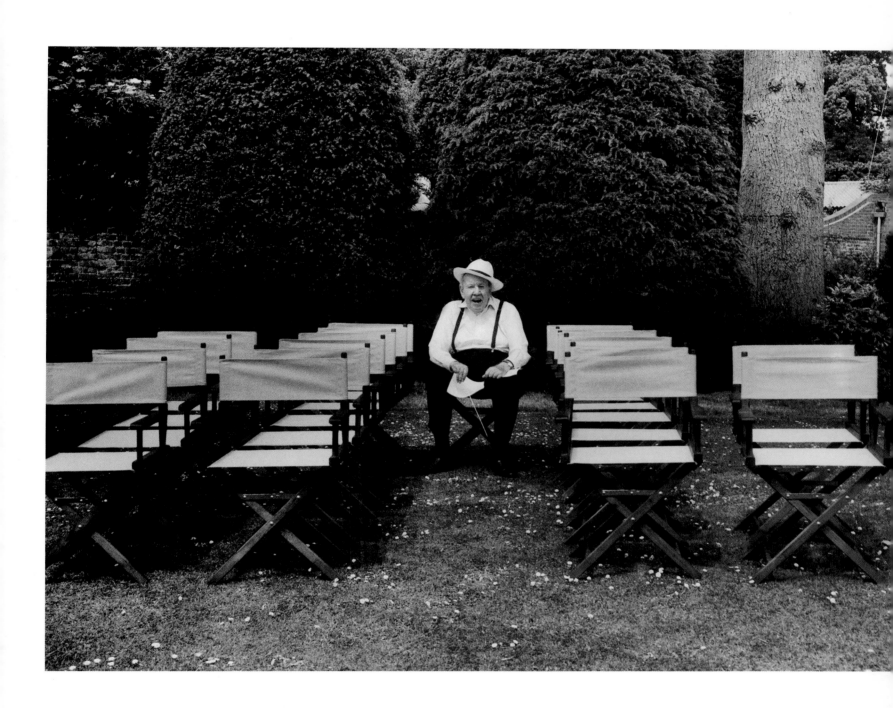

Sir Malcolm Arnold, composer, 1999
Among modern British composers Arnold has been rather neglected, even though he wrote some great film
scores – *Bridge on the River Kwai* and *Tunes of Glory* – and more than sixty classical CDs of his music are
available. He is a formidable man and one of those people who knows absolutely everybody: all the music
and film world; prominent people in the art world, painters, sculptors, and so on. In conversation he is likely
to go off at a tangent and you can't keep him on the straight and narrow. I suppose it befits a composer
that he's a man you have to listen to, rather than talk to; but great fun to be with.

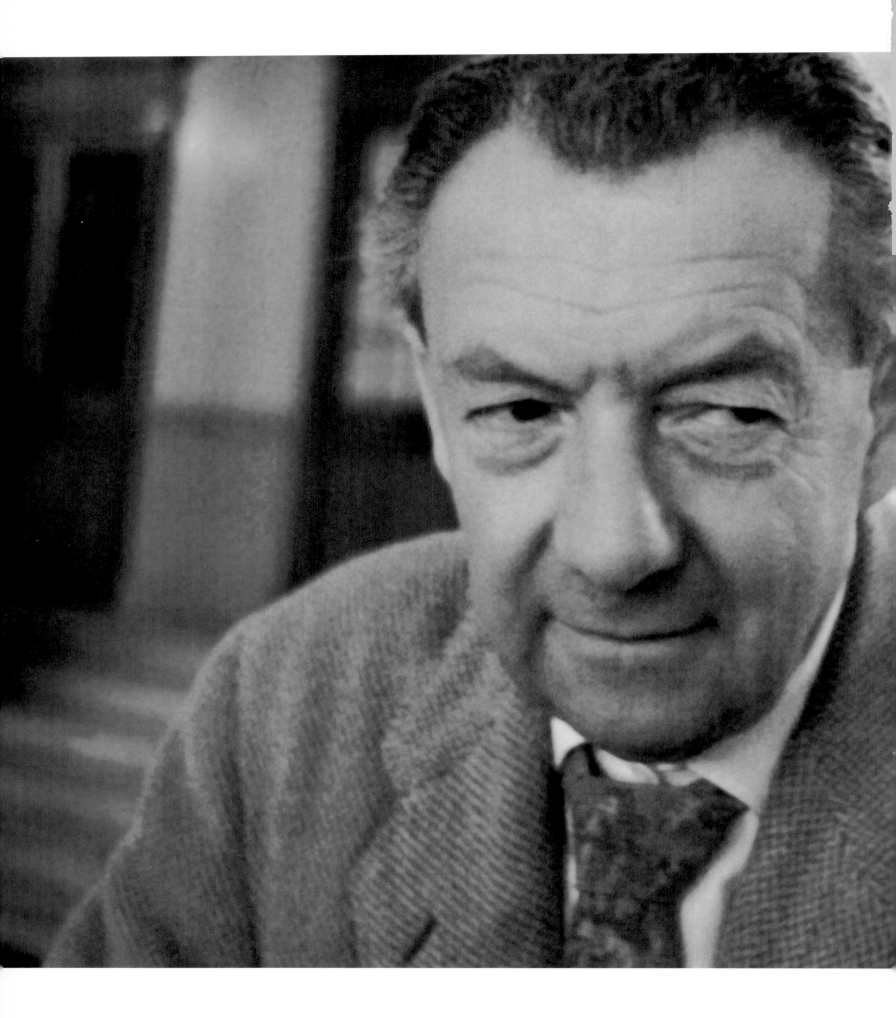

Benjamin Britten, composer, 1968
Britten, one of England's greatest musicians and the first
to be made a life peer, died in 1976. By the time I took
this photograph in London he had become ill and was
avoiding photographers.

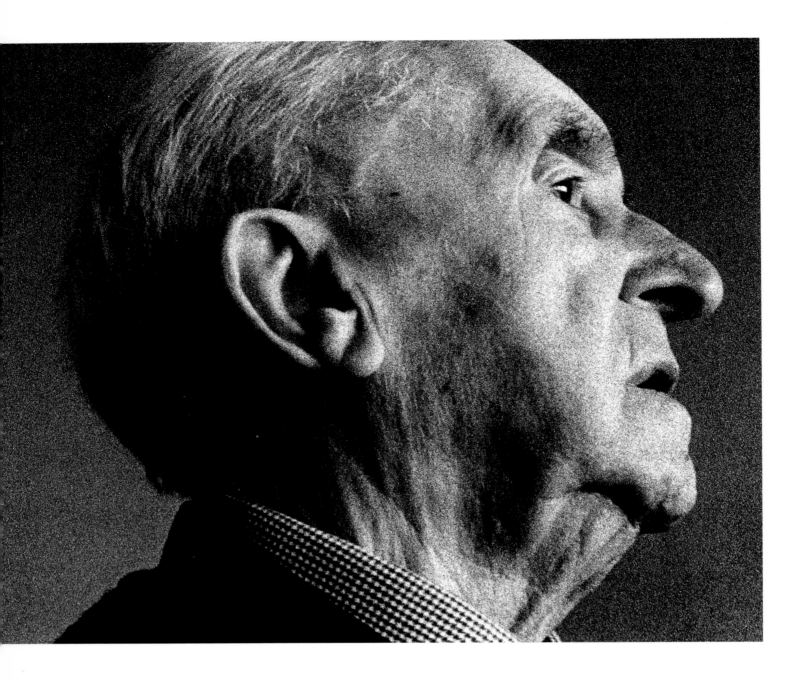

Above: Havergal Brian, composer, 1972
Brian was one of the most prolific, yet least-known of British composers. His work was rarely performed, partly on account of its complexity and its demands on the performers (his Gothic Symphony requires nearly 1,000 people: a very large orchestra, double chorus, a children's choir and four brass bands). He lived in a small bungalow in Shoreham, Sussex, and seemed surprised that anyone would want to come and photograph him, or that I knew of his existence.

Right: Alfred Brendel, concert pianist, 1984
While working for the German publication *Die Zeit*, I met Brendel's future wife, Rene. She recommended me for a series of record sleeves featuring music that Brendel was then recording – I did about twelve in all.

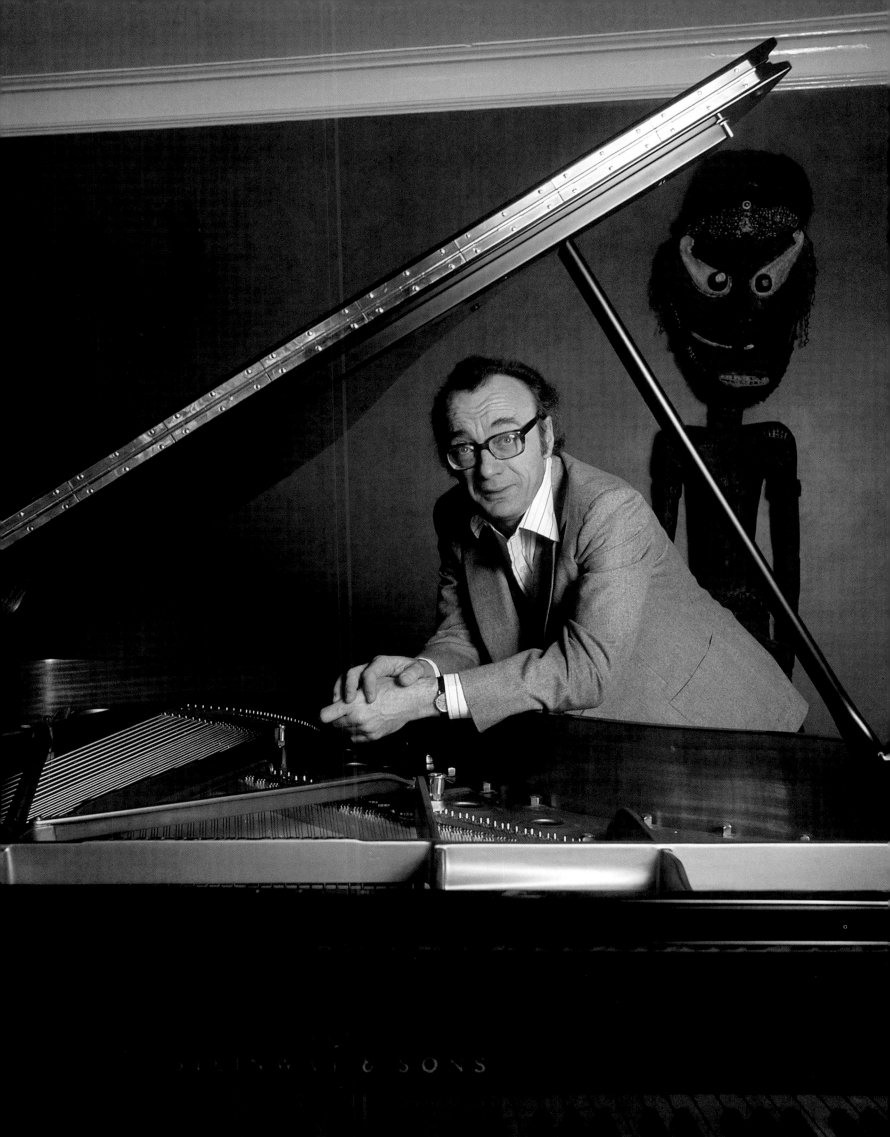

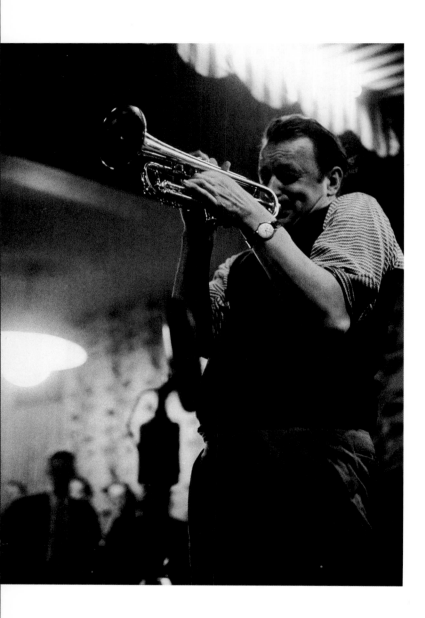

Above: Humphrey Lyttleton, musician, 1956
The legendary band leader, journalist and calligrapher
was photographed in the Oxford Street jazz club: still
blowing strong, and still packing them in.

Right: Julian Bream, musician, 1964
I photographed the world-famous classical guitarist
outside his house in Dorset.

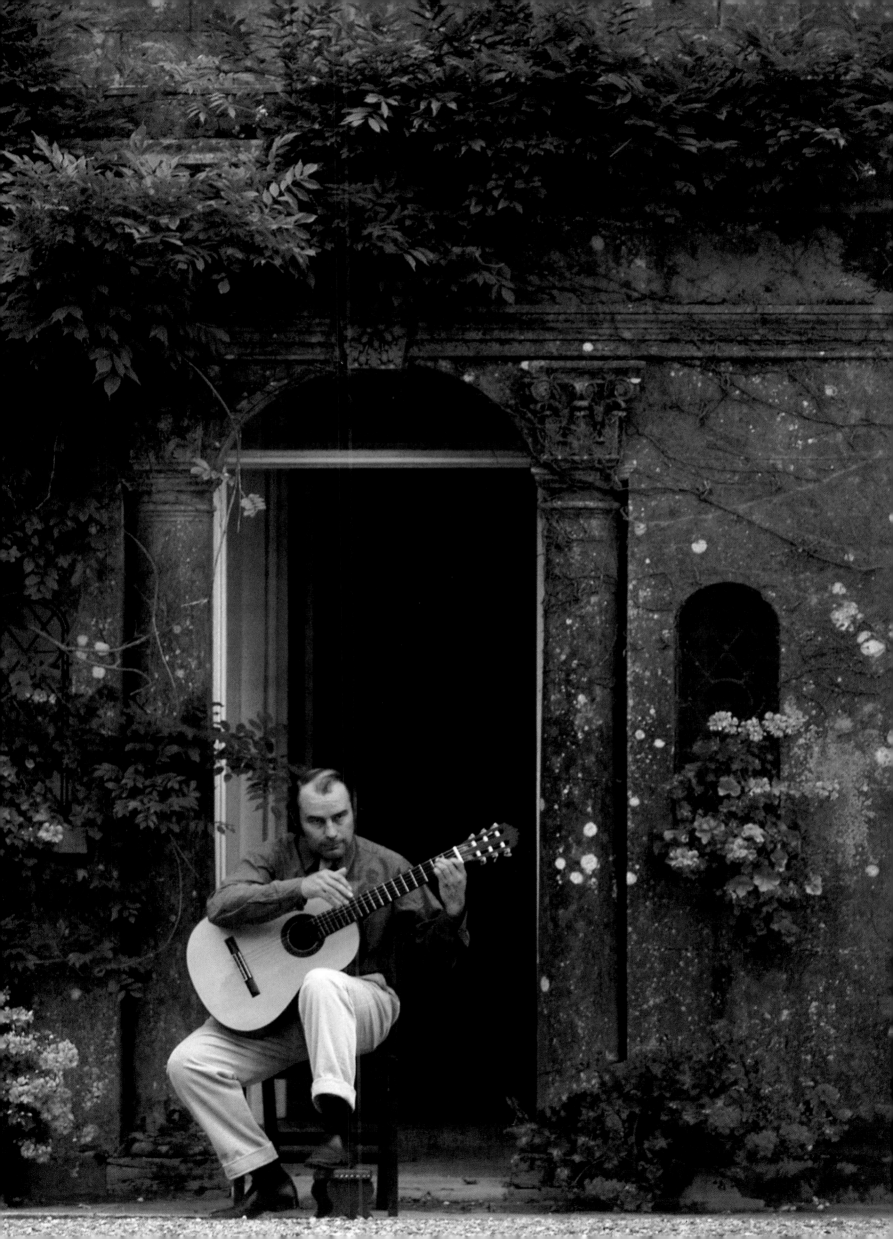

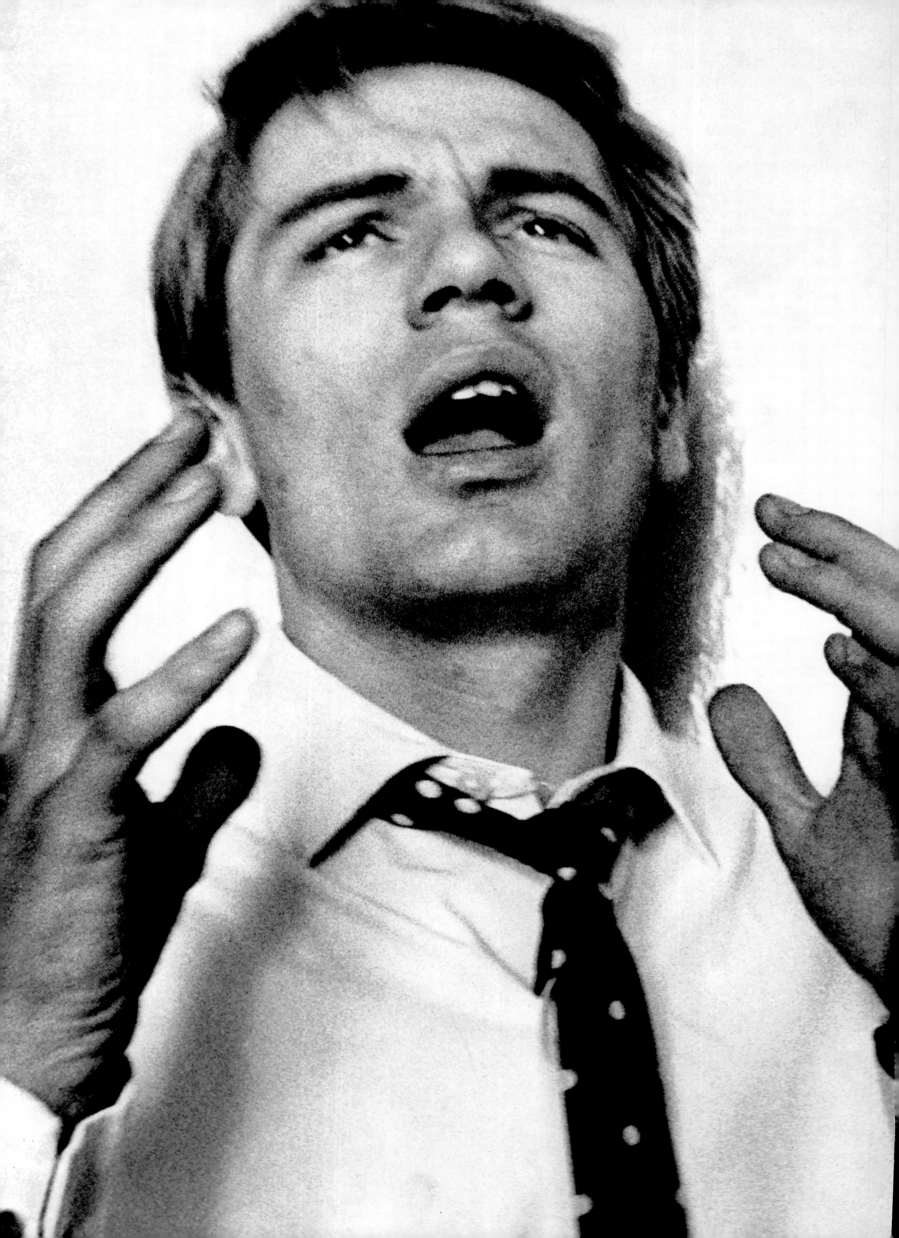

Left: Adam Faith, singer, 1960
Right at the start of his career, before he was launched, Faith was a shy, timid chap when I photographed him in a flat in King's Cross. He seemed to be controlled by agents and hangers-on. It was difficult to get him alone, but I managed to persuade him to sing in the kitchen so that I could get a decent picture of him, away from the others.

Below: P.J. Proby, singer, 1969
The 1960s' rock star was famous for splitting his tight trousers during a particularly energetic performance. I took this photograph while he was rehearsing in a Manchester Methodist mission, nicknamed the Albert Hall.

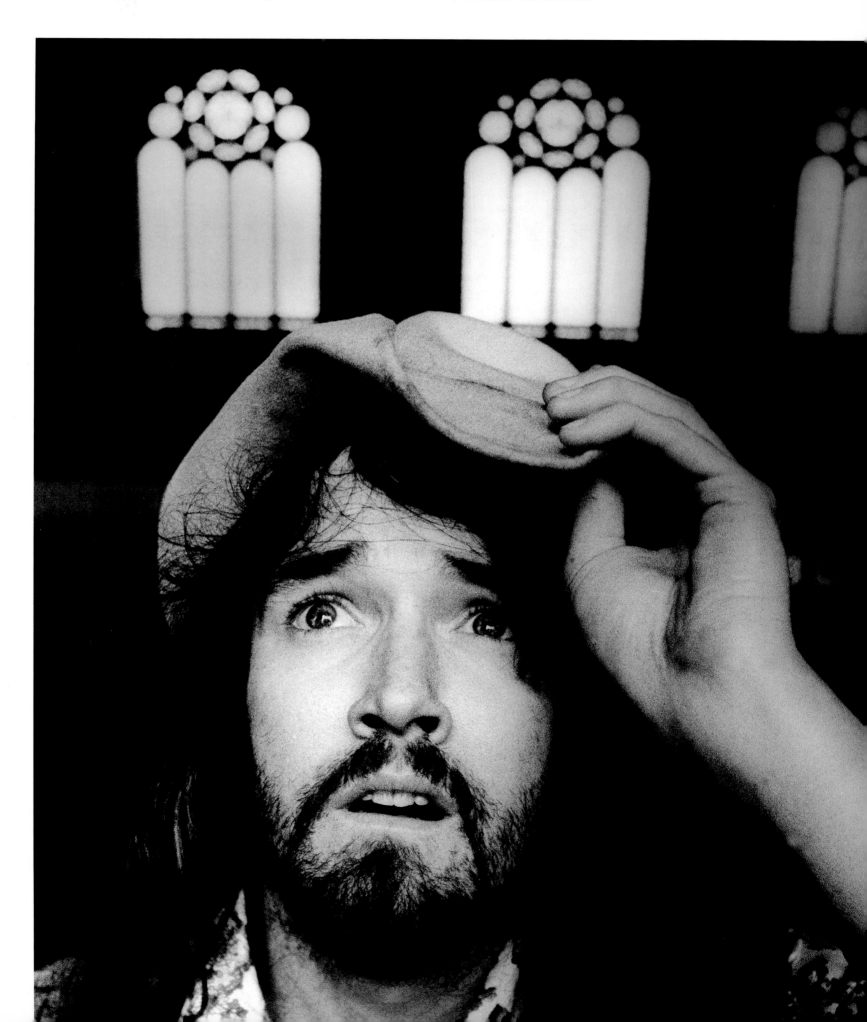

Biography

1936
Born Cheam, Surrey.

1939
House destroyed by a German bomb, which hit a 200-year-old Elm tree in our garden. My mother and I were in the house at the time, shocked but unhurt. In 1940, we moved to Gulval near Penzance in Cornwall, where I attended the village school, captured below in an illustration by Quentin Blake.

1954/55
Served my National Service in the Air Force, where I started as a Fighter Plotter, then joined the Special Tasks section as a photographer and finally worked on War Graves assignments.

1955/57
Awarded Surrey Major Scholarship to study photography at Guildford School of Art. There were only about 20 students, most of whom weren't interested in pursuing photography as a career as it wasn't accepted as an art form at the time, and photographers were rarely credited.

I worked part-time for Desmond Lilly, the *Daily Express* photographer, in his private wedding business and for his newspaper assignments, whilst I was still a student. One Easter Saturday I did five weddings and receptions on the same day. I earned £5 for each one, when the average weekly wage was £6.

As an art student I was always hard up. Over several years the Photography Department had acquired a number of jobs for Surrey County Hall. These were mainly jobs for the County Services – for schools, hospitals (below), clinics, dentists, the fire brigade. The Department couldn't find anyone to do them and so offered me unlimited film if I would take the photographs – all of which I found a great challenge and thoroughly enjoyable.

For the front cover of a school leaver's brochure, I used a model from the Foundation Course at Guildford, a student Tessa Traeger (below), who later became my first assistant at *Queen* magazine.

1955
I met the sculptor Henry Moore. We developed a close friendship that lasted over 35 years. One of my early pictures of his sculptures, when I was still a student, was used half-page on the front page of *The Times*, an unheard of size in a newspaper not noted for pictures.

1956
I took front-of-house pictures for the theatre in Guildford, and worked for a local paper. I embarked on my first European tour, travelling to France, Germany, Austria, Yugoslavia, Italy and Spain. I took hundreds of pictures (centre column) and sold many for features in newspapers and magazines, often writing articles to accompany them. My car attracted a great deal of attention, especially in Yugoslavia where the people lined the streets. We stayed at the Grand Hotel Ljubljana for just 3/6 (35p) a night, for luxurious rooms with silk sheets and brocade curtains.

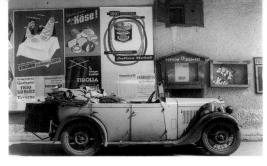

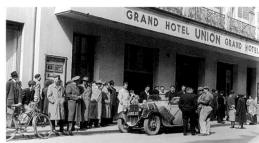

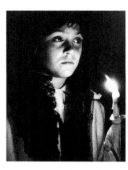

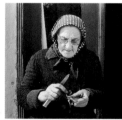

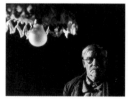

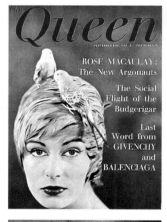

1957
Joined *Queen* magazine as full-time staff photographer. *Queen* was a traditional magazine that was entering a new era under the leadership of Jocelyn Stevens and Mark Boxer (below).

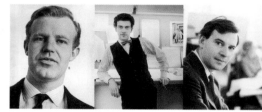

1958
I was commissioned to provide the photographs for a book, *The Hand of Life*, with Lord Richie Calder.

1959
Started working for the *Observer* taking front-page pictures, portraits, and fashion editorials.

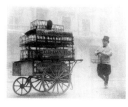

One of the early features I did for *Queen* magazine was on people working at dawn. It was amazing in the 1950s how few early risers there seemed to be in London. One of the people was our milkman in Pimlico, Mr Daniel, who was always very smartly dressed (left). After the photograph appeared in the magazine he became quite a celebrity, appearing on television, radio, and in newspapers.

My first fashion shoot for *Queen* magazine (right). The fashion editors weren't too pleased to have a photographer thrust upon them, when previously they had been at liberty to choose their own. The

shoot took place in the entrance of the National Gallery in Trafalgar Square. I had no assistants, and had about 20 onlookers crowding around and getting in the way, wanting to see what was happening. Someone walked off with my camera case, and all the fashion people were inside getting the outfits ready – a frustrating experience. However, I later had a letter from Norman Parkinson telling me how fresh, good and lively my fashion shots were and he thought I would have a good future as a fashion photographer. He passed on to me several advertising shoots, so I will always be grateful to Parks for his encouragement.

I accompanied the Glyndebourne Opera Company to Paris, on assignment for *Queen*. I took portraits of the company, including the founder of Glyndebourne, John Christie (right).

One of my early covers for *Queen* in 1958 (below), with the model Pagan Gregg. I didn't possess flash equipment and the birds were alive, so the model had to remain motionless for long periods while we caught the birds and placed them on the hat.

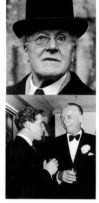

Lord Snowdon and Douglas Fairbanks (above). From my time at Guildford I had admired Tony's work in *Vogue* and I was pleased to shoot the portrait for his book.

1960
I married Julia Mardon, a photographer, below left, with my elder son Sebastian and daughter Dolly.

I first met Robert Graves (below) when I went to stay with my tutor's widow, Veronica Weedon, who was teaching Robert's children at the time. We were all asked over for lunch and, subsequently, several photo sessions.

1961
I did a weekly series of portraits for *The Sunday Times* in their Portrait Gallery for their Profile interviews. Including Senator J. William Fulbright, Rear Admiral G.P.Thomson, Professor A.K.Cairncross, A.J.Ayer and Harry Secombe (right).

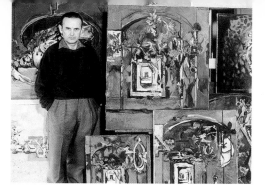

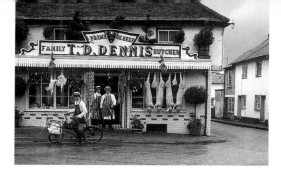

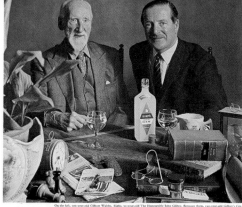

1962

I met and became friends with Graham Sutherland (above and right) and photographed him many times during his life.

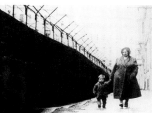

This picture of the Berlin Wall (below) in 1962 is from a series I did for *Go Magazine!* This was a radically new travel magazine which Jocelyn Stevens started. Bill Brandt did a feature on Brighton with black pebbles, dark skies, and deserted streets that gave one the impression of some Northern city in its darkest days. Soon however the magazine had to revert to conventional holiday pictures.

I contributed to *Safety Magazine*, (below left) produced for the Iron and Steel Federation, for 12 years – it was fun to do, and a complete change from my normal work.

1963

I met the artist Marc Chagall (above), in his house in Venice on assignment for *Queen* magazine.

1964

In September I was offered staff jobs by the three colour magazines – the *Observer*, *The Sunday Times*, and the *Daily Telegraph*. I decided to stay at *Queen*, but continued to work for all three newspapers!

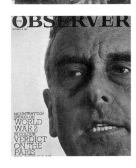

Mark Boxer became Editor of *The Sunday Times* magazine and I did numerous assignments, such as Father Simplicity (above right), for a feature on people who grew giant vegetables and flowers.

Lord Mountbatten (right) for the first *Observer* magazine cover.

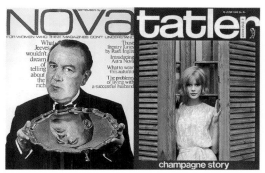

For many years I did the photography for The British Travel Association in America, through the advertising agency Ogilvy & Mather. On one particular occasion, they wanted to feature a village shop and David Ogilvy, the advertizing guru, said he remembered a butcher's shop in his Aunt's village in Hertfordshire. I drove to see it and found it looked rather run-down, with flaking paint and very drab. So we smartened it up and created a scene for a Victorian photograph – providing aprons and boaters, a Victorian bicycle, geraniums and bay trees – I then took the shot (top, centre). Later I received a telegram from David Ogilvy - 'Fantastic picture – just how I remembered it'!

For one *Observer* assignment I took portraits of Rita Tushingham (right). She is a marvellous actress with the most powerful eyes.

1965

Dennis Price on the first cover of *Nova* (below left): a rather slick magazine.

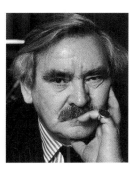

I worked regularly for *The Tatler* (above right) in 1965, doing fashion stories and covers.

I was asked to join the RCA and start a Photography Department to teach painters and graphic designers. I said I would only go if I could have full-time photographic students. Reluctantly Sir Robin Darwin, the Rector of the RCA (below), agreed. Later, however, after the students had applied, he returned their admission fees saying the

College couldn't afford it. He wrote to me, saying that Photography allied to some other discipline was its true function in life. I answered that people were saying that in the 1840s and to hear someone, particularly the Rector of the RCA, saying it in the 1960s was beyond comprehension. I then said that I would teach the students for free and enrolled Henry Moore's daughter, Mary, and a Fulbright scholar, Richard Rogers. After these early teething problems, the course ran smoothly. Robin and I were later to become very good friends.

At this time I photographed for the Milk Account at Ogilvy & Mather, working with the Art Director, Roger Phillips. Roger, who was a great character, came to my studio for a photographic session. He noticed a Guards uniform and couldn't resist trying it on. I took a photograph of him with a bottle of milk. Roger then made an advert of it that was accepted by the Milk Board. A day

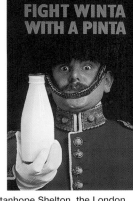

later I was summoned to Stanhope Shelton, the London boss of Ogilvy & Mather. Both Roger and I were carpeted. Firstly, for doing an unscheduled ad, and secondly for using a staff member in the picture – a sin in those days. Many years later I organized a lecture by Shelton for the students at the RCA for poster designs since the 1930s. To my surprise this was one of the posters he showed as being a good example of how posters communicate. Afterwards when I mentioned it to him he said, 'Well I never said it wasn't a good photo!' For an advertising poster it was also remarkable for it sold to students both in New York and London, to pin up in their lodgings.

'Mr Gilbert Walshe is 102. Told me the quality of my gin was an <u>old</u> London tradition when he was a young man.'

Beware the Sympathetic Ear

Note that the aim of the inclined ear is to obscure the embarrassing fact that the tonic water is not the one you're expecting. Only You-Know-Who's Tonic Water has the bittersweet tang, the particular effervescence, that does full justice to the gin you just ordered. Only You-Know-Who's Tonic Water has the Secret of Schh...

Order your tonic by name

Dear Mother,

On an assignment for *Queen*, with Hugh Johnson in Cape Town (right) visiting vineyards. Hugh was an old friend and we were working on a book of English manor houses together.

1966

Took the definitive portrait of Her Majesty the Queen, for the British and Commonwealth stamps.

1967

During this period I worked extensively in advertising, particularly for drink products (above). At first I wasn't very interested in advertising, but later found it great fun and particularly liked doing posters – once having nine 48-sheet posters up in London at the same time.

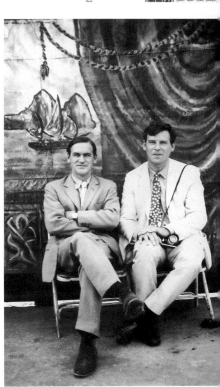

1968

The *Queen* cover of Ophelia (right). Willy Fleckhaus, the great Art Director of *Twen* magazine phoned me wanting to know how it was done. Was it sandwiched together? When I told him that it was done straight in a child's paddling pool in Hugh Johnson's garden he just didn't believe it!

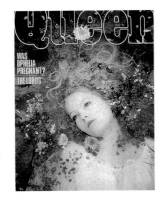

That year I worked extensively for H. H. the Aga Khan in the Costa Smeralda, Sardinia.

I also published my book on Henry Moore. I had spent 12–14 years working on the book, and at some 530-odd pages it was almost as heavy as one of his sculptures! It won the award by an International Jury as the best Art Book recently produced in the world, and set new high standards in compiling and designing art books. This further cemented the relationship between Henry and I (above).

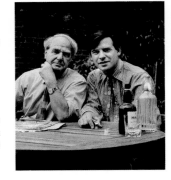

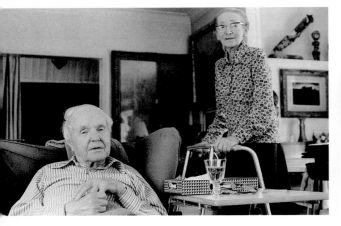

Henry and his wife, Irina (above). Henry described Irina as 'wonderful, she has always been the same, she is not impressed by status or wealth, dislikes pomp, knows her own mind and sticks to it'. They lived in a sixteenth-century farmhouse, Hoglands, where Henry had built a wonderfully light sitting room to house his art collection, carpeted with very expensive yellow carpet that showed every footprint. Whenever I visited I always removed my shoes as Irina was obsessed with keeping the carpet clean. Henry used to get up early in the morning, before Irina, and check the carpet, sweeping up any dirt. In 1984 the French Government awarded Henry the Commandeur De L'Ordre National de la Legion d'Honneur. President Mitterand arrived at Hoglands with a huge entourage, landing by helicopter in the parkland. The presentation took place in the yellow sitting-room. Half-way through the ceremony, Irina came in and started sweeping up the mud around the President, saying in quite a loud voice, 'I do like John, he takes his shoes off!' Henry, quite unabashed, turned to Irina and said, 'Don't worry now dear – I'll clean it up as soon as they have gone.'

Henry in Forte dei Marmi (below), wearing his daughter Mary's wig.

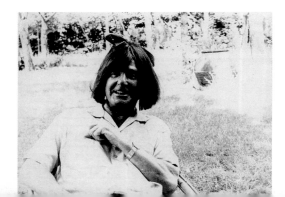

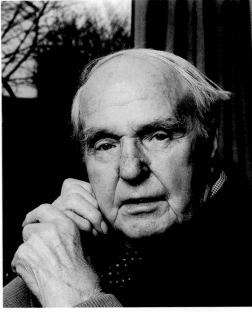

Henry a short while before his death (above).

The cover of the *Telegraph* (right), who serialized the book which I worked on with Marina Warner.

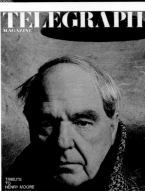

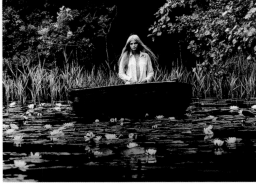

1969

At this time I worked for several pharmaceutical companies and the British Medical Journal, who all seemed to want pictures in black and white looking like editorial pictures from magazines (above).

I took the portrait for the Christmas cover of *Queen*, (right) with a pinhole camera that I made with a shoebox.

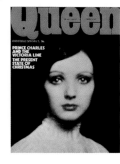

The Photographer, Art Director and Account Executive (left) in between one of the advertising shoots for Ogilvy & Mather, who I regularly worked for at this time.

1970

Die Zeit magazine (right). I particularly enjoyed working for the German magazines – they were so well organized, quick and undemanding.

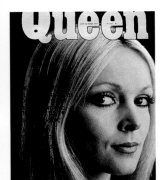

I was asked to do the pictures for The Arts Multi-Projection Show, as part of the The British Exhibiton at Expo in Japan. The photographs of musicans and artists, were arranged and projected on 64 projectors as a mosaic.

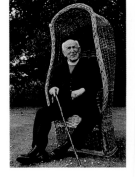

The last cover for *Queen* magazine (left) before it merged with *Harpers*.

1971

I photographed Archbishop Lord Fisher (below) in his garden. He had retired to a little village in the West Country. I asked him what his local vicar had thought when he had suddenly turned up in his parish? He said, 'What do you mean? Naturally he was delighted'. I said, 'How often do you give a sermon?' He replied, 'Every week of course!'

I did a series of photographs on various English towns with John Betjeman, each one being an interesting and different experience.

Sir Roland Penrose (below), a surrealist painter and member of the Arts Council, was a good friend. He commissioned me to photograph Picasso's sculptures for a book project.

1974

At the RCA Degree Show, the Victoria and Albert Museum purchased 40 photographs for their Permanent Collection from my students, proving that photography had become an established art form in its own right.

I sat for my Doctorate at the College. For some reason they organized the most high-powered committee they had ever had there. The Chairman was the spy and Keeper of the Queen's pictures, Sir Anthony Blunt. The other members were Sir Roland Penrose, Professor Misha Black, Professor Guyatt, and Professor Bernard Meadows. The Staff were running a book on my chances, and gave me the odds of a rank outsider. As the subject was Henry Moore's sculpture, I found the two and a half hours most enjoyable and was passed unanimously!

DR JOHN HEDGECOE FOCUSSING.

THE MAD DOCTOR AT IT. AGAIN.

1975

An old friend, Peter Kindersley, started a new publishing company, Dorling Kindersley, and asked me to do some photography books. I did *The Book of Photography* and *The Handbook of Photography* – sometimes referred to as 'the photographer's bible'. These two books have sold nearly three million copies between them, and altered the face of practical photography books.

Portrait, 1977 (below).

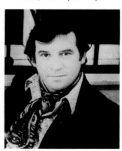

1977

I produced several covers for the *Radio Times*, combining images both by cut-and-paste, and projection techniques. It was at this time that I also took portraits, mainly of scientists and musicians.

I worked on a book of Michaelangelo's *Sonnets*, with my daughter, Dolly (left).

1978

Nonie Beerbhom (below), was a poet, writer, academic, and great friend. I had known Nonie since my Guildford Art School days and she was always full of wonderful encouragement whether I was working on a project or writing an article or a book.

1980

I did a book for the publisher James Mitchell, on nudes. It was mainly shot at Castle Howard in Yorkshire. Lord Howard, a friend, let us have the run of the house and provided parties for most of the week. It was great fun. James Mitchell, aiming to get publicity, called the book *Possessions* to infuriate the Women's Lib. However, he also managed to get me nick-named 'Chauvinist Pig of the Month' in *Spare Rib* and banned from several libraries!

Photographs from *Possessions* (above).

Lady Beauchamp (right) lent me her house, Madnesfield Court, for a photo shoot and offered herself as a model, at half price due to her age – she was over eighty!

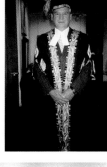

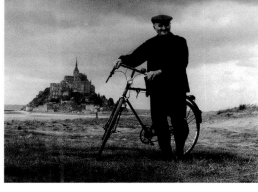

1982

I was commissioned by the French Government Tourist Office (above). However, the French provinces didn't like to be told from Paris that an Englishman was coming to do the work – so it only lasted a year.

1983

I took over as Acting Rector of the RCA in 1983–4 (right and taking convocation, below). Jocelyn Stevens then took over in what he has described as the best job of his life.

I produced a series of 8 programmes for the new television station Channel 4, called *What a Picture!* The series was repeated a year later.

In the same year I provided the cover photographs for an extensive series of psychology books, published by Methuen & Co.

1984

Produced *The Book of the Nude*, for Dorling Kindersley.

1985

I did a part-work (right) for Orbis based on my instructional photography books.

1986

I enjoyed a wonderful collaboration with A. L. Rowse (below) which resulted in three books, including *Shakespeare's Land* and *Rowse's Cornwall*.

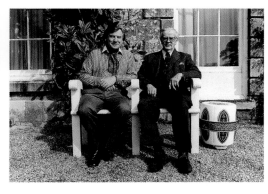

1987

I published books on Portrait and Landscape Photography.

1990

Published *The Video Photographer's Handbook*.

1991

Took the photograph used on the wine label (below) for the RCA senior common room wine.

ROYAL COLLEGE OF ART

GRENACHE BLANC
VIN DE PAYS D'OC
1991
BOTTLED BY VVO 11100 NARBONNE
PRODUCE OF FRANCE
11.5%vol
75cl

1992

Took the photographs for an exciting book *Zillij – the Art of Moroccan Ceramic.* The photographs were also displayed in a large exhibition.

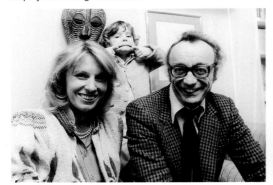

1993

I photographed a series of record covers for the concert pianist Alfred Brendel (above).

1994

Published *The Spirit of the Garden*, a collection of photographs of beautiful gardens from around the world.

Took early retirement from the Royal College of Art to concentrate on books and exhibitions.

1996

My first novel, *Breakfast with Dolly*, was published by Collins & Brown.

1997

Produced a CD-Rom for Anglia Television (above).

Worked for English Heritage on the *Visitors' Handbook*, a book on Stonehenge and England's World Heritage.

1997-98

I returned to work for H.H. the Aga Khan, photographing his studs in Ireland and France.

In 1998 I published a new book on Henry Moore, *The Monumental Vision*.

At present working on Entertainers and a new novel.

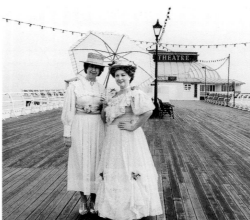

Portrait of John Hedgecoe by Astrid Rippke, 1999.

The Royal College of Art:
Started Photography Department, 1965
Head of Department and Senior Tutor, 1965–74
Awarded Degree of Doctor, RCA, 1972
Appointed a Fellow, 1973
Reader in Photography, 1974
Awarded The Chair in Photography, 1975–94
Started Audio Visual Department, 1980
Started Holography Department, 1982
Pro Rector, 1981–93
Acting Rector, 1983–84
Appointed a Senior Fellow, 1992
Emeritus Professor, 1994

Exhibitions in: London, Sydney, Toronto, Venice, Prague.

Collections in: Victoria and Albert Museum, Tate Gallery, Art Gallery of Ontario, National Portrait Gallery, Citibank-London, Henry Moore Foundation, Museum of Modern Art in New York, Leeds City Art Gallery, Ministry of Culture-Morocco.

Awards: Awarded Honorary Laureate and Medal by Czechoslovakia for contributions made to photography. Awarded Honorary Fellow of the Indian Institute of Photography.

The Art of Colour Photography, 1978, won The Kodak Book Prize in Stuttgart.
The Photographer's Handbook won The Grand Prix Rechnique de la Photographie, The Museum Francais, Paris in 1980.

I have produced over 20 best-selling photography books, published in 35 languages. They have influenced and have been adopted by photographic schools throughout the world.

Publisher's Acknowledgements

'My skinny little cherry tree' by George Barker, reproduced with permission of Faber & Faber. Extract from Patrick Cambell's column, reproduced with permission from *The Sunday Times*.

Author's Acknowledgements

My grateful thanks to all those people who have given me such a happy and varied life over the years – particularly the Publishers, Editors and Art Directors who have commissioned and paid me for doing what I so enjoy. I would especially like to thank Jocelyn Stevens who took me on in the first place and helped me in so many ways – we've been battling together since! Professor Dick Guyatt who got me to join the Royal College of Art where I made so many friends, both staff and students.

Mark Collins and Cameron Brown who were enthusiastic about doing a book of my early portraits. My Editors Sarah Hoggett and Katie Hardwicke, always so positive. Adrian Bailey with reminiscences and help with the text. Jenny Mackintosh, my assistant, who spent so much time searching for elusive negatives and helping on the photo-shoots. To all those people who willingly and kindly gave of their time and suffered so from my camera lens! To Richard Nemar-Smith and David Moss of Reflections for printing and supplying prints for my exhibitions of portraits.

To Ilford for their superb films.

The Proprietors of the magazines, newspapers and advertising agencies mentioned in this book and for hiring me in the first place.

Lastly Grant Scott, who designed this book with such panache.